LINO TAGLIAPIETRA

LINO

TAGLIAPIETRA

In Retrospect

A MODERN RENAISSANCE
IN ITALIAN GLASS

BY SUSANNE K. FRANTZ

Museum of Glass, Tacoma ~ University of Washington Press, Seattle and London

CONTENTS

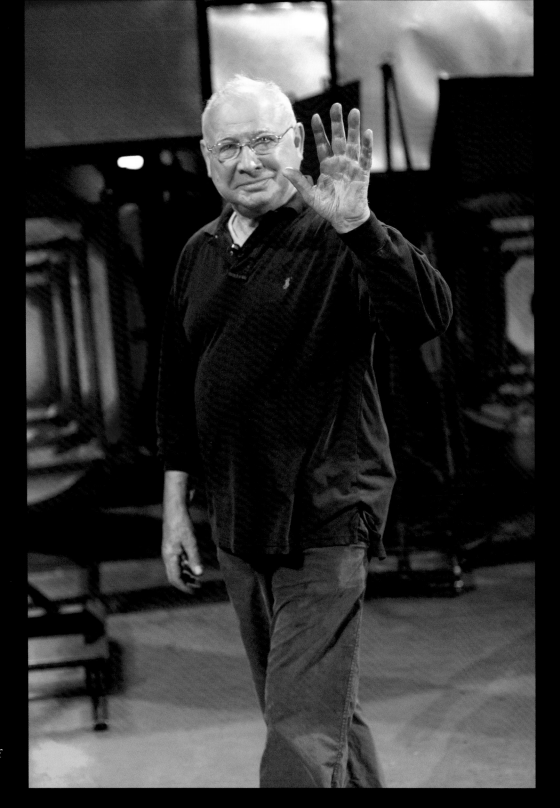

FIG 1. Lino at the Museum of
Glass, Tacoma, Washington,
2007

FOREWORD

Lino! The name itself, the glorious glass it connotes, and the passionate artist it represents evoke a powerful urge to do homage to the lifetime achievements of a man who is honored as a maestro—possibly the greatest glassblower working today. It is my hope that the exhibition, *Lino Tagliapietra in Retrospect: A Modern Renaissance in Italian Glass*, the video documentary, and this accompanying catalogue, all organized and produced by the Museum of Glass, will provide that homage.

This is the first comprehensive retrospective and scholarly examination of Lino Tagliapietra's work and the first major traveling exhibition to be organized by the Museum of Glass.

The exhibition is most meaningful, however, because the story it tells goes beyond the accomplishments of one man and his work. Lino represents the creative electricity that flows between two of the world's great centers of art, Murano, Italy, and the Pacific Northwest region of the United States. His time-honored role as a teacher and mentor to virtually every artist in the Northwest's Studio Glass movement is legendary, but his influence is also apparent in China, Japan, and Australia—and filters far beyond any political or geographic boundaries.

It is perhaps redundant to attempt to describe the elegant playfulness and fluidity of Lino's work in a catalogue replete with startlingly beautiful images. Instead, I will relate a simple comment, offered as an absolute truth, by one of the members of his glassblowing team as they readied the glass furnaces and equipment for Lino in the Museum's Hot Shop: "The glass knows." What he meant, and what was understood, was, "the glass knows that it is Lino working today, and it will behave as it does only for him."

The exhibition, the catalogue, and the video documentary reflect the time, commitment, passion, and energy of many people, who have undertaken this project with joy as well as hard work. The Museum and its Board of Trustees are deeply grateful to Lino Tagliapietra, his wife Lina, his family, and his trusted studio director, Cecilia Chung, for the privilege of organizing this important retrospective, and for their cooperation and investment of time.

Special thanks go to exhibition curator Susanne K. Frantz, former Curator of Twentieth-Century Glass at the Corning Museum of Glass; to the internationally acclaimed scholar and glass historian Dr. Helmut Ricke of the Düsseldorf, museum kunst palast, Glasmuseum Hentrich; and to the renowned Seattle glassmaker and early Tagliapietra student, Dante Marioni, as well as to the University of Washington Press and the many lenders who have generously loaned works from their collections.

First and foremost, I thank Rebecca and Jack Benaroya for their extraordinary support of this project, as well as the The Paul G. Allen Family Foundation, Russell Investments, Windgate Charitable Foundation, Heritage Bank, The Boeing Company, Click! Network, *The Seattle Times*, and the *Seattle Post-Intelligencer*. All have contributed to the success of this undertaking.

The Museum of Glass is a young institution with the dream of becoming the steward of the Northwest glass story. Lino Tagliapietra is a mature statesman of the Studio Glass movement. We are deeply honored that he entrusted the legacy of his life's work to our care.

—TIMOTHY CLOSE
Director/CEO, Museum of Glass

ACKNOWLEDGMENTS

Lino Tagliapietra's many friends and admirers generously assisted in countless ways, both with this exhibition and its publication. It was a privilege to be part of the experience and to work on a project that was greeted with such enthusiasm. As always, the opportunity to spend time with Lina and Lino Tagliapietra was a pleasure and I thank them and their family, especially daughter Marina, not only for their cooperation and kind hospitality, but also for their patience in providing information and efforts in locating and securing rare pieces.

Cecilia Chung, Director of Lino Tagliapietra, Inc., accepted many responsibilities and just a few of her contributions include the initial logistical organization for most of the objects, gathering data and photographs (including most of the images from Lino's early years), answering inquiries and facilitating communications, and compiling a chronological listing of Lino's series of work. The assistance provided by Dennis Palin in her office was also invaluable.

Sincere thanks also go to Director and Chief Executive Officer, Timothy Close, and Susan Warner, Director of Public Programs, Museum of Glass, who conceived the idea and wished to undertake it at the highest possible level of quality. Susan oversaw everything from beginning until end.

It is safe to say that almost the entire Museum of Glass staff devoted much of their time for over a year to this one effort, but specific thanks are offered to William Bitter, designer of the installation and its traveling components; Liz Cepanec, coordinator of the working sessions by Lino and his team in the Museum Hot Shop; Rebecca Engelhardt, Registrar, who consolidated the objects and photographs; and Todd Pottinger, Audio Visual Producer, creator of the accompanying video documentary. I am also appreciative of Kate Albert, Assistant to the Registrar; Dixie Coggins, Chief Advancement Officer; Hannah Fields, Grants Manager; Tyson Griffin, Curatorial Assistant, and Maria Kadile Konop, Marketing Manager.

Sigrid Asmus was indispensable in her tireless and impeccable editing and good cheer, and Michelle Dunn Marsh must be thanked for the exceptionally beautiful design of this publication. Photographer Russell Johnson kindly provided numerous images.

Colleagues and friends Helmut Ricke and Dante Marioni wrote brilliantly in their own voices about the place of Lino Tagliapietra in glass history. Dante was more than generous with his time, guidance, and reminiscences. Many others also kindly agreed to be interviewed, answered streams of questions, and loaned personal photos, objects, and archival materials; they include: Rob Adamson, Marina Angelin, Marina and Marino Barovier, Dale Chihuly, Dan Dailey, Fritz Dreisbach, Peter Drobny, Robert Frehling, Richard Marquis and Johanna Nitzke Marquis, Rosa Barovier Mentasti, Benjamin Moore, Giovanni Sarpellon and Sandro Zecchin, and Michael Scheiner.

Tina Oldknow, Curator of Modern Glass at the Corning Museum of Glass, provided transcripts of her many interviews with Lino and made possible the loan of pieces from that collection. Gail Bardhan, Reference Librarian at the Rakow Library, never failed to find answers to my queries. Thank you also to David Whitehouse, Executive Director, and CMoG staff members Warren Bunn, Registrar; Joseph Maio, Chief Preparator; Jill Thomas-Clark, Rights and Reproductions Manager; and Nicholas Williams, Photographic Department Manager.

Curator Dorris Kuyken-Schneider in the Netherlands cannot be thanked enough for sharing her archives, astute insights, and detailed memories.

I am deeply grateful to the lenders to the exhibition and those who helped make those loans possible, including Matisse P. Etienne and Else van der Veldt of Etienne & Van den Doel, Expressive Contemporary Art, the Netherlands. George Stroemple and curator Linda Tesner graciously allowed me to choose from the extensive Stroemple collection of Tagliapietra goblets. Rosa Barovier Mentasti loaned the rare *Orfeo* that she fell in love with and purchased many years ago. Lina, Lino, Marina, and Silvano Tagliapietra made available many of their family treasures. Appreciation is extended to all of the following lenders for entrusting their objects: Marina Angelin, Corning Museum of Glass, Dan Dailey, Anna and Mario Ferro, Giorgio Ferro/Galliano Ferro, Guido Ferro, Paula Ferro, Düsseldorf, museum kunst palast, Glasmuseum Hentrich, Dante and Alison Marioni, Johanna and Richard Marquis, Rosa Barovier Mentasti, Vanna and Lorenzo Quintavalle, George R. Stroemple Collection, Lino and Lina Tagliapietra, Lino Tagliapietra, Inc., Marina Tagliapietra, and Silvano and Nelli Tagliapietra.

Other individuals provided expertise and helped in a variety of ways: Beverly Adams, Alison Marioni, Paula Bartron, Grace Cochrane, Eva Czernis-Ryl, Geoffrey Edwards, Kate Elliott, Donghai Guan, Brian Hirst, John Kiley, Laura de Santillana, Jane Milosch, Yoriko Mizuta, Michael Monroe and Nora Atkinson, Jean-Luc Olivié, Jennifer Opie, Kait Rhoads, Jonathan Schmuck, Amy Schwartz, Yungshan Wang, and Mary B. White.

Final thanks go, as always, to Millie and Milt for their encouragement and support.

—SUSANNE K. FRANTZ

9

Opposite: FIG 2. Vessel (DETAIL), 1990. (CAT. 46, PL. 38)

LINO TAGLIAPIETRA IN RETROSPECT:
A MODERN RENAISSANCE IN ITALIAN GLASS

Susanne K. Frantz

Some of the narrow lanes on the seven small islands that form Murano are named after renowned members of its historic glassmaking society, including the Barovier and Seguso families, Giacomo Cappellin, Paolo Venini, and Vittorio Zecchin. Upon disembarking from the boat, two things become viscerally noticeable to the visitor. The first is the smell that has soaked into every brick: it is the odor of combustion, familiar to anyone who has spent time in the places where glass is made. The scent is warm (if that is possible) and smoky, even though gas has replaced the beechwood shipped from Croatia that still fueled the Muranese furnaces when Lino Tagliapietra was a child.[1] The second sensation is of white noise in the background; it is the unremitting rumble of the furnaces for heating and melting glass. In some locations the sound builds to a roar and can disturb a night's sleep, but usually it is muted and registers on the consciousness only when a tone differs or temporarily stops. Even while sitting in his Murano office, Lino will casually remark that the day's color melting at Venini must have just finished because he detected a slight shift in sound.[2] For Lino, glass represents his life: Venice and the lagoon, its shadow and the light. "It is part of my culture, my brain, my blood."[3]

Lino is one of those individuals that everyone seems to gravitate toward and wants to know. The interest lies both in his work and in the man himself. The course of his career in glass craft and art—beginning in childhood and maturing in the factory setting—is unheard of in American Studio Glass and has the added appeal of a kind of "rags-to-riches" story. As an artisan, the level of his glassblowing skill still trumps all other efforts in the United States, almost thirty years after his first visit. What he designs and makes is rooted in the thousand-year-old Venetian glassmaking tradition,[4] yet at the same time is so fresh and creative in interpretation that it overshadows many of his contemporaries. His work stands within the grandest tradition of the decorative arts, an honored discipline of unabashed beauty and exquisite craftsmanship.

The elements of the Lino Tagliapietra equation do not tabulate to the expected result. How many individuals born into a working class family, raised on an island that exemplifies the word "insular," and trained in an ancient handicraft with a minimum of scholastic education make the transition to being an acclaimed artist with an erudite world view? Great technical skill alone and a heartfelt desire to make that mysterious thing known as *art* rarely add up to the real thing, especially when the aspirant has little or no formal training in such areas as life drawing, design and composition, or the history of art. To begin in a milieu that tends to be secretive, jealous, and wedded to the belief that there is little to learn from the outside world does not promote invention and curiosity. Provincial does indeed describe Lino's background and the odds of his altering the course of glass history were not promising. Nevertheless, that is what he did. In addition, he grew to be a gentleman and an educator, an intelligent and well-informed political and cultural conversationalist, a lover of Tolstoy, Turgenev, American basketball and C-SPAN, and an excellent cook.

Lino was born in an apartment on Murano's Glassblower's Channel (Rio dei Vetrai) close to his present home, but the family soon moved to a row house on Campo San Bernardo. Murano's domestic housing is often wedged between glass-related enterprises and the one closest to the Tagliapietras was the newly established independent workshop of Archimede Seguso, one of the greatest of twentieth-century glassmakers. Unlike Seguso, one of his early inspirations, Lino was not instructed in the craft by his father or uncles. Nor was he born into a glassmaking dynasty like his wife Lina (née Ongaro), who can point to a family crest on display in Murano's civic glass museum (Museo Vetrario). The Tagliapietra family came from the nearby island of Burano known for lacemaking and fishing, not glass. Various personal and economic factors led to his parents' 1926 relocation to Murano, where Lino's father found work at the Venini & C. glasshouse, but not as a glassblower.

Upon meeting this bright and articulate man, one is taken aback to learn that he left school at around age ten. While child labor unfortunately remains commonplace in much of the world, it is not the background of many individuals in the field of modern art in any medium. It is natural to jump to the conclusion that Lino went to work because his family was poor and the additional income was a necessity. He was born during an international economic depression and his early childhood coincided with World War II—a time of food shortages, air raids, and some bombing of the nearby port.[5] His family was indeed low income, as was almost everyone else on Murano at that time, but the choice to end his formal education was Lino's alone. And while many on Murano apprenticed at a young age, the decision to quit school (one that he regrets to this day) was upsetting to Lino's parents. Older brother Silvano was already employed in the glass industry, but he continued his education

and in later life became a journalist and a historian. Lino, on the other hand, missed a year of school due to illness and was frustrated upon returning to the classroom. He wanted to get to work, to grow up. When he could not be dissuaded, his father found him a position helping in a shop for the repair of windows and old furniture. The venture with wood was brief and soon he was hanging around the workshop of Giuseppe "Beppo" Toso where he opened and closed the molds for the glassblowers and cleaned the blowpipes and pontil rods.

In the telling and retelling of Lino's story, his biographers habitually cite one memory from the war years that has taken on the character of a childhood epiphany. It is a classic example of a kid's interest that was sparked and never extinguished. Like the other children, Lino played all over the island where there were open spaces and the water in the lagoon was so clear that he could catch fish and soft-shell crabs with his hands.[6] Back then, Murano still had fields of vegetables, a fish market, three theaters, and plenty of bakeries and butcher shops. A favorite spot for soccer games was the wider than normal stretch of Calle Bertolini that ran next to a garden and behind a number of glass factories lining the Glassblower's Embankment (Fondamenta dei Vetrai). Glancing through the back door of the glasshouse A. Ve. M. (Arte Vetraria Muranese), Lino's attention was caught by the flames of the furnaces and the movements of men blowing glass. He had been on the periphery of glassmaking all of his short life, had played in Venini where his father worked and on Calle Bertolini dozens of times, yet something clicked on that day: "I saw a big fire and lots of smoke and people making beautiful pieces. I wanted to try this." Nothing less than a lifelong devotion to glassmaking was kindled and the same things that fascinated him then continue to attract him over sixty years later: the flames and the molten material, the technology and chemistry, the immediacy and physicality of the work.

Immediately after the end of World War II times were still tough on Murano and there was widespread deprivation. The Italian glass industry was crippled, but it struggled through crisis after crisis, began to rebuild, and then quickly responded to the rising demand for reconstruction materials, especially lighting components.[7] After Toso, Lino entered a more formal period of unpaid apprenticeship in the lowest position on the three-person glassblowing team of "Piccolo" Rioda. It was Rioda, a short, kind man, who taught Lino how to gather glass correctly on the blowpipe. Lino stayed with the master glassblower for almost a year, moving around the various factories where he rented workspace.

During the summer of 1946, while still eleven years of age, Lino earned his first paycheck as a general employee of Vetreria Archimede Seguso.[8] He started at the bottom and slowly worked his way up through the hierarchy of positions. In a glasshouse on Murano, a crew of typically three to five workers forms a *piazza* (the station centered on a glassblowing

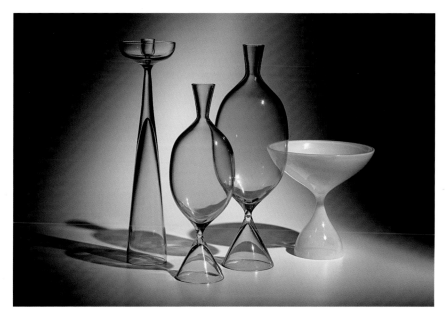

FIG. 3. Designed by Giorgio Ferro and made by Lino Tagliapietra, Candlestick, two Flask Vessels, and Chalice, 1960. These objects were exhibited at the XXX *Biennale de Venezia* of 1960 (CAT. 1, PL. 1)

bench). At Archimede Seguso, five *piazze* and twelve individual color crucibles encircled the central furnace. The basic positions are defined, from the lowest rank, as: *garzonetto* (literally, boy—the general helper), *servente* (first assistant), and *maestro* (master, lead glassmaker). To advance from one level to the next takes years and depends not only on skill level, but also on the movement of other workers to different positions and ultimately to retirement, freeing up key slots. Lino rarely worked directly with Seguso, who was both the owner and the head glassblower, but remembers that the *maestro* "could move an incredible amount of glass with elegance."[9] Seguso also had an effective way of collaborating with the other *maestri* on new ideas and he gave his employees opportunities to develop. Most of Lino's time was spent assisting *maestro* Attilio Frondi on his team of four. Considering his eventual role as a designer, one would have expected Lino to take full advantage of any artistic courses available on Murano, yet he only enrolled for one evening class that he chose not to finish.[10]

There is no single correct way to blow glass, and working methods vary not only from country to country, but also from factory to factory. When Lino left Seguso in 1955 and joined the new glasshouse of Galliano Ferro he had to adapt to Ferro's ways. Although he seldom makes them anymore, he became the company's designated goblet (*bicchiere*) maker and produced many of the pieces representing that glasshouse in the Biennale exhibitions.

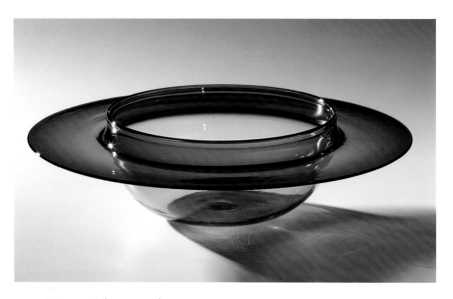

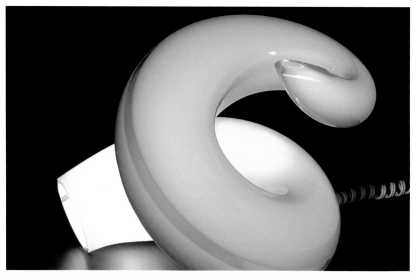

FIG 4. *Saturneo*, 1969 (CAT. 2, PL. 3)

FIG 5. *Varigola* Lamp (DETAIL), 1970 (CAT. 6, PL. 5)

In his essay, glass artist Dante Marioni discusses how the drinking vessel presents some of the most demanding challenges to the blower. Making a perfect goblet (often referred to as a cup) requires as much time and skill as a larger work and sells for much less. Most often they are made in the *Vecchia Murano* style—reproductions of antique designs from the sixteenth through eighteenth centuries, and their ornate nineteenth-century variations.[11] Lino's mastery of the form returned to the forefront years later, after he left industry and was free to concoct both traditional and unorthodox goblets for his own pleasure.

Lino made a practice of staying after work to sharpen his skills and he saved his money to hire others workers to assist him. In addition, he wanted to learn all aspects of the science of glassmaking: chemical composition, for example, and the gas-to-air ratio for the most efficient flame; he spent all night in the workplace observing the proper way to melt the glass mixture. He was still working at Galliano Ferro and twenty-one-years of age, not unusually young, when he advanced to the level of *maestrino*, the step just before *maestro*, the most accomplished of glassblowers. It took approximately one more year before he was acknowledged as reaching that highest level. Dante Marioni also points out how the terms "master" or "*maestro*" have been abused; it seems that the title is conferred upon anyone with a certain degree of skill at doing anything. Even in Murano one hears it used as a congenial sign of respect—but as Lino says "There are *maestri*, and there are *Maestri*." One gains the title through consensus within a factory rather than through systemized examination by the general industry and the skill levels of all masters are not

equivalent. The promotion is a joint decision made between a company's existing *maestri* and the owner.

A Muranese glass factory—no matter how small and no matter how splendid the handwork—is just that, an industrial facility where workers are paid by the piece and are expected to reach a quota. Often the high-ceilinged workshop is located just behind a stylish showroom opening onto a busy street. Unlike today's air-conditioned Studio Glass facilities with sophisticated electronic gadgetry, computer-regulated heating and cooling programs, safety and environmental precautions, and an atmosphere that ranges from well-run hospital to house party, the places where Lino grew up and worked through middle age were dimly lit, grimy, hot and sweaty, with outbursts of singing providing the only music. They could be rough, and the only role for women was in administration or cleaning and packing. The atmosphere nurtured a competitiveness that could be friendly or downright nasty thanks to years of jostling side by side, living as neighbors, dating each other's sisters, eating lunch together and taking breaks for drinking *taggiata* (half crème de menthe, half anisette) that "makes breath clean for blowing."[12] Almost everyone had at least one silly nickname, often derogative and in the local dialect.[13] The first half of the 1960s was a particularly tumultuous time in the Italian glass industry. The national economy was experiencing sharp inflation and business slumps; there was flood disaster and the ensuing financial burden; exports were down and so was the quality of design and production, and there were labor disputes with accompanying work slowdowns and strikes adding to the already intense atmosphere.[14]

This was Lino's world. It was manual labor, albeit highly skilled manual labor. Only after fourteen years of executing the ideas of other people did he begin to develop his own designs. He doesn't draw, so his ideas were rendered three-dimensionally at the company furnace during lunchtime or before and after the day's work shift. Around 1966 he produced his first distinctive model, the *Saturneo* vessel made of a single bubble of glass tooled into a wide, flared opening and with an extended flat "ring" like the eponymous planet. The basic technique for making the *Saturneo*, in which the ring is formed by folding the glass and then squeezing it to make a ridge, can be traced back to ancient Roman times.[15]

None of Lino's designs went into production at Galliano Ferro, or Venini, where he subsequently worked for about fourteen months, or even immediately after he cofounded the firm La Murrina in 1968. By the early 1970s, however, his ideas were increasingly incorporated in the La Murrina line and were earning him royalties. The firm specialized in lighting and Lino created many lamps, including the spiraling *Varigola*, the *Concorde* inspired by the latest aeronautical wonder, and *Formichiere* (Anteater), which won a Grand Prix for lighting at the 1972 Barcelona Trade Fair. Around 1976 he developed the *Saturno*, formed from two separate bubbles of glass rather than one. Like the *Saturneo*, the *Saturno* has a wide collar or ring, but the center is often spherical with an opening either on the top or bottom. The *Saturno* was made in a new way rather than in the Roman technique and it became Lino's signature design. It was adapted for industrial production both as decorative vessels and as various types of lampshades. It later evolved into a sculptural format to which Lino has continued to return. The form may be asymmetrical and turned vertically, with openings on both sides of the sphere, and mounted on a tall metal stand.

Lino's career as a mature and well-remunerated figure of the Muranese glass populace could have easily peaked in the 1970s, but he always had a curiosity about the greater world. He studied the history of other countries, cultures, and religions; he wanted to know about art—historic and contemporary—and made a practice of visiting exhibitions, including the Biennales di Venezia, with his sophisticated sister-in-law "Etta" (Maria Antonietta Ferro Tagliapietra), and then with Lina Ongaro, whom he began dating when they were both sixteen and married in 1959. The relationship between the artist and glass was already on his mind in 1976 when he helped organize the first of three symposia, the Scuola Internazionale del Vetro (International School of Glass), to ally visual artists and craftsmen as equals.

It is no secret that in the making of an object the glassmaker may bring as much to the table as the designer; it is one thing to make a drawing and quite another to realize it from a moving, molten mass. The degree of input varies, but if he or she is not aware of the capabilities of the material, or fails to understand how it is handled, the lead glassmaker alone makes the choices that will determine the success or failure of a prototype or a unique object. Despite this responsibility, it is standard practice to mark a piece of glass solely with the name of the company—only occasionally is the author identified and credited, and rarely the maker. The undemocratic habit even carried over later into the world of Studio Glass; however, both the artist and the glassmaker signed the works produced during the symposia.

These successive gatherings grew in scope and convened in numerous glasshouses and lecture venues on Murano with exhibitions of the finished pieces held in the intervening years. As artistic objects, the results were not groundbreaking; their importance is in representing a desire by the local glassmaking fellowship to infuse something new and stimulating into a declining mainstay.[16]

Lino always had ambition and an eye for opportunity and advancement. In 1977 he left La Murrina to become head glassblower, designer, and overseer of production at another new company, Effetre International, a division of the larger firm Effetre, and devoted to high-quality lighting and decorative items. At this time he was also taking some note of the

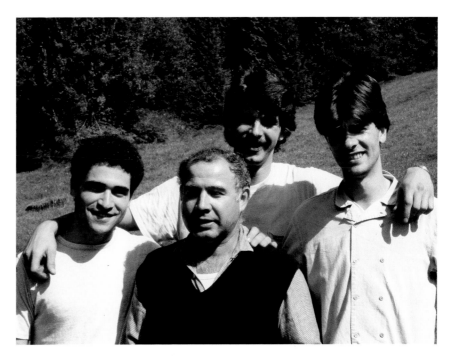

FIG. 6. Left to right: Michael Scheiner, Lino Tagliapietra, Richard Royal, and Bejamin Moore at Pilchuck, 1979.

American Studio Glass artists trickling through a few Murano glasshouses, particularly Venini & C., where his brother-in-law, Francesco "Checco" Ongaro, was a *maestro* and worked for forty-five years. Checco was open-minded and good with the foreigners who were assigned to him, but although he and Lino were close friends Lino seldom encountered the young Americans. Muranese glass workers do not make a practice of visiting other factories; the industry's notorious secrecy is not reserved solely for foreigners.[17] Lino did, however, meet Californians Michael Nourot and John Milner when they visited La Murrina in 1972, and in 1980 he made and co-signed roughly twenty pieces at Effetre International with another American glass artist, Douglas Navarra.[18]

A few years later, Benjamin Moore, the Education Coordinator of the new Pilchuck Glass School north of Seattle, Washington, was spending his Fulbright Fellowship at Venini and was working with Checco. A friendship formed and Moore invited the *maestro* to be a Visiting Artist at Pilchuck during the coming summer of 1978. Checco agreed and traveled with his wife Rina to the rustic encampment in the midst of a tree farm where he demonstrated traditional Italian glassmaking for three weeks during a class taught by Moore (who spoke Italian). Fritz Dreisbach, a pioneering American glass artist, technologist, and educator was at the session and recalls that until then most Americans had been exposed only to interpretations of Italian techniques, "never the real thing." To the delight of his audience, Checco "whipped out" objects in ways that Dreisbach and the others had been wondering about for years.[19]

Checco had been to the United States once before at the behest of John Milner and he seemed to enjoy the Pilchuck experience, but when Moore asked him to return the next summer, the *maestro* declined. Even Lino isn't sure what provoked the decision, but funds were sorely limited for compensating Checco and it is no secret that Rina was uncomfortable with the idea of her husband using his vacation time to blow glass outside of Murano.[20] Lino, on the other hand, did not hesitate to accept when Checco suggested that Moore invite his brother-in-law in his place. Moore remembers: "From the first time I met Lino I knew that he was different. The other glassmakers who kindly invited me to their homes lived in regular blue-collar environments. Lino and Lina's house, however, had been remodeled in a modern style and copies of the design magazines *Domus*, *Casa Vogue*, and *Abitare* could be found in the living room. His work at Effetre International had a more contemporary feeling than other production on Murano. It showed a real design sensibility and an exploratory approach to the material." Moore's letter to Tom Bosworth, director of Pilchuck, seeking permission to invite Lino reads, "I have another dandy lined up . . . another fabulous personality, speaks no English, but will be great with the students, [he] has an explorative nature. Does very good work of his own, very good taste, a very unique and rare Venetian glass master."[21]

At age forty-five, one would expect Lino to be so entrenched in the rhythm of his life as a family man and professional that he would not dream of giving up his precious annual holiday to work halfway across the world for free, but he was now curious about what was happening in the United States and what opportunities might await him there. If he spent the rest of his life in Murano he could reach a level no higher than *maestro*, a goal he had already fulfilled. With only his ticket in payment, he plunged into his first trip to America, as well as his first ride in an airplane. Traveling alone, he took a bag of glassmaking implements to the airport and was disappointed to learn that he could not carry the precious tools into the passenger cabin.[22] En route, a terrorist scare delayed the connecting flight in London causing him to arrive too late in New York to catch the flight booked to Seattle. Bear in mind, this is a man who spoke no English and had never ventured far outside of Italy.[23] Needless to say, when Moore's colleague, artist Michael Scheiner, waited at the Seattle airport to pick him up on the designated day, Lino did not get off of the plane. Instead, he was delivered one day later at Pilchuck's remote site by a taxi taken from the airport and with a meter that read over one hundred in 1979 dollars.[24] He owned no slides of his work and so carried two Effetre International trade catalogues to show the students what he did.

Lino has often described his horror at what he faced at Pilchuck—inadequate tools (his own went back home from the Venice airport with Lina when they couldn't accompany him onboard) and substandard glass that was worked at too cold a temperature. Moreover, although Benjamin Moore's glassblowing skills were among the highest in American Studio Glass, even he could not provide Lino with support remotely comparable to what he had in Italy. Scheiner, who worked with Moore at assisting Lino, recollects his panic at trying to keep up and follow instructions given in Muranese dialect and by hand signals. The mutual frustration level was high, but Scheiner recalls that "it was as if the glass community had been visited by God himself. God had come to Pilchuck. He was a bit tougher than Checco had been and had the energy of three men. Lino is a perfectionist and one of the things that he passed on to his students was his rigor and demand for excellence."

Every day Lino made what the students wanted to see: he pulled lengths of *zanfirico filigrana* cane that looked as if lace was floating inside the rod of glass, joined the rims of hot bubbles for banded *incalmo* pieces, showed various ways to blow glass into optic molds, and fashioned *reticello* vessels by inserting one bubble into another causing the lines of cane embedded in each to cross and entrap a grid of tiny air bubbles. He fashioned Renaissance-style dragon-stem goblets as well as some of the icons of twentieth-century Italian manufacture— the *Veronese*, *Fazzoletto*, and *Occhi* vessels. Much of the information he conveyed, such as how to make what came to be known as the "classic Lino punty," was basic and essential for

proper glassmaking. Fritz Dreisbach remembered that in the pre-Lino days of Studio Glass, an oversize connection of glass was applied to what would become the base of a piece in order to transfer it from the blowpipe to the punty rod for finishing. Because grinding equipment was not generally available, the wads were chipped off after cooling, leaving a rough, irregular bottom. Americans had also tried sand, cones, and hollow rings as punties so that the piece could come off the rod without "tearing a hole in the bottom." By watching Lino, Dreisbach learned that the secret was to make the point of connection as small as possible and to put it very close to the center. When Lino first attached the punty, he pulled it back right away, which prevented the contact point from becoming too large. This subtlety was especially important for delicate work such as goblet making. Also, Lino would hesitate before he accepted a bit from an assistant—waiting for the moment when the temperature was exactly right. Dreisbach was struck by the different ways that Lino tweezered and snipped the glass, and how he kept it very hot by repeated trips to the "glory hole." These details seem small, but they are critical to the success of the craft. Despite his willingness to help, Lino wasn't passing out his hard-earned information on a silver platter. "He comes from a tradition that required analysis; one had to watch closely and figure out how things were done," says Michael Scheiner. Rather than taking copious notes or photographs and pelting him with dozens of questions, Lino expected students to simply pay close attention. When asked about marvering the hot glass that first summer, Lino's response was, "You have to search to know."

Lino believes that he came to Pilchuck at exactly the right time—for both Studio Glass and himself. Students were hungry for information and excited about the material. Richard Marquis, who had spent his Fulbright time at Venini ten years before and was among the best of the American glassmakers, could see that Lino had to "dumb everything down to our skill level."[25] Nevertheless, they had enough background to appreciate what they were seeing, and had sufficient "dip and drip" experience to try to imitate it. For Lino, Pilchuck was an intriguing mixture, a locus of ideas and people that he had never experienced. He was at the height of his skills and cognizant of a new moment in glass in which he could share his culture and build upon it. According to Benjamin Moore, Lino grew each year as a teacher: "We were all so fortunate to be on that spot when he came. Lino became a very giving educator—whatever we wanted to know, he was more than willing to share. Lino's knowledge of glass is complete and it encompasses much more than the act of blowing." In addition to imparting his experience and knowledge with students, he became concerned with furthering creativity, posing the question: "How do you discover yourself?"

Recognizing himself as part of a long and noble tradition, Lino wanted that history to continue and flourish wherever it could. Through his teaching he made sure that it did, but not everyone in Murano embraced his view. The attitude of some *maestri* was "*morto mi, deve morir anca la fornace*"—"when I die, the furnace should too";[26] they disdained teaching anyone at all, even a young Muranese. Others resented the dissemination of information abroad, yet information had been seeping out for centuries and one wonders how they could believe themselves to be the last guardians of secrets never divulged outside the lagoon.[27] Whatever the motivation behind the opinions, there is indeed a difference between allowing others to watch a demonstration and in giving instruction in an American school. No doubt it became even more irritating to some when that instructor gained recognition and a following outside of the island. Lino was not the first to walk away from the Muranese glass industry to become an independent artist, but he would become the first to experience such widespread international recognition—especially in the United States.

The early examples of Checco and Lino's disciplined craftsmanship and work ethic set in motion a shift in priorities that would eventually raise the standard of Studio Glass glassblowing worldwide. Lino has a seemingly inextinguishable zeal for the history, the material, and the process, and he takes it all deeply seriously. "He is more enthusiastic about glass than anyone else," says Dante Marioni. "He loves working, he works all of the time, and he works better than anyone else. He brings craft to a completely different place."[28] That craft is not just a job, nor is it a diversion, a hobby, or a novel way to play with some ideas. Glassmaking shapes Lino's identity, establishes his place in society, and it is the way that he supported himself and his family with dignity. His attitude was a far cry from the ambivalence toward craftsmanship of more than a few of the early Studio Glassmakers—they wanted and needed expertise, but only up to a certain point. Insecure in their status as artists working in a craft-related material, at times they overcompensated by mistaking a desire for artisanal mastery with soulless technical obsession—as if one had to choose between art and craft. One of the many important things that American glass artists learned from their European colleagues, most notably the Italians, the Scandinavians, the Finns, and the Czechs, is that the two factors are not mutually exclusive. Technique is not cheap: it can and often does lead to greater sentience and expressiveness. According to Lino, "You must know what you are doing so that you can change what you do."

The Americans who studied in Murano and then with Lino at Pilchuck went on to spread the information they gleaned throughout American university art departments.[29] Checco and Lino were followed by more of their countrymen who introduced a variety of specialized methods for working with glass.[30] Fine craftsmanship once again became a respected goal rather than being disdained as a hindrance to art making. Like Benjamin Moore years before, a new generation of students, including the teenaged Dante Marioni, was drawn

to the challenge, rigor, and values of Venetian glass. But the story would have been very different if Lino had not made the commitment to return summer after summer, not only to demonstrate his skills, but also to build on what he had taught the season before—giving continuing input to a circle of dedicated glassblowers. This had the secondary benefit of developing an early pool of helpers who could assist him at a professional level in Seattle and at other venues where he was now invited, including the Haystack Mountain School of Crafts in Maine.[31]

Lino did not arrive in America as a fully developed artist. After he returned to Pilchuck for the second summer he began spending additional time demonstrating at the Glass Eye production studio founded by Rob Adamson, whom he had met in Italy. The historicist pieces that Lino made at the Glass Eye were greatly admired by Adamson's employees and customers for their elegance and finesse, but while Lino was setting the Seattle glass scene abuzz with displays of incredible skill, the traditional forms he generated seemed timid within the context of current glass art. His work was not represented in the important survey exhibitions of the day: the 1972 *Glas heute* (Glass Today) at the Museum Bellerive, Zurich, Switzerland; the first *Coburger Glaspreis* in 1977, an overview of recent European glass by the Kunstsammlungen der Veste Coburg, Germany; and *New Glass: A Worldwide Survey* by the Corning Museum of Glass, New York, in 1979.

In 1981 and 1982 more formative influences entered Lino's life, affected his thinking, and advanced his growth as an artist. During the Murano Scuola gatherings of 1976 and 1978 he worked with several artists and was particularly impressed by the veiled and elegant erotic allusions of Zvest Apollonio, Emilio Baracco's concept of interchangeable geometric parts for sculpture, and the graphics of Lojze (Luigi) Spacal. However, it wasn't until the third and final Scuola in 1981 when he was teamed with the patriarch of Dutch glass design, Andries Dirk Copier, that he met an artistic soulmate. Copier was also paired with *maestri* Checco Ongaro and Mario "Grasso" Tosi, but the bulk of his time was spent with Lino and a bond of trust was quickly established between the two.

Copier, unlike the other artist participants in the symposium, had decades-long experience with glass and arrived at the conference prepared with detailed schematic drawings. He was an admirer of Belgian artist Michel Seuphor (1902–1999) and the influence of Seuphor's drawing style can be detected in Copier's distinctive use of spiraling wraps (trailed onto the glass while the mass is rotated) and *filigrana* canes.[32] Sometimes Copier wanted the canes to be squeezed, making them slightly wavy, and in contradiction to all the rules of finishing instilled in Lino, Copier asked him not to evenly trim the ends of the slightly twisted canes that sometimes corseted the vessel. Instead of working them smoothly and invisibly

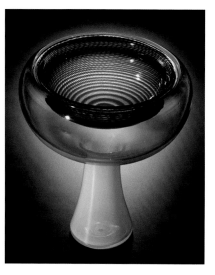
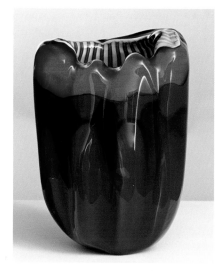

FIG 7. Lino Tagliapietra and A. D. Copier, Footed Vessel, 1981 (CAT. 12, PL. 11)

FIG 8. Lino Tagliapietra and A. D. Copier, Vessel, 1984 (CAT. 13, PL. 12)

into each other, he wanted the irregular tips left exposed on the rim to create unusual optical effects when viewed at different angles through the thick wall of glass.[33] Curator Dorris Kuyken-Schneider wrote that by doing so he allowed the canes to form a border of "thin lines and white dots to produce a playful (albeit, to the eyes of the Murano glassmakers, untidy) finish."[34] Copier also nested multiple vessels made with the fine linear decoration so that an intricate web of crosshatching appeared as one looked through the concentric walls. Lino has the ability to catch the spirit of a designer's intent and, in turn, Copier was receptive to his contributions. Together they made it possible for Copier to create a new body of work to which he gave the honorific title *Collezione Lino*.[35]

Despite the fact that Copier was hard of hearing and neither spoke the other's first language, they managed to carry on a verbal dialogue that touched upon many subjects, including art, glass, and the relationship between the two. Lino says that before working with Copier he never fully understood how glass could be a medium for art. Copier had a "vision of glass" and taught Lino to study the vessel in a different way, as if it was a picture mounted in a frame and hung on the wall. "We analyzed the space, the proportions, and the geometry," says Lino. "Sometimes we would jump directly into a discussion of Piet Mondrian and the way he divided space."[36] In 1987 Lino wrote, "I found the periods we spent together fantastic because he [Copier] introduced me to a new dimension of glassmaking in which I rediscovered my own relationship to glass and started to experience it as art. For that I will

always be grateful to him."[37] The two remained friends and worked together four more times before Copier passed away in 1991.[38]

Through his friend the physician Gianni Rosetto, Lino also met Marina Angelin around this time. Angelin was a young psychiatrist wanting to try her hand at designing glass and in 1982 they began exchanging ideas after work—Marina making simple sketches and models and Lino working them out in the glass, back and forth. Many *maestri* have found inspiration for their own work through cooperation with a designer; notable pairings of the 1930s include Alfredo Barbini with Napoleone Martinuzzi, and Archimede Seguso with Flavio Poli. Some of the most memorable concepts from Effetre International between 1982 and 1986 were by Lino and Angelin and his first appearance in the international Studio Glass arena was when their striking red and black *Psycho* vase was published in Corning's *New Glass Review* (5) of 1984. Angelin had an affinity for broad areas of bold color and utilized the graphic potential of a black outline. The sharply defined sections were interpreted by Lino using contrasting canes for delineation, the *incalmo* technique for stripes, and even by turning the axis of the work to reorient the format. In later years the axis might be changed several times in a single piece such as a *Medusa*, which becomes its own body of water punctuated with inset *incalmi* invertebrates.

Most designs from Effetre International were produced in editions of a maximum of one hundred objects. They were marketed in various ways, but many of the products available in the United States during the 1980s were developed and made exclusively for Oggetti, a wholesale enterprise for high-end lighting and decorative accessories. One particular success for Oggetti was the 1982 Tagliapietra/Angelin series of five eggs graduated in size.[39] Many works were made by Lino as prototype experiments, but for various reasons never went into production. Some are Lino's solo efforts and others stem from brainstorming with Angelin. The pieces exist as unique objects but may have been made in a few variations. For example, there are no more than five manifestations—each somewhat different—of the compact *incalmo* vessel *Orfeo*, with its heavy walls and asymmetrical internal design. Even some pieces depicted in the company sales catalogue, such as the huge, shell-shaped platter *Teodorico* from 1985, were so difficult to make that only a handful were produced.

Within a turbulent five-year period Lino was exposed to a wealth of new people, places, and ideas: the Scuola symposia, the first trips to Pilchuck, and the first collaborations with Copier and Angelin. One can only wonder at what was incubating in his mind. While he was becoming increasingly recognized as a craftsman and personality outside of Murano, stylistically he was still finding his way and casting about in several directions. Throughout the first half of the 1980s he continued to hammer out ideas with Angelin and to work full

time at Effetre International. Time off was spent teaching in the world of Studio Glass rather than on the beach or in the mountains with his family. Following Lino's first trip to Pilchuck, his wife Lina almost always accompanied him while friends and family at home cared for the children.

In 1986 Lino reached the age where he could retire and collect his pension, but although he cut back on his time at Effetre International he did not end all work there until 1989. The affiliation with Angelin also stopped around that time due to her pregnancy with a second child. Shortly thereafter, management decided to discontinue the separate Effetre International branch and its resources were absorbed into the rest of the company. The years following 1986 represent a period of transition. His designs for industry had to be cost effective and exactly reproducible by both Lino and the firm's other glassblowers. Lino had worked this way for over forty years and as innovative as many of those designs were, the factory system was not the place for either spontaneity or personal expression. It is no surprise that he needed an extended time of exploration and growth while moving from industry toward becoming an independent artist.

Lino's career was given an enormous boost by his first important museum exhibition. It did not take place in America or Italy, but rather in the Netherlands. Through Copier he had come to know Dorris Kuyken-Schneider, curator at the Museum Boymans-Van Beuningen in Rotterdam; she proposed and organized *Uit het licht van de lagune, By the Light of the Lagoon* featuring Lino's glass and textiles by the duo Norelene. The pieces by Lino depicted

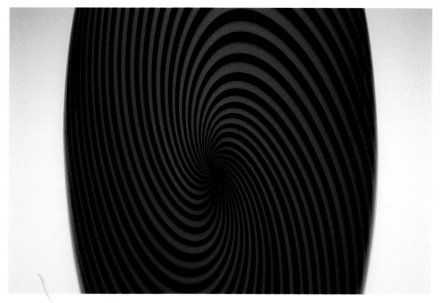

FIG. 9. Lino Tagliapietra and Marina Angelin, *Psycho* Vessel (DETAIL), designed in 1983, dated 1984 (CAT. 24, PL. 20)

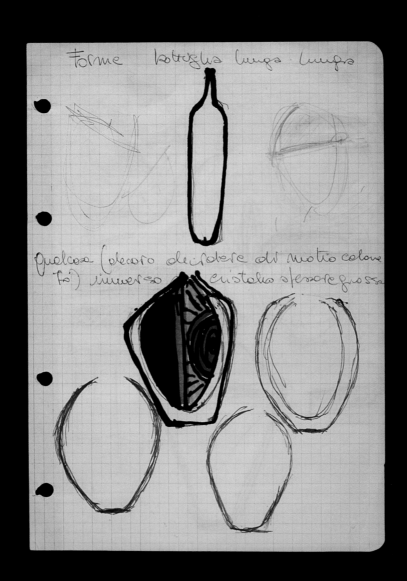

FIG. 10. *Orfeo* Vessel design sketch by Marina Angelin (CAT. 26)

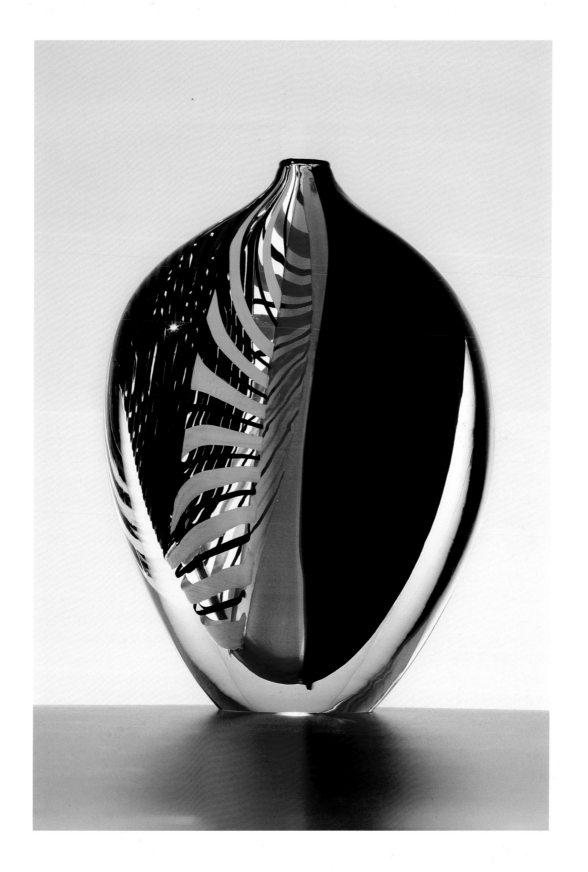

FIG. 11. Lino Tagliapietra and
Marina Angelin, *Orfeo* Vessel,
around 1984 (cat. 25)

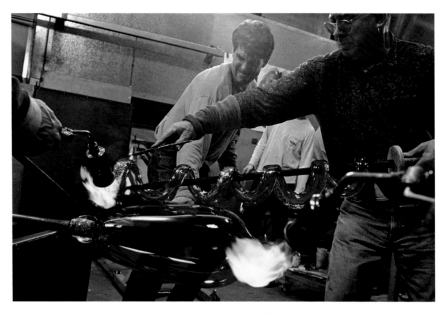

FIG. 12. Lino applying coil to a *Venetian*, assisted by Richard Royal, 1988

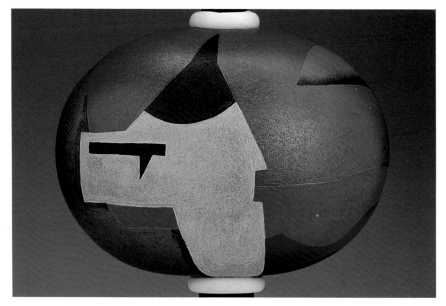

FIG. 13. Lino Tagliapietra and Dan Dailey, *Viale* (DETAIL), 1989–1993 (CAT. 44, PL. 36)

in the exhibition catalogue are pastel-colored and undeniably beautiful, but they still show considerable influence of Archimede Seguso and Andries Copier. The most successful have a light, aquatic feeling: the soft, flattened vessels covered in pale vertical canes bring to mind sea grasses and the undulating tentacles of jellyfish.

Lino's "retirement" and increased availability put him more in demand to assist various individuals and companies. His work with Dale Chihuly started with a set of tableware commissioned as a wedding gift for the American Studio Glass artist's fiancée. It was followed in 1988 by what was meant to be a series of new Chihuly designs inspired by Italian glass from the first half of the twentieth century—the *Liberty* and *Novecento* styles. The first group of what came to be known as the *Venetians* was executed by Lino over a two-week period. Chihuly is adept at working with the strengths of his glassblowers: he drew two views of each idea, an elevation and a plan, and then "Lino would make it. I hardly ever told him anything. Nineteen out of twenty times he understood my drawing or improved on it."[40] The first attempts incorporated relatively spare, applied details that were in tune with genuine Italian Art Deco fashion, but as Lino relaxed with Chihuly's asymmetry the vessels grew richer and more elaborate. Immersing himself in the possibilities, he drew upon his knowledge of historic Italian glass when laying on massive hotworked flowers and leaves, looping handles, and spiraling ribbons and coils that tumbled from and around the vessels. It was as if the nineteenth-century decorativeness of Salviati & C.'s goblets, the 1920s lyricism of Guido

Balsamo-Stella, and the monumental and richly textured glasses of Ercole Barovier and Napoleone Martinuzzi from the 1930s were being channeled and synthesized into something more exuberant and sculptural.

The series was successful for Chihuly and it came at a time when he seemed to be searching for a direction away from his giant seashell and blossom forms that already drew from thinly blown, organic-looking Italian glass. Without Lino's creative input, encyclopedic knowledge, and virtuosity it is doubtful that the *Venetians* would have materialized in their Rococo brilliance.[41] Although it was not envisioned as such, the combination of Chihuly and Tagliapietra surpassed the usual gaffer / designer arrangement.[42] In retrospect, it is clear that Lino and Chihuly were coaxing, encouraging, and daring each other, one step at a time, into something new that would have been impossible for each to accomplish alone. "He has unbelievable skill and has been a huge influence," says Chihuly. "He also has a great personality. We would work from seven until four, Lino would shop down at the Pike Place market until six, and then jump in a cab and go cook dinner for someone. We didn't have much free time together because his calendar was always full—everyone wanted Lino to come to their house."[43]

Lino's influence was profound on the other artists with whom he worked around this time. They included Monica Guggisberg and Philip Baldwin in Switzerland, and Dorothy Hafner in New York. Guggisberg and Baldwin's output adopted a decidedly Italianate

tone—stylistically and technically—as a result of the experience. Lino accepted only a few of these projects and his ambivalent view toward the division of labor might be summarized in the title of his 1994 text, "When There Is an Artist Between the Glass and Me." In his eyes, the one and only example after Copier of what felt like true reciprocation was with Dan Dailey, who had spent time at Venini in 1972 and whom Lino describes as "the most European of the American artists."[44] As were the pieces made with Copier, the new objects went further than a fifty/fifty pastiche of the distinctive styles of each contributor. Some of the austere vessels with their smooth semi-matte surfaces seem more Dailey, and others more Tagliapietra. Intermixed are traces of Surrealist art—the sculptural forms of Max Ernst and tight, flat suggestions of lonely painted landscapes. The pieces were all blown by Lino in 1989, but it was not until 1993 that the fired enamel paintings by Dailey and other coldworking processes were completed on fifty objects. All pieces were inscribed with both Dailey and Tagliapietra's signatures.

After leaving Effetre International Lino expanded his teaching time abroad and sometimes rented time in other facilities to make his own work. He created some pieces for the firm of EOS Design del Vetro, managed by Laura de Santillana and founded with her father Ludovico and brother Alessandro after the family glasshouse, Venini, left their hands. Steuben, the American manufacturer of costly handmade decorative glass, also hoped to join forces with Lino. In 1998 he spent two weeks at the company's plant in Corning, New York, blowing glass and working out ideas for possible inclusion in the retail line. According to Peter Drobny, one of Steuben's in-house designers at the time, the idea was "to match the best glassblower in the world with the best glass"—Steuben prides itself on the purity of its material. The occasion was highly unusual for Steuben, which had often called upon outside designers, yet never one who actually blew his own work. It was a challenging project for Lino not only because color is one of the great unifying characteristics of Italian glass and he was now confronted by an absolutely colorless material, but also because Steuben is noted for the high lead content of its batch recipe, which makes it softer and more heat retentive than the soda-lime glass mixture of Murano. The two types of glass must be handled differently and time was lost while he became accustomed to the material. Also, no matter how beautiful the overall piece, even the tiniest bubble or some other almost imperceptible imperfection in a piece of Steuben will cause it to be rejected. There are no exceptions, and while Lino is fussy, the inflexible policy seemed at times to be counterproductive. Nevertheless, Drobny says that Lino "addressed these matters and made adjustments on the spot. His ability to adapt to a strange material was unbelievable."[45] In the end, forty of the objects were finished and offered for sale by Steuben as unique works. Lino retained ownership of several others and was free to finish and do with them as he chose, but not to market them as Steuben products.

By the second half of the 1990s, with the brief exception of Steuben, Lino had stopped accepting outside projects in order to concentrate on his own. The work grew increasingly bold and risk-taking both in color and form. Distinct layers in the glass were emphasized, the cane work became more substantial, and *battuto* and *inciso* carving were selectively added to diminish or destroy reflectivity and also to add texture. The *Hopi* series, initiated in the early 1990s and based on Native American ceramic and basketry forms, represented a leap forward. Now the vessel profile was more exaggerated, with extremely constricted openings, broad shoulders, and small bases. The nearly opaque, spiraling black-and-red cane striations, so powerful in the earlier *Psycho* vase and the *Kratos* series with Marina Angelin, were now pinched and manipulated to form concentric, interlocking hooked patterning that echoed ancient Mimbres pottery designs as well as nineteenth-century surface treatments from Loetz, Tiffany, and other European and American glasshouses.

Lino makes every piece of his work himself with the assistance of helpers whose numbers have grown as the work has increased in complexity. Although he works with up to twelve people at a time, Lino's core group of assistants was formed in the late 1990s and includes Nancy Callan, John Kiley, and David Walters. Blown glass isn't a medium that one can linger over and it is not usually nurtured in secluded surroundings. Lino's work is born in

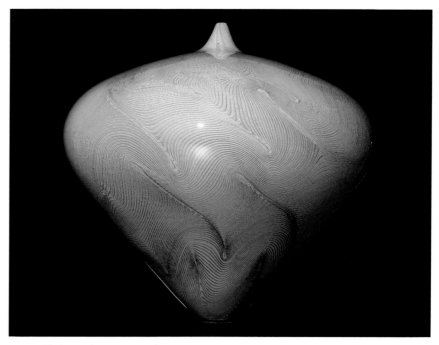

FIG 14. *Hopi*, 2003 (CAT. 96, PL. 88)

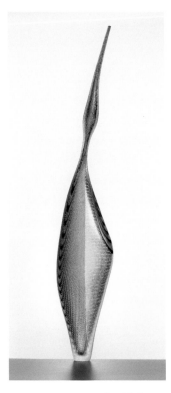

FIG. 15. *Oca*, 2002, made with the Pilchuck '96 technique (CAT. 93, PL. 86)

an expensive-to-run, virtually public arena with the help of a group on whom he relies and who are waiting for his next move, his next choice. The outcome is inconstant: "It depends on the environment," he says. "It also depends on the quality of the glass, and sometimes the annealing may be wrong. It also depends on whether I have the technical support—[now] I need a lot of people to help because I use a lot of color. It depends on the way that I feel and what I want to do today." Rarely are pre-made, commercially manufactured colors used in his pieces. Instead, they are made from the old recipes that Lino collects. Many are mixed and melted according to his specifications in the United States, but a few special hues of black, white, red, and yellow are melted by Lino alone using the small furnace in his Murano studio.

Lino doesn't lack positive reinforcement as he works, but like every glassblower, whether laboring in a factory or a school, failure still takes place before an audience. Other than the periodic eruptions of activity, the movements are slow; sometimes it seems as if most of the people on the work pad are just standing around watching. But he describes the necessary synchronization as a tempo: "I say to the people I work with: Please, we dance together. You must dance with me. You must stay with me."[46] Lino exchanges a few words, hums, sings quietly or whistles, all the while appearing to ignore the pipe that he turns constantly with one hand, keeping its gather of molten glass on center. Only another glassblower will distinguish the many discrete gestures and movements: hand signals to the helpers and slight adjustments of the tools. Dante Marioni describes Lino's technique as "surgical precision with no drama." Subtle details are most important: the difference in the appearance of color layers when seen through a rim that has been cracked off rather than trimmed with the shears, or the contrast between "soft" and "hard" whites placed side by side.[47]

Over the years Lino has adapted and invented many techniques and tools. Some, like the "Pilchuck '96" appear deceptively easy: How hard can it be to make lines run vertically or diagonally on a piece of blown glass? Surely in 1938 the Swedish designer Tyra Lundgren hoped that her simple and elegant design for a leaf-shaped glass dish with fanned striping would be easy to fabricate, but woe to the glassblower at Venini who had to determine how to make it. That forerunner to "Pilchuck '96" involves a lengthy series of steps including one

in which the entire mass is folded. Employing a bewildering technique just for the sake of appearance is never Lino's goal; rather, the objective is a precise graphic effect, no matter how it is attained.

One thing that he has no patience for is the finishing that is executed once the work has been annealed and cooled. Lino began to add cutting and engraving to his pieces after leaving industrial production, where they were usually deemed too expensive to use. As Marino Barovier observes, Carlo Scarpa was the first modern Italian designer to break up the entire surface of an object with cutting.[48] There is a wide assortment of treatments including the most commonly seen *battuto*, short superficial cuts producing a texture similar to hammered metal, and the slender grooves of *inciso*. The type and placement of cutting on Lino's work refer to the patterning within the glass as well as to the three-dimensional form. He may specify it to be used sparingly, only as an accent, or—as it has increasingly evolved over the past ten years—as a prominent element of the design that sculpts the overall shape. Unlike Scarpa, Lino rarely, if ever, seems to desire a completely matte surface. Each cut on a *Stromboli*, the series most rigorously worked, is individually polished by hand, and it may require thirty-eight to forty-six hours to finish one piece. Almost all of the work undergoes a certain degree of finishing at Coldworks in Seattle, but the long incised lines of the *Endeavor* boats and the deep carving of the *Strombolis* are done exclusively in the small, three-man Fabbris family workshop, Otello, on Murano.

There has been considerable speculation regarding what made Lino Tagliapietra's visual language mature at around age sixty into something unique. Some people (including Lino) draw attention to the general influence of American Studio Glass and the youthful experimentation and freedom that he and many other traditionally trained glassmakers and designers have found to be so liberating. At Pilchuck they had tacit permission, in fact were encouraged, to try and to fail without recrimination. Others refer more specifically to Lino's time working with Dale Chihuly. As Fritz Dreisbach said, "Everyone is influenced by Chihuly, in one way or another." In his straightforward way Lino offers this self-evaluation: "I am a totally normal person, I am no genius. I have difficult moments. I don't know why something new emerges." He will acknowledge, however, some innate talent for handling the glass by ceding, "For some reason, my hands stay a little bit light." He also points to the unwavering support and management skills of his wife Lina and daughter Marina, and to Cecilia Chung, Director of Lino Tagliapietra, Inc. since 1996. The concerns that they free him from allow greater concentration on the glass.

Clearly Lino's aesthetic did not emerge from a vacuum: How much art does? It is not difficult to pick out influences from the great designers and glassmakers of the past, and

Helmut Ricke makes mention of several in his essay. When those precursors are invoked, interwoven, and synthesized into Lino's volcanic flow of ideas and then fashioned with his hands, without outside intervention, he truly fulfills the poet Ezra Pound's urging to "make it new." Regarding his approach, Lino says, "I'm totally open. I think that what I like to do the most is research. I don't want to represent Venetian technique only—even though I was born with it and it is possible to recognize [it in] my work. Your style is what you are. My older work has a different spirit and my expression has changed. When we blow glass we are connected with the form, the material. Sometimes I return to an earlier idea because at that time I did not have the skill that I have now."

Lino and the mechanics of his practice may be dissected ad nauseam, but it will never be possible to understand how he conceives each piece in his head. Although some drawings exist, they were not made as working guidelines for assistants or even to refresh his own memory. He selects a group of colors in advance and lays out the cane lengths that might be used, but most of his decisions are made in front of the furnace, while the glass is the consistency of hot taffy

and fighting to move off center. As the glass is shaped all the colors look essentially the same—shining red-amber—due to the temperature. The designs include myriad details that may require completely different techniques. Surely it is difficult to keep it all ordered in the mind's eye and sometimes Lino must feel like he is "blowing blind." He cultivates a response to the moment. That is not to say that there is no premeditated concept or that he is not in control of the glass at all times; however, the quest for "spontaneous perfection" is fundamental. The expansive range of styles, many in simultaneous production, testifies to the physical and creative resources at Lino's command. On the other hand, a rich vocabulary of techniques combined with a teeming imagination also harbors the potential to overwhelm an object. The distance between a form teased to its maximum potential and the folly of mannered exhibitionism is narrow and precarious.

The majority of the works by Lino Tagliapietra now accessioned into public and private collections were made during the past ten years, the period of his most fruitful and distinctive output. The period was jump-started by his first sizable grouping of objects, the

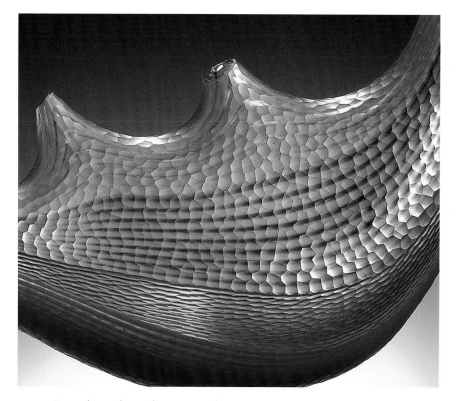

FIG. 16. *Manhattan Sunset* (DETAIL), 1997 (CAT. 58, PL. 51)

FIG. 17. *Batman* (DETAIL), 1998 (CAT. 63, PL. 57)

1996 *Metamauco* (Drowned Island) installation. The title was inspired by an ancient name for Venice, Malamocco, and subsequent works in the series were entitled *Manhattan Sunset* and *Giudecca*. Eighteen tall vessels in pale transparent glass were lightly cut with vertical bands to suggest the reflected light of the lagoon on the shimmering windows of the Giudecca island. They were assembled on a glass slab supported by a mass of slim metal shafts. The table design brought to mind both the reeds of the ancient marshlands on which Venice was founded as well as the pilings of its buildings.

Just two years later, a second installation, the *Flying Boats*, impressed his audience again. Blown glass is a notoriously difficult medium in which to attempt monumental sculpture. The bubble, the natural touchstone of all blown glass, puts constraints on size and potential forms. Lino ingeniously circumvented the inherent limitations by hanging multiple pieces of glass from light lines to form a wall of overlapping horizontal striations. Each boat or gondola started as a long, hollow form with tapered ends that was opened to form a canoe-like shape. The colorful slivers were so elongated and detailed with canes and cutting that they seemed like floating pheasant feathers or burst seed pods. Other works in the series were called *Endeavor* in honor of the legendary 1934 British racing yacht.[49] The sophistication of these first two installations confirmed that Lino's understanding of sculptural composition extended beyond the individual object.

Those singular pieces have remained steady in their formal simplicity and self-containment. For some, like the *Spirale*, the manipulation of space is internal, encased within a smooth, transparent pod; in others a neutral form serves as a ground for the dense drawing of canes, trails, or *murrine*. While the essence of light and water is inescapable, and despite the seemingly descriptive titles, specific literal representation is the exception. The extended necks of the tall, slim pieces entitled *Dinosaur*, for example, could just as easily symbolize spermatozoa or the tail of a zygote, a swimming fish or a droplet of water. Fluidity lies at the heart of the freely blown glass form, and upon cooling the flowing movement of the molten substance is held in place forever. The shapes are invariably (and somewhat superficially) likened to the sculptures of Constantin Brancusi and other artistic giants who favored refined, organic contours. Nonstop fluidity, however, can be limiting and burdensome. An element of enlivening tension must be interjected, and Lino does so by stretching, swelling, and contracting the silhouette, and by disrupting the smooth surface skin with shallow cuts. The pieces feel harmonious and balanced, but the apprehension generated by their poised precariousness is not an illusion.

And there are still surprises. The *Batman* pieces from around 1998 are dense little crescents that fit comfortably in two cradled hands. They are not light—physically or visually; the confection of pastel bubbles could not be more distant. The earliest are almost completely

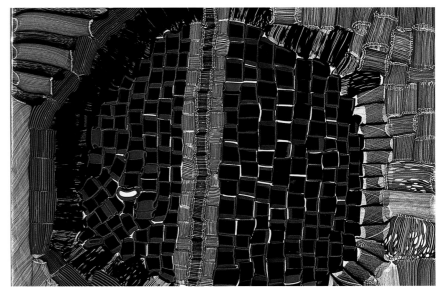

FIG. 18. *George* (DETAIL), 1999 (CAT. 79, PL. 71)

opaque and made in flat grays and greens with overall cutting that invites handling and gives them a reptilian quality. There are so many analogies: carved animal horn and shark teeth, weathered coral, igneous porphyry, tightly plaited basketry. Like dressed stones, the colors buried beneath one another are revealed though the edges of saw marks, sometimes conjuring a moiré effect. Sloughing off more of the outermost layer pushes the lapidary feeling to a raised cameo. These are dark objects, despite the slashes of primary color and occasional transparency. Even the association of the title with a *noir* comic book hero isn't as corny as it might seem considering the nocturnal animal evoked. Each *Batman* feels tribal, but does not come to that state through exploitation and mimicry of ethnic cultural material.

If there was ever any thought that Lino's talent lay only in blown glass, that notion was dismissed in 1999 by a series of panels created at Bullseye Glass in Portland, Oregon. Called *La Carta dei Sogni* (Paper or Tapestry of Dreams), which Lino has described as a psychological expression of the dream as a subconscious text or site where all desires and hopes are deposited. He sees the kiln as a blank slate for receiving and fulfilling his own ideas, feelings, and energy. The series was preceded a few years earlier by a few small fused works using dichroic glass canes, but those experiments give little hint of what was to follow.

Each panel is autonomous and was made mosaic style by assembling chopped fat canes and their respective *murrine* slices, some with a thick, colorless core that appears ringlike when placed on end.[50] The mass of each glass component, with its own embedded drawing, provides

genuine visual and physical depth within the overall plane. The concept of fusing cane lengths to form a flat surface harkens back to architectural efforts by Paolo Venini from around 1957.[51] Like Venini, Lino fills the entire pictorial field, but what emerges is an intricate composition rather than a geometric pattern, and the arrangements refer to Lino's conversations with Copier about the powerful ways that space can be divided. The flat, rectangular format is an advantage. While there is no doubt that the vessel may be a valid sculptural form while simultaneously offering a surface for painting, combining two- and three-dimensional formats into a logical and unified whole is difficult. Furthermore, any design must adapt to the inherent 360-degree canvas; while there is potential for spectacular optical effects when using transparent glass, every view must always be seen through the opposite wall with the attendant distortion and overlap.

A new aesthetic was provoked in Lino when he was freed from the constraints of the furnace. Now the visual attribute striking the viewer is a combination of ethnic weavings and embroideries, Aboriginal imagery, Byzantine stylization, and street graffiti. He packs broad swaths with parallel lines in jagged horizontal and vertical rows; a red snake with seemingly empty eye sockets coils through *filigrana* canes that are more netlike than ever. Such benign titles as *Central Park* and *George* belie the fervor of undiluted colors—the most successful chromatic combinations verging on the outrageous. As much time as necessary may be taken to complete the decisions for a fused object—hours and days rather than seconds and minutes. Changes are made, adjusted, and then changed again and again until the tray goes into the kiln and the heated glass softens enough to bind together yet not melt until the colors run. The panels illustrate how a defined direction and the luxury of deliberation foster more in-depth development in a body of work.

Lino's influence, and therefore Murano's, reshaped international glass. If not for his teaching the achievements of Studio Glass would have unfolded more slowly, and surely at a different level and in a different form. The already fulminating magnetism of Italy was inevitable, but Studio Glass artists were handicapped by a lack of firsthand information. As for the United States, as Fritz Dreisbach sums it up: "American-Italian style is Lino style." And Lino asserts, "I think that the Americans take Venetian technique—and I would say at least 70 percent of the technique evidenced in current American glass is absolutely Venetian—and apply it in very personal ways."[52] Referring to the heightened interest in Italian glassmaking techniques during the 1980s and 1990s and the Venetian-style glassware made in Northern Europe during the Renaissance, curator Tina Oldknow commented to Lino in 1998, "I think that there is almost a *façon de Venise* movement happening in Seattle."[53] That phenomenon was a doubled-edged sword: for a while there was a tendency to mine the history of Venetian glass and imitate it too closely; the *battuti* and *murrine* designs of 1940 by Carlo Scarpa for Venini were notoriously cannibalized. The impulse to copy will always survive—it is a centuries-old convention on Murano—but the drive to reproduce models from the *laguna* eventually settled down in Studio Glass. Most artists are well aware of the difference between taking inspiration from something and plagiarizing it. Now historic designs and methods more often assume their rightful place as a foundation on which to build something of one's own.[54]

In 1996 and 1998 attention was again focused on Murano and there was an infusion of energy when the international survey exhibitions, *Venezia Aperto Vetro: International New Glass*, were staged at various sites around Venice. So large and splashy that they could not be ignored, the shows generated discussion and abetted several energetic new projects. Despite the temporary enlivening effect of the events, glass still struggles on the island. Few young Muranese wish to train to the level of *maestro* and glass is imported en masse from China for reselling in the tourist emporia. Murano missed its great opportunity by not inviting Lino to develop and oversee a local educational program. His talents and resources could help keep glass tradition alive and flourishing on the island, and, more importantly, insure that Muranese output stayed relevant to the rest of the world.

A walk down Calle Bertolini today still leads one past the back doors of several glass factories; A. Ve. M. is closed, but Venini continues to occupy the same location. It isn't far from Lino's studio and office and the modest house where he and Lina have lived since their marriage. Murano is still home, but Lino says that he feels equally at ease in Seattle, where the couple also has a residence. Sixty-plus years of physically challenging work has taken its toll on his body—especially his hands, once paved with calluses, and shoulders—but he is more prolific now than ever and doesn't enjoy looking back at the past.

How often does an artist accomplish something specific and concrete that opens new possibilities exceeding his or her own work and, as a result, affects the course of art history? Without hyperbole, that is the truth about Lino Tagliapietra and his influence on the history of blown glass. Thanks largely to him the technical standard of the craft was raised worldwide and the former greatness of Murano lives on in a variety of innovative and evolving incarnations in Seattle, Amsterdam, Canberra, and countless other sites. As Benjamin Moore says, "Lino is the last of his generation who could share what he did." In addition to his role as an educator he is recognized for combining perfect craftsmanship and glorious tradition with an intelligent and advanced vision for glass—his own, Murano's, and beyond. Lino hopes that people will detect in his work "the passion for the material and for the fire." Perhaps what he wrote of Andries Copier in 2000 may be considered an apt description of himself: "He always had the huge hope to continue to make beautiful objects until old age, with clarity and love."[55]

SUSANNE K. FRANTZ, curator of *Lino Tagliapietra in Retrospect: A Modern Renaissance in Italian Glass*, is an art historian and the former Curator of Twentieth-Century Glass at the Corning Museum of Glass.

Notes

1 Despite their aromatic romance, the emissions in the air have been of serious concern since the glass factories were moved to Murano from Venice in the late thirteenth century. Safety conditions have improved, but glass factory workers are still subject to all manner of toxic pollutants and the blowers constantly breathe in fumes from the furnaces.

2 Lino Tagliapietra is referred to by his first name throughout this text. The familiarity is a reflection of general usage and the warm regard held for him in the glass world. The terms "glass artist" and "glass art" are respectfully used in discussing Lino and other individuals because the aesthetic and oeuvre they share are medium specific.

3 "Conversation," in Columbus Museum of Art, *Concerto in Glass: The Art of Lino Tagliapietra* (Columbus, OH: Columbus Museum of Art, 2003), p. 18.

4 In standard use, the term "Venetian" glassmaking refers to the industry on Murano.

5 Lino remembers that the large furnaces used for drying wood fuel doubled as shelters during air raids. The uncle of his future wife, Lina Ongaro, cared for a milk cow and chickens housed by the Venini family in their glass factory. For additional wartime memories, see Matthew Kangas, "A Conversation with Lino Tagliapietra," *Viva Vetro! Glass Alive! Venice and America*. (Pittsburgh: Carnegie Museum of Art, 2007).

6 The waters of the lagoon are no longer clear and a certain amount of the pollution is caused by waste from the glass industry. Today, the glass manufacturers of Murano are pressed to meet new environmental requirements legislated by the European Union and also the Italian government. If the factories do not reduce the amount of wastes that they release, they face closure, but enforcement is difficult and slow.

7 Anonymous article, "Italy Resumes Limited Work in the Face of Many Obstacles," *Retailing*, October 25, 1945, p. 4. A report in the May 1947 issue of *Glass Digest* stated that at that time only ten of the fifty-two glass factories on Murano were back in production.

8 According to Lino, his employment with Archimede Seguso began in June of 1946. For unknown reasons his civic work record—*Attestato di Lavoro*—gives his starting date as January 16, 1947.

9 This quote and all others by Lino Tagliapietra, unless otherwise noted, are taken from a series of interviews with the author held in Corning, NY (November 11, 1995), Seattle, WA (February 1, 2007), Murano (April 18–24, 2007), and Tacoma, WA (May 21, 2007).

10 There is considerable confusion about the schools that have played a role in Muranese glass history. According to Giovanni Sarpellon and Sandro Zecchin, around 1862 the Abbot Vincenzo Zanetti (1824–1883) established a "Scuola festiva di disegno per gli artieri dell'isola di Murano" (Sunday School of design for the craftsmen of the island of Murano), in a room of Murano's glass museum, which he had founded the year before. It was not a professional school for glassmakers, but rather a school of design. At an unknown date during the first part of the twentieth century the school, which was owned by the City of Venice, was given the name "Corso serale per maestranze Abate Zanetti" (Abate Zanetti Evening School for Workers—or, literally, Evening classes for workers Abate Zanetti) and survived until 1972; the last design teacher was Anzolo Fuga. In 1937, the "Istituto Veneto per il Lavoro" (Venetian Institute of Employment) founded a professional school for glassmakers: the "Reale Scuola Secondaria di Avviamento Professionale—Specializzazione Vetraria" (Royal Secondary Vocational School—Glass Specialization), a three-year program following primary school. Upon graduation from the "Scuola Secondaria," a student could enroll in the two-year program of the "Reale Scuola Tecnica Industriale Angelo Beroviero" (Royal School of Industrial Technology Angelo Beroviero). Luigi Zecchin was director and teacher of glass technology until both schools closed in 1946. The author thanks Giovanni Sarpellon and Sandro Zecchin for providing their expertise and much-needed clarification of this history in correspondence of July 31, 2007.

Murano's current Scuola del Vetro Abate Zanetti is meant to be the heir of the original institution, but is more oriented toward various forms of Studio Glass rather than industry.

11 Around 1885, pioneered by the glasshouse founded by Antonio Salviati, fashionable goblets become increasingly elaborate and colorful, combining elements from different periods and cultures.

12 Conversation with the author, October 25, 1995. All subsequent quotes from Benjamin Moore, unless otherwise noted, are from an interview conducted January 31, 2007. Benjamin Moore was recalling his time as an American student at Venini (September 1978–May 1979, September 1979–May 1980). One of his tasks was to pick up refreshments for work breaks.

13 Lino's nickname, as cited in the 1977 exhibition catalogue for the first Scuola Internazionale del Vetro, was "Gnofoli." See Scuola Internazionale del Vetro, *Primo corso per artisti* (Venezia: Arti Grafiche Gasparoni, 1977), p. 59. According to Benjamin Moore, another of Lino's nicknames referred to his family's origins in Burano.

14 Georgette Cartigny, "Letter from Europe: Renewed Spirit and Quality in Italy," *Gifts and Decorative Accessories*, Vol. 63, 1967, p. 32. See also various miscellaneous anonymous news items in *Home Furnishings Daily*, 1961–1963.

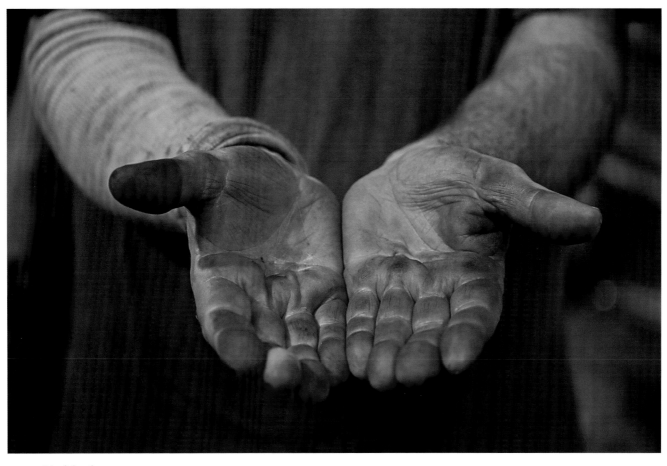

FIG. 19. Lino's hands, 1998

15 In the past this technique was often used for making the foot of a vessel or to add a decorative detail. It was introduced to American Studio Glass around 1972 by James Carpenter, who taught it at the Rhode Island School of Design following his Fulbright time at Venini. For awhile it was dubbed the "RISD Ring" or the "RISD Ridge."

16 The project differed from La Fucina degli Angeli, a commercial enterprise that had been loosely translating designs by visual artists into glass editions, often with no face-to-face encounter, since around 1954.

17 A telling example is the fact that Lino was never permitted to watch Alfredo Barbini, one of Murano's greatest *maestri* and owner of his own glasshouse, at work.

18 Although Dale Chihuly and Richard Marquis spent their Fulbright Fellowship time at Venini, Lino didn't meet them until he traveled to the United States.

19 All quotes by Fritz Dreisbach are taken from a conversation with the author, January 13, 2007.

20 Rina, who came from the Della Valentina family of glassmakers, made a return visit to Pilchuck with Checco in 1995. Checco taught with Lino that year and again in 1998 and 2003. Rina had never seen her husband at work until her first trip to Pilchuck. The same is true for Lina Tagliapietra: the first time that she saw her husband Lino blow glass was when she accompanied him to Pilchuck in 1980.

21 Letter dated February 23, 1979, Benjamin Moore archives.

22 Lino collects tools and says, "A new tool is like meeting a new person. It takes time to establish a relationship."

23 Most of the primary sources for Lino Tagliapietra's history consist of interviews conducted in English (as were all of those by this author). As such, some information is invariably lost and/or misinterpreted during transcription and editing. When possible, it is best to listen to Lino in his own words. Interviews conducted by Tina Oldknow, Curator of Modern Glass at the Corning Museum of Glass, and the author may be accessed as podcasts; see the Bibliography. While Lino's English is now excellent, fond examples of "Lino-isms" circulate among his friends and include such phrases as: I think incredible mistake; No correctly way; Uppa the floor; Incredible nice energy; Firsta we pulla the cane, thena we maka the pasta; You maka the art or you maka the glass? And from assistant John Kiley: If one makes a mistake: "Why you do lika dis?" If Lino wants to flatten something: "We squeeze"; when he wants to leave: "We stay or we go? I thinka we go."

24 All quotes by Michael Scheiner are taken from a conversation with the author, February 10, 2007.

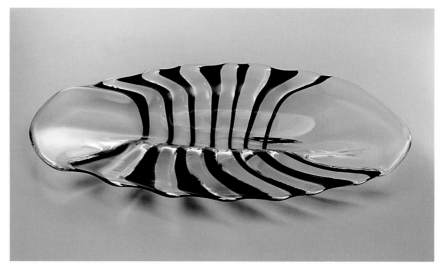

FIG. 20. *Teodorico* Platter, 1985 (CAT. 29, PL. 23)

25 Richard Marquis from a conversation with the author, March 19, 2007.

26 Andrea Tosi, "Livio Cimarosti 'Ciocio,' *Maestro* di Tradizione e Stile," *Vetro*, Year 2, #4, July/September 1999, p. 51.

27 Glassmaking by Italians working outside of Italy took place well before Lino Tagliapietra's venture to the United States and is well documented. The Venetian Republic did indeed strive to protect its industry and had laws prohibiting the re-exportation of certain materials required for glassmaking; however, itinerant Italian glassmakers founded and worked in glasshouses elsewhere in Europe from the Middle Ages. In 1295 a law was instituted forbidding the emigration of Venetian glassmakers (upon threat of various punishments including the possibility of execution) who wished to work outside of Venetian territory, but the law was not strictly enforced and glassblowers were routinely granted clemency. See Erwin Baumgartner, "Une Tradition Millénaire," in *Venise et Façon de Venise: Verres Renaissance du Musée des Arts Décoratifs*, (Paris: Union Centrale des Arts Décoratifs, 2003), pp. 22–23.

 Italian glassmaking was not confined to the Venetian lagoon and there were other centers including Florence. Craftsmen from the mountain village of Altare were encouraged to work abroad, and by the sixteenth century hundreds of Italian glassmakers were working north of the Alps in the German-speaking countries and Flanders, Holland, France, and England. Florentine Antonio Neri's textbook on glassmaking, *L'Arte Vetraria*, was published in 1612; it was translated into German within ten years and into English in 1662. The Muranese were noted for producing sheet glass, mainly for mirrors, by blowing and opening large cylinders. The technique for casting glass into large sheets for windows was developed by Bernardo Perotto (Bernard

Perrot) from Altare, while working in France during the eighteenth century. See Ada Polak, *Glass, Its Traditions and Its Makers* (New York: G. P. Putnam's Sons, 1975), pp. 53–69, 127–128.

Italians were among the many European immigrants who found work in the American glass industry in the nineteenth century and into the twentieth. While they were certainly not all *maestri*, some trained glassmakers among their numbers included Alessandro Moretti (1922–1998) and his brother Roberto Moretti (1930–1986), immigrant glassblowers from Murano who began working at the Pilgrim glass factory in West Virginia during the 1950s. American Studio Glassmakers had little access to this information on their own turf before 1978, but tourists to Venice have long watched the glassmakers at work. To learn what he could, Harvey Littleton, one of the founders of American Studio Glass, spent a month and half taking tourist tours in Murano during the late 1950s. From the 1960s and into the early 1980s Ludovico Diaz de Santillana, proprietor of Venini, gave a procession of Americans access to the entire factory. He allowed Dale Chihuly to take Super 8 movies of the glassmaking in progress during his 1968–1969 stay. During his time at Venini in 1974–1975, William A. Prindle, a student of the Rhode Island School of Design, took notes and step-by-step black-and-white photographs of the various glassmaking techniques plus the batching and melting processes. His documentation was carried out with the permission of the Venini management and the workers that he studied. Prindle published some of the information in a series of articles called "Unusual Hot Glass Techniques" from 1976 through 1977 in the periodical *Glass* (formerly *Glass Art Magazine*, Broomfield, Colorado). At Venini around 1979, with the permission of one of Murano's greatest glassblowers, Mario "Grasso" Tosi, Benjamin Moore made detailed photographic records of the *maestro*'s techniques; see Frantz, "The Italian Connection: Americans at Venini," in *Viva Vetro! Glass Alive!* All this is not to say that there was nary a grumble expressed by any of the Venini workers. It has been suggested that the Americans and other foreigners were too insignificant to be threatening, but some employees complained (with good reason) that the students were absorbing their information and, with few exceptions, were producing little in return such as viable models for production.

Although he wasn't trained as a glassblower, the Italian sculptor Italo Scanga preceded Checco and Lino to Pilchuck and had already introduced his own strong Italian sensibility and historic perspective to the school by 1974. Gianni Toso came from Venice in the spring of 1976 to demonstrate glassblowing as part of the "Great California Glass Symposium" at the California College of Arts and Crafts in Oakland. He returned to CCAC in 1977 and 1983 and also made presentations in other American university art departments.

28 All quotes from Dante Marioni are taken from a conversation with the author January 31, 2007.

29 For example, a demonstration and workshop by Richard Marquis at the University of California, Berkeley, May 6, 1971, and at the California College of Arts and Crafts, May 7, 1971. Marquis's MA from the University of California was conferred September 19, 1972. His thesis, *The Making of Canne and Murrini* [sic] *and Their Use in Blown Glass Forms*, was of great interest and copies were circulated among the Studio Glass community.

30 Italian Instructors and Artists in Residence at the Pilchuck Glass School
Note: The following information, dating from 1971 through 1995, is taken from Tina Oldknow, *Pilchuck: A Glass School* (Seattle, WA: Pilchuck Glass School, 1996), pp. 276–278.

Italo Scanga—1974, 1976, 1977, 1979, 1980, 1981, 1983, 1985, 1986, 1987, 1988, 1989, 1990, 1992, 1993, 1994, 1997, 1999
Blowing and hotworking glass at the furnace:
 Checco Ongaro—1978, 1995, 1998, 2003
 Elio Quarisa—2001
 Dino Rosin—1988, 1998, 2001, 2002, 2003
 Loredano Rosin—1988, 1991
 Davide Salvatore—2004
 Livio Seguso—2003
 Livio Serena—2006
 Pino Signoretto—1989, 1990, 1992, 1993, 1994, 1995, 1996, 1997, 1999, 2004
 Lino Tagliapietra—1979, 1980, 1983, 1985, 1987, 1991, 1993, 1994, 1995, 1996, 1998, 1999, 2000, 2003
 Andrea Zilio—2002
Flameworking:
 Lucio Bubacco—1997, 1998
 Vittorio Constantini—2006
 Emilio Santini—1999, 2000
 Cesare Toffolo (Rossit)—1991, 1993, 2000, 2003
Mosaic:
 Felice Nittolo—1993, 1994, 1995, 1996, 1998, 2002
Coldworking, cutting, and engraving:
 Mario Seguso—1998

31 Moore continued to work closely with Lino over the next several years, as did Marioni. Other early assistants included Paul Cunningham, Ruth King, Josiah McElheny, Brian Pike, Richard Royal, Preston Singletary, and Mark Weiner.

32 Copier's feelings about the *filigrana* canes and wraps are reflected in a line of poetry by Charles Blanc (1814–1881) that he quoted: "Every line, straight or crooked, diverging or parallel, has a secret relationship [sic] with an emotion." See "Introduction," in *A. D. Copier 1986: Filigrane Interferenti,® Nieuwe Unica A. D. Copier, Uitvoering in Samenwerking met Effetre International Murano* (Arnhem, Netherlands: Gemeentemuseum Arnhem, 1986).

33 Dorris Kuyken-Schneider in correspondence with the author, July 7, 2007.

34 Dorris Kuyken-Schneider, "Lino Tagliapietra's Influence in the World of Glass and His Relationship with Copier," in Titus M. Eliëns, *A. D. Copier & Lino Tagliapietra, Inspiratie in glas, Inspiration in Glass* (Ghent: Gemeentemuseum Den Haag, Snoeck-Ducau & Zoon, 2000), pp. 145–146.

35 Copier worked previously in Murano in 1926 with Napoleone Martinuzzi, Venini's Artistic Director. He participated in the 1981 Scuola Internazionale del Vetro after Dutch curator Dorris Kuyken-Schneider began looking for new opportunities for him to work with glass (he had retired from the Leerdam Glassworks / Glasfabriek Leerdam after fifty-six years of employment). The esteemed designer had expressed interest in experimenting with *filigrana* cane, a Muranese specialty and one of Lino Tagliapietra's, therefore Kuyken-Schneider queried her German colleague, Helmut Ricke, for suggestions. Ricke, who knew that two symposia had already taken place in Murano, pointed her in the direction of one of the organizers of the third, Rosa Barovier Mentasti, and the invitation was extended. In honor of his eightieth birthday, a committee in the Netherlands raised the funds to underwrite Copier's participation. The author is grateful to Dorris Kuyken-Schneider, author of some of the most thoughtful writing about Lino, for sharing her insight and archives pertaining to Copier and Tagliapietra.

36 "Conversation," *Concerto in Glass: The Art of Lino Tagliapietra*, p. 17.

37 Dorris Kuyken-Schneider, "Lino Tagliapietra's Influence in the World of Glass," p. 143.

38 Possibly the fact that from 1981 Lino made sure that his name was always written on the base of the objects he made had something to do with what he took away from the experience.

39 Conversation between the author and Robert Frehling, May 9, 2007. The eggs were retailed separately, rather than as a set. The edition quickly sold out and was immediately followed by a second series of five eggs in pastel colors. While only 100 examples were made of each size and color of the eggs, other designs for Oggetti were made in editions of 250 objects.

40 All quotes by Dale Chihuly, unless otherwise noted, are taken from a conversation with the author, March 21, 2007.

41 Not all of the *Venetians* were made by Lino. Chihuly continued the series working with other glassblowers.

42 For Lino's reminiscences on the project, see Lino Tagliapietra, "When There Is an Artist Between the Glass and Me," *Glass Art Society Journal* (Glass Art Society, 1994), pp. 65–69. This article provides a firsthand account of Lino's experiences while working with Dale Chihuly, Andries Copier, and Dan Dailey.

43 For Dale Chihuly's perspective on the *Venetians* project, see "Dale Chihuly," *Glass Art Society Journal* (Glass Art Society, 1990), pp. 36–40.

44 "Dale Chihuly," *Glass Art Society Journal*, p. 69.

45 All quotes by Peter Drobny are from a conversation with the author, March 16, 2007.

46 Interview with Daniel Kany in the catalog for *Lino Tagliapietra: "La Ballata del Vetro Soffiato,"* an exhibition at the William Traver Gallery marking the Italian *maestro*'s achievement in the world of Studio Glass (Seattle, WA: William Traver Gallery, 2002), p. 72.

47 One example of a "hard" or "stiff" color is *opaladura*, a white that melts at a very high temperature and can form a sharp, thin line that is perfect for making *filigrano*. A color that melts at a lower temperature will display a softer edge.

48 From a conversation between Marino and Marina Barovier and the author, April 20, 2007, and detailed in Marino Barovier's *Carlo Scarpa, I vetri di un architetto* (Milano and Brescia: Skira editore, Brescia Mostre, 1997).

49 The name of the yacht is spelled *Endeavour*.

50 Bullseye Connection Gallery, *Lino Tagliapietra at Bullseye Glass: Masterworks from Furnace and Kiln* (Portland, OR: Bullseye Connection Gallery, 1999); the overleaf reads: "The project began with over nine kilometers of hand-pulled *filigrana*. These two-color canes were subsequently hotworked into an extensive palette of multicolored *zanfirico* canes by Tagliapietra and a team of Seattle and Portland glassworkers."

51 Helmut Ricke and Eva Schmitt, *Italian Glass: Murano – Milan 1930–1970* (Munich and New York: Prestel, 1997), Plate 143, p. 155.

52 Louise Berndt, "Murano's Opinion," *Glass Magazine* 56, Summer 1994, p. 39.

53 Transcription of Tina Oldknow's interview with Lino Tagliapietra, November 23, 1998. The author is indebted to Tina Oldknow for her generous sharing of several interviews.

54 For many years Lino's designs have been imitated and faked (with forged signatures), both in Murano and farther afield. Sometimes it is done for pure financial gain, and sometimes simply because of a dearth of original ideas. "Copying is not flattery, it is convenience," says Lino, "Don't flatter me so much."

55 Lino Tagliapietra, in "Andries Copier," Titus M. Eliëns, *A. D. Copier & Lino Tagliapietra*, p. 2.

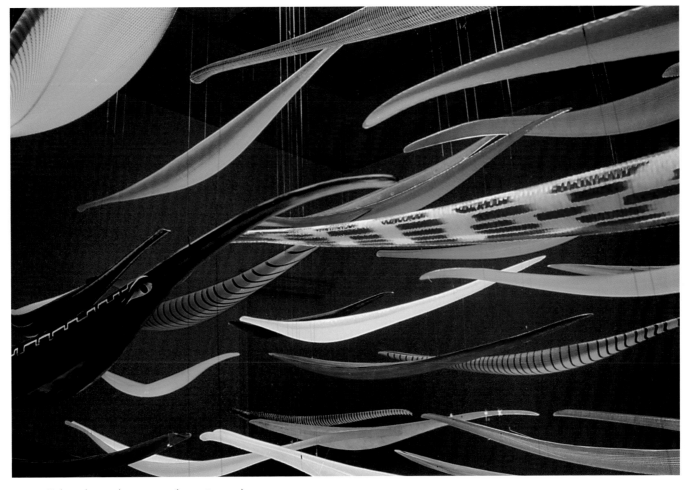

FIG. 21. *Endeavor* (DETAIL), 1998–2003 (CAT. 68, PL. 61)

TRADITION AND RENEWAL:
VENETIAN WAYS AND LINO TAGLIAPIETRA

Helmut Ricke

The colored glass thread appears at the beginning of glass art. It decorated prehistoric beads as well as the early glass vessels of Mesopotamia and then of Egypt. It spiraled around the walls of *unguentaria* (small ointment jars), was shaped into glass canes, accentuated the rims of vessels, and was combed into decorative feather patterns. For glass, it was not a question of imitating the transparency of rock crystal but of replacing the accidental patterning of the delicate veins in agate, onyx, malachite, and carnelian with intentional and purposeful decoration. In this way, humankind created its own semiprecious stones, superior to those in nature, so that it could subordinate their decoration to the laws of symmetry and the ideals of harmony and equilibrium, thus making them part of its ordered world. The prerequisite for the success of works in this new material was an understanding of the aesthetic laws of the interaction of lines and planes, of form and decoration, and of colors (FIG. 22).

In 3,500 years of glassmaking history this scenario has not essentially changed, and against this background it is fascinating to look at an artist who unquestionably speaks the language of our time and is yet deeply rooted in this tradition.

Nowhere else in the world is the bond between the present day and the beginnings of glassmaking as intense and continuous as on Murano. A young glassblower who takes his first steps toward future proficiency inevitably becomes a link in a chain; he has to measure his own achievement against the standard set by earlier generations. Building on this foundation, he will eventually attempt not only to attain these standards, but to surpass them and set new ones—if he is prepared to take up this challenge. Ambitious young glassblowers in Murano were always driven by comparison of their work with that of recognized and admired older masters and the challenge of, "If he can do it, I can do it better." This was Lino Tagliapietra's way—a typical Venetian one—but in taking it he has gone much further than many others have.

Our view of the glass art of Murano has for the most part been formed by the brilliant achievements in the filigree glass techniques of the sixteenth and seventeenth centuries (FIG. 25). Venetian glass is not, however, just *filigrana* glass. The budding master must first secure the foundation, his proficiency in the free blowing (without the use of molds) and shaping of viscous glass, capacities that have always been the central prerequisites for Venetian glass art and that characterize its inner essence and particular quality (FIG. 26). Lino Tagliapietra achieved this sought-after competence in the glassworks of Galliano Ferro as a matter of course. Ac-

cording to Tagliapietra, he owes much to the older masters who recognized his talent and handed on their own knowledge to the ambitious young glassblower. Very early on, however, he began to wonder how earlier masters had achieved certain effects and forms. In this he did not confine himself, as one might reasonably expect, to the past centuries of Venetian glassmaking traditions. Instead he went all the way back to the beginning of glassblowing. Looking at Roman glass, such as he found in Murano's Museo Vetrario and elsewhere (FIGS. 22, 23, 30),[1] he saw effects that would provide challenges and lead him to his own solutions at the furnace. To take one example, Tagliapietra likes to point to the wide rings of his *Saturno* and *Saturneo* pieces, which presented technical problems his study of Roman glass inspired him to address.[2]

A talented Muranese glassblower in training typically orients himself with respect to the works of his master, as well as to works that he sees in other glasshouses. For that individual, Murano is the center of the glass world and he is aware of little else. This turning inward, marked by a certain disregard for the outside world, was always the weakness of glassmaking

FIG. 22. Bowl, fused *filigrana* canes, Roman Empire, late 1ST century BC–1st century AD. Murano, Museo Vetrario

FIG. 23. Flask, ribbon glass, Roman Empire, 1st century AD. Murano, Museo Vetrario

on Murano. The Venetian way was never questioned and was seen as the only correct one. Specifically Venetian techniques—free blowing, *murrine*, mosaic and filigree glass, *incalmo*, *reticello*, and others—were learned from the cradle, so to speak, and remained the central possibilities in glassmaking, with little change in their formal execution. Even today a large part of the production, as one can see in the Venetian shops, is oriented toward Venetian glass art of the sixteenth and seventeenth centuries.

Of course this background also shaped Tagliapietra's assessment of himself. Like every *maestro* in Murano, he knows Venetian glass of the sixteenth and seventeenth centuries down to the last detail and I am certain he could make exact copies of the elegant and extravagant products of this period without any major preparation. However, he was never very interested in reverting, for example, to the technique of *reticello*, in which two pieces with applied threads are fitted exactly into one another to create a finely detailed decoration of air bubbles. The few occasions when he does choose *reticello* simply prove that he naturally excels in this technique as well.[3] The same is true for the classical work with *zanfirico* glass canes. The filigree glass works of the Renaissance and Baroque periods in Venice essentially drew their effect from the large variety of *zanfirico* combinations (FIG. 25). In place of the embedded, usually spiraling milk-glass threads of these early works, Tagliapietra's show strongly colored, but often simpler, thread combinations whose effect unfolds only in their dynamic lines and bundling.

For the most part, Tagliapietra also left aside the art of extraneous applications of glass—not for lack of skill, but in recognition of the fact that artists had already reached the ultimate in perfection and excess in this area in the second half of the nineteenth century (FIG. 27). He prefers object forms with clean outlines, whose walls offer him unlimited possibilities of expression, his true interest.

In three-dimensional sculptural work, nineteenth-century artists also reached hardly surmountable peaks in the fine details and the virtuoso handling of the material. It is an achievement that Tagliapietra does not feel called upon to surpass, although this is a direction that has been pursued widely in Murano, even if mostly just by enlarging and coarsening various effects. Early on he saw more clearly than others how the development from the technical perfection of the late nineteenth century to the large figurative sculptures—all the fish, horses, and loving couples that make visiting the shops on Piazza San Marco a doubtful pleasure—has harmed glass art in Venice more than it has helped.

Tagliapietra's path as a designer and master, first carrying out works in the glasshouse La Murrina and then in the future-oriented glassworks Effetre International, and finally as an independent artist, was clear from the beginning: the closed vessel shape remained the formal basis of his work. Technically, he sought to find new creative possibilities in the traditional filigree glass procedures, *incalmo*, and—even if only to a limited degree—in the mosaic-glass processes. This was the realm in which he developed his proficiency, and he has remained true to this principle to the present day, even if the distinction between vessel and object has become fluid, and the forms of his works increasingly have a life of their own as they gain a lively sense of movement.

Precursors: Carlo Scarpa and Venini

Following the excesses of historicism in the nineteenth century, the filigree glass techniques fell into the background in Venice for several decades. After the First World War, in 1921, Paolo Venini and Giacomo Cappellin relied entirely on the tradition of free blown or optic-molded glass as they undertook a daring reorientation of Venetian glass art.[4] It was only during the collaboration between Venini and the young architect Carlo Scarpa in the later 1930s that they returned to the possibilities of working with *murrine* and finally also with opaque white and colored filigree glass. While Scarpa generally used the white threads in a very restrained manner, primarily with the very fine, yet dynamic lines of *mezza filigrana*,[5] he intentionally avoided creating the tension of additional movement in his designs for colored filigree glass. In his *tessuto* pieces, the vertical threads follow the usually simple and severe vessel contours. What is central to his design are the alternating colors of the threads (FIG. 28). This was a new beginning, but the emphasis on the vertical colored glass canes running parallel to one another still owed a great deal to the sixteenth-century Venetian tradition.

Much more revolutionary, on the other hand, was the introduction of a design principle that had until then been extremely uncommon in Venice—structuring the entire surface of the vessel by cutting (FIG. 29). In this, Scarpa may have been inspired by French Art Nouveau glass—by the use of expressive cut structures in the work of Emile Gallé, and in particular by the *martelé* surfaces of glass by Daum Frères in the city of Nancy. Within a short period, Scarpa developed a large variety of similar *battuto* cutting techniques in which the surface appears hammered, and of *inciso*, finely structured engraving, innovations that traditional masters in Murano must have perceived as an absolute provocation.

For centuries Venetian glass was not imaginable without the gleaming surface created in the fire. At the very most, gilding, enamel painting, or diamond-point engraving might be considered acceptable because these decorative techniques heightened the shine of the surface and underscored its effect. The few engraved glasses of the eighteenth century from Murano were fundamentally un-Venetian and have to be seen first of all as ineffective attempts to ward off the powerful competition presented by the newly developed Bohemian cut glass. Even in

FIG. 24. *Incalmo* Pitcher, Middle East, presumably Iran, 8TH to 10TH century AD. Düsseldorf, museum kunst palast, Glasmuseum Hentrich

FIG. 25. *Filigrana* Pitcher and goblets, Venice, mid-16TH to early 17TH century. Düsseldorf, museum kunst palast, Glasmuseum Hentrich

FIG. 26. Decorative bowl, blown, Venice, late 17TH century. Düsseldorf, museum kunst palast, Glasmuseum Hentrich

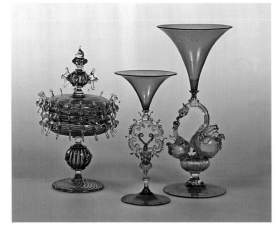

FIG. 27. Decorative goblets, blown with hot applications, Giuseppe Barovier for Salviati & C., last quarter 19TH century. Düsseldorf, museum kunst palast, Glasmuseum Hentrich

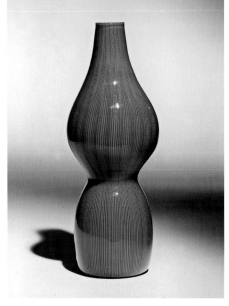

FIG. 28. *Tessuto* Vase, Carlo Scarpa for Venini & C., 1940. Steinberg Foundation, Vaduz

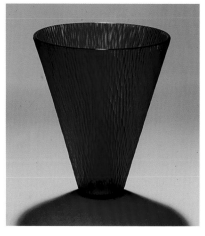

FIG. 29. Vase with *battuto* cutting, Carlo Scarpa for Venini & C., 1940. Steinberg Foundation, Vaduz

the 1920s the Muranese workshop S.A.L.I.R., which specialized in engraving and cutting, seemed very exotic.

With Venini and Scarpa's initiative, this orientation changed fundamentally and the more progressive forces on Murano discovered the potential of designing the surface by relief cutting. As early as 1949, the young Fulvio Bianconi cut vessels and objects with his own hands to create an expressive surface structure (FIG. 31); Venini himself found new ways of working with *inciso* and *battuto* in the 1950s and in 1967–1968 gave the Czech Miroslav Hrstka the opportunity to realize his own very personal expression in relief cutting (FIG. 32). Other manufacturers, such as Aureliano Toso, with impressive designs by Dino Martens for the Biennale di Venezia 1954, and Alfredo Barbini with his incised *Vetro Pesante* objects, soon followed.[6] That Lino Tagliapietra increasingly structures the surface of his more recent works by cutting can thus be rather precisely linked to those developments within modern Venetian glass art. General awareness about how far these developments go back, their extent, and their significance was raised only in the 1980s[7] and it is surely no coincidence that Tagliapietra turned to the cut glass surface at the same time that Carlo Scarpa's work was being rediscovered. He himself points to the impression it made, saying it was at least as significant for him as his study of cut Roman glass. An ancient masterpiece of this genre from the cemetery near Zadar in Croatia is preserved in Murano's Museo Vetrario (FIG. 30).

A closer look at Tagliapietra's work of the 1990s shows clearly how much he went beyond Scarpa's creations, both of the late 1930s and his designs for the 1940 Biennale.[8] With his much more complex filigree glass structures, Tagliapietra developed completely new ways of contrasting different types of structures in cut glass. He created an unusually lively interaction between the color and line structures and the surfaces. Even so, in modeling the surfaces by cutting, the execution is generally subordinated to the interplay of the colors and threads, fol-

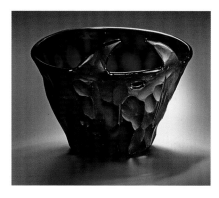

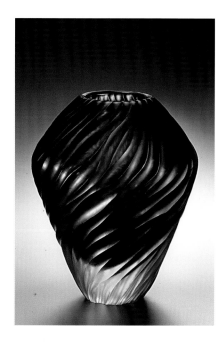

Above: FIG. 31. Bowl with *battuto* cutting, designed and executed by Fulvio Bianconi, 1949. Steinberg Foundation, Vaduz

Right: FIG. 32. Vase with cut decoration, Miroslav Hrstka for Venini & C., 1967–1968. Steinberg Foundation, Vaduz

lowing and conforming to them. In addition to the rich contrasts and harmonies of the skeins of threads, Tagliapietra also created textures, tempting viewers to feel and touch the surfaces. Thus the contrasts between various types of relief join the dialogue of color and decorative pattern. But in place of the austere restraint and severe forms of the late 1930s, Tagliapietra has now created something completely original, very different from Scarpa's original intentions: the carefully thought-out lines of color and cutting, referring to one another, make the form more dynamic. The form responds to the surface, the course of the threads underscores or disturbs the movement of the shape, and the structure of the cutting accentuates or counteracts the alignment of the threads. Each object is a complex formation of conflicting elements that nevertheless finally come together and become one entity. In place of the harmony that Giovanni Sarpellon spoke of as the fundamental principle in Tagliapietra's work as recently as 1994,[9] his more recent pieces are an expressive marriage of dynamics and contrasts.

The Significance of the Revolutionary 1950s

The leap from Carlo Scarpa's work of the 1930s to Tagliapietra's of the 1990s seems immense. This impression is adjusted when we look at the eventful years after World War II—the period between 1948 and 1960. The events of this time did not yet actively define Lino Tagliapietra, but he followed Scarpa's production with interest even if he was still a very young man. In the 1960s, as a young master, he would certainly have known the period well and been consciously aware of it.

FIG. 30. Plate, cut and polished, Roman Empire, late 1ST century AD. Murano, Museo Vetrario

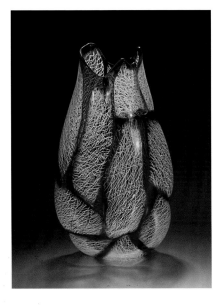
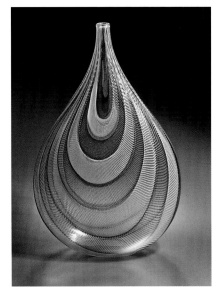

Left: FIG. 33. *Merletto* Vase, Archimede Seguso, 1953. Steinberg Foundation, Vaduz
Right: FIG. 34. Vase, Archimede Seguso, for the 1954 Venice Biennale, Düsseldorf, museum kunst palast, Glasmuseum Hentrich

In this connection, the name of his early *maestro*, Archimede Seguso, inevitably comes up. It is well known that Tagliapietra was an apprentice who sometimes worked in Seguso's glasshouse when it was small and when significant things were happening. There Seguso produced the later-famous *Merletti*, technically very complicated filigree glass vessels characterized by their refined sensibility and nervous agitation. They remind one of pillow lace—thus the name—and are today counted among the most typical products of 1950s' Muranese glass art (FIG. 33).

The achievements of Seguso and his masters must have greatly impressed the still very young Tagliapietra at the start of his professional career, and it seems natural to recognize in them the source of the decisive impulse that awakened Tagliapietra's ambitions and determined the path his work would take in the following years.

For him, however, this connection is not so obvious. The memories of the years at Archimede Seguso seem to be obscured by the experience that "life's not easy at the bottom." His works from the 1980s and early 1990s clearly reveal an acute analysis of Archimede's production (FIG. 34).[10] It would seem, however, that these similarities result not so much from the immediate impressions of the apprentice in the glassworks but from the young master's later study of the oeuvre of the successful older *maestro* and competitor. Nevertheless, Archimede Seguso's concentrated artistic efforts to find new ways of working with filigree glass remain more closely connected to Tagliapietra's magnificent achievements in this direction than to the works of other masters in Murano. This is true for his early works and is still obvious today in those works with arched *zanfirico* canes, which resonate with Archimede Seguso's glass of the 1950s. Also closely related are Tagliapietra's series *Cantu* and *Asola*

(CAT. 116), reminiscent of Archimede's *Merletti* and plainly contrasting with the intense colors and dynamics of the rest of his production that year.

Archimede Seguso, however, was not the only one who turned to dazzling filigree glass in the 1950s. The initiative for the new movement came once again from Murano's leading glassworks. As early as 1949, Paolo Venini, in collaboration with Fulvio Bianconi, rang in the renaissance of filigree glass with his epoch-making *Fazzoletto* (Handkerchief) vessels.[11] For this group, which combined a contemporary form with appealing elements borrowed from the textile arts, he still used the traditional *zanfirico* canes. But this was soon to change.

In the early 1950s, peaking around 1954, numerous novel models in filigree glass were produced by Venini, who utilized the potential of the technique in very different ways (FIG. 35). Several clearly show that the work of Archimede Seguso had made an impression.[12] Looking back, we can observe in the filigree glass of Archimede Seguso and Venini a not-to-be-underestimated intermediate step leading the way to Lino Tagliapietra's creations of the 1980s and 1990s.

Although on first glance they are hardly obvious, links also occur between Venini's glass of the 1950s, during the period when he was promoting the *incalmo* technique—which precisely joins together two or more differently colored prepared pieces—and Tagliapietra's later work. From the mid-1950s Venini increasingly used this procedure, one that had been known since the early Middle Ages in Islamic countries (FIG. 24). The work was based on preliminary designs by Carlo Scarpa of 1938,[13] in part for models designed by himself or his studio, in part for models in connection with *murrine* by Riccardo Licata (FIG. 36). In the 1960s, in designs for Venini by Tapio Wirkkala and Timo Sarpaneva, these activities reached a peak.[14]

While the clear separation between the different zones of color remained a binding design principle in the Venini work, Tagliapietra has chosen to fuse separately blown pieces as a means toward achieving a much more complex form. That he created the work in the *incalmo* technique can be difficult to comprehend; how it was made can often only be guessed at and often the uninitiated viewer will not receive an answer to his questions. Sometimes we may be reminded of Roman ribbon flasks, which Tagliapietra has known since he was a child (FIG. 23), but his work always goes far beyond such precursors.

The mosaic glass techniques—as Ercole Barovier, in particular, cultivated them, fusing and subsequently inflating small, prepared colored-glass elements (FIG. 37)—like the related *pezzato* (patchwork) technique, highly valued by Bianconi—are also part of the traditional background against which Tagliapietra's work developed. In Tagliapietra's more recent works, however, the boundaries between techniques are expertly combined and often become fluid. In contrast to Venini's vessels in the *mosaico tessuto* (woven mosaic) technique (FIG. 35), for example, where he also employed small filigree glass tiles like mosaic pieces, the individual

FIG. 35. *Tessuto* Mosaic Vase, Fulvio Bianconi or Paolo Venini for Venini & C., 1954. Düsseldorf, museum kunst palast, Glasmuseum Hentrich

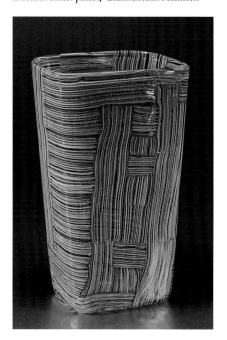

FIG. 36. *Murrine* / Incalmo Vases, Riccardo Licata for Venini & C., 1955–1956. Steinberg Foundation, Vaduz

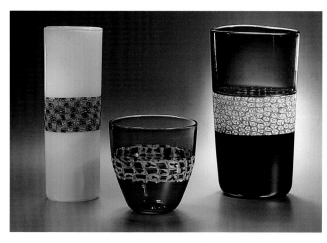

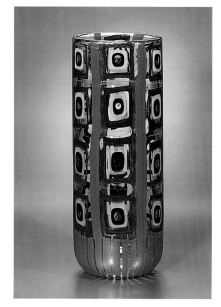

FIG. 37. *Dorico* Vase, Ercole Barovier for Barovier & Toso, 1960, executed 1962. Düsseldorf, museum kunst palast, Glasmuseum Hentrich

FIG. 38. Vase, Model No. 5034, Dino Martens for Vetreria Aureliano Toso, 1953. Düsseldorf, museum kunst palast, Glasmuseum Hentrich

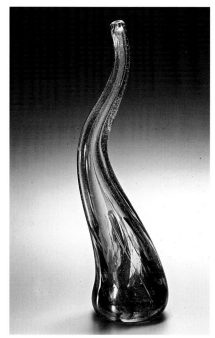

FIG. 39. *Bottiglia Sirventese* Vase, Dino Martens for Vetreria Aureliano Toso, 1956. Steinberg Foundation, Vaduz

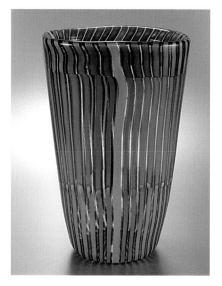

FIG. 40. Vase, Anzolo Fuga or Luciano Ferro for A.Ve. M, Murano, late 1950s–early 1960s. Düsseldorf, museum kunst palast, Glasmuseum Hentrich

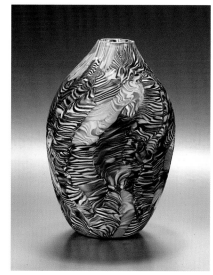

FIG. 41. Mosaic Vase, Vertreria Fratelli Toso, 1960s. Düsseldorf, museum kunst palast, Glasmuseum Hentrich, donation Steinberg Foundation, Vaduz

elements in Tagliapietra's works are not used as structural building blocks in a severely outlined vessel body, but rather as forceful elements that heighten the tension and movement within the plane.

From this perspective, Dino Martens, with his designs for Aureliano Toso (FIG. 38),[15] is closest to Tagliapietra within the context of Muranese glass art of the 1950s, even formally anticipating some of his designs (FIG. 39). Martens is one of the few Muranese artists of the 1950s who knew how to employ the technical possibilities that the big masters in the leading glassworks had at their command in such sovereign fashion that the physical perfection of the glass is subordinated to the artistic idea. His love of experimentation and creative energy can only be compared with Fulvio Bianconi. Martens, however, like Bianconi, was a designer and not a glassblower. In actively combining both these professions, Lino Tagliapietra is one of the exceptions in Murano's tradition, both past and present.

We could no doubt considerably expand the number of important and independent designers and masters who have their place somewhere in Tagliapietra's memory, and have thus contributed consciously or unconsciously to his artistic vision of the world. During the late 1950s and 1960s, for example, Tagliapietra would certainly have been very much aware of the compelling works created at A.Ve. M. (Arte Vetraria Muranese) based on designs by Anzolo Fuga and Luciano Ferro (FIG. 40), as well as the amazing, freely developed mosaic glass creations by Fratelli Toso (FIG. 41).[16] They are all part of the fertile soil that fuels the growth of Tagliapietra's art. Certainly Tagliapietra would not be the artist he is today, however, if he did not have the adventurous spirit and curiosity that led him to dare to step outside Murano, or to leave the island to convey his knowledge to others and to experience what the dynamically growing new spirit in American glass art was all about.

"Murano meets Studio Glass" is, however, not the subject of these notes. The significance of meeting A. D. Copier, Tagliapietra's first visit to Pilchuck, discovering his skills as a teacher, and the contact with young artists whose drive is powered by their joy in the arduous work with the material—a joy that the Muranese have largely lost—all this changed not only the person, but also the artist. Both profited: the outside world, and, above all, the American glass scene, which would look completely different today without Tagliapietra's contribution, and the artist himself. His work clearly shows that he has reached new horizons.

Of course he was always the one giving; there was little he could learn at the various educational institutions at which he taught. In several of his most recent works we see technical similarities with the "montage" process for flamework developed by Albin Schaedel in Arnstadt, German Democratic Republic, and Kurt Wallstab in Griesheim near Darmstadt, starting in the 1950s (FIG. 42).[17] Tagliapietra may have regarded it as a challenge to translate

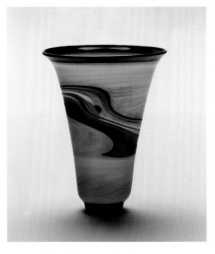

FIG. 42. Flameblown vase in the *montage* technique, Kurt Wallstab, Griesheim, 1982. Düsseldorf, museum kunst palast, Glasmuseum Hentrich

the small-scale flamework onto a large scale by fusing prepared elements with a larger piece at the furnace and subsequently distorting and drawing out the piece.[18] But although Kurt Wallstab also taught at Pilchuck, he and Tagliapietra never met and a direct exchange of experience did not take place.[19]

Today on the streets of Murano locals greet Tagliapietra with an admiring "*Ah, l'Americano.*" He is not an outsider yet his special position is obvious. In the typical Muranese manner, his success has brought imitators and successors into the arena—a somewhat dubious expression of recognition and respect. And probably a small group also regards him as a traitor, one who reveals "Murano's secrets" to the outside world.[20] Tagliapietra continues to emphasize that Murano does not have any secrets, only a tradition against which true excellence is possible only if the artist has willpower. It is this willpower that he finds more in the young glass artists in America than at home.

In this scenario he is a wanderer between worlds who has remained a true Muranese—even if he creates most of his works in Seattle. He does not regard the centuries-long tradition as a burden but as a matter of course, and moreover, as an active strength and privilege. He sees the past as part of the present. Rarely does his drawing on the past convey the sense that he is thinking of a prototype; in general it feels only like background music while the motif itself seems dominant, never heard before and new. The comparison with musical compositions is one that repeatedly presents itself for Tagliapietra's work. The many colored inclusions embedded in his large forms as ribbons or windows, often bring to mind the cadences that allow a pianist, for example, to allow his own ideas free reign within large compositions. His interpretations of the known allow what could previously not be perceived to be heard, while the range and variety of his innovations seems inexhaustible.

Tagliapietra now brings together in a grand synthesis the technical genres of Venetian glass that even up to the 1950s and 1960s had been kept neatly separate. This should not be seen, however, as a dazzling end in itself, but rather the result of his search for new expression. In his works of recent years, Tagliapietra never uses the countless techniques he could draw on for their own sake. They are always subordinated to his ideas. His goal is a certain expression, an emotional mood, an artistic idea. He always chooses a technique or a combi-

nation of techniques that corresponds to the respective subject and to the concept behind it. It is the quality of this approach, embodied in work at a very high level of originality, that sets his work apart from the arts and crafts and makes his achievement a legitimate part of contemporary glass art.

Translated from the German by Claudia Lupri

DR. HELMUT RICKE is the Curator of Collections, Düsseldorf, museum kunst palast (formerly known as the Kunstmuseum), and the Chief Curator and Director of Collections of the institution's Glasmuseum Hentrich. He is a distinguished art historian and an expert in the history of glass.

Notes

1 The collection of glass from Pompeii and Herculaneum, now preserved at Museo di Capodimonte in Naples, was particularly important to him.

2 This information and other details that follow are based on conversations the author held with Lino Tagliapietra in Murano on April 22 and 23, 2007.

3 See the vase of the *Hopi* series, made in 1997, in Marino Barovier, *Tagliapietra: A Venetian Glass Maestro* (Dublin, 1988), no. 22.

4 For Venini, see Franco Deboni, *Venini Glass* (Trieste, 1996); Helmut Ricke and Eva Schmitt, *Italian Glass: Murano – Milan 1930–1970* (Munich and New York: Prestel, 1997); and Anna Venini, *Venini: Catalogue Raisonnée 1921–1986* (Milan, 2000).

5 The term describes a glassmaking method that results in fine white glass threads; these lie close to one another without overlapping and spiral around the vessel wall, creating a very refined but also clear and simple form of decoration.

6 See Ricke and Schmitt, *Italian Glass*, pp. 88–89, for Bianconi; pp. 153, 162, and 171 for Venini; pp. 172–174 for Hrstka for Venini; and pp. 246 ff. for Barbini. For Martens's designs for Aureliano Toso see Marc Heiremans, *Dino Martens: Muranese Glass Designer: Catalogue 1922–63* (Stuttgart: Arnoldsche Verlagsanstalt, 1999), pp. 33, 95–97.

7 This is primarily due to Marino and Marina Barovier, who made the work of Scarpa public with several exhibitions and who provided exemplary documentation of Carlo Scarpa's achievement with their catalogue raisonnée; see Marino and Marina Barovier, *Carlo Scarpa: Glass of an Architect* (Milan: Skira Editore, 1998).

8 See in particular the excellent close-up photos in Barovier, *Tagliapietra*.

9 Giovanni Sarpellon, *Lino Tagliapietra: Vetri, Glass, Verres, Glas* (Venice, 1994).

10 See the vase *Tartana* of 1981, ibid., p. 43, no. 2, with Archimede Seguso's biennale vase of 1962, here fig. 13. Also see works such as the vase made in 1982, ibid., pp. 48–49, no. 6, which are very close to Archimede Seguso productions.

11 See Ricke and Schmitt, *Italian Glass*, p. 100.

12 Ibid., pp. 133–140.

13 See Deboni, *Venini Glass*, no. 84.

14 Ibid., no. 133. For the Finnish designs see the exhibition catalogue *Finns at Venini. Venini suomalaiset* (Riihimäki, Finland: Finnish Glass Museum, 2007).

15 See the exhibition catalogue *Lino Tagliapietra: La danza con fuoco. A Dance with Light* (New York: Heller Gallery, 2004) and object number 16, Fiori di Cipolla, 2004. For an excellent survey of works by Dino Martens see Heiremans, *Dino Martens*.

16 Ibid., no. 12, model *Stromboli*, 2004.

17 His interest in these pieces, which are constructed in an extremely complex manner, may have been aroused by one of the numerous publications on these German flameblowers. For Schaedel, see *Albin Schaedel: Glas vor der Lampe geblasen. Aus der Sammlung des Angermuseums* (Museen der Stadt Erfurt, 1979). For Kurt Wallstab, see the exhibition catalogue *Kurt Wallstab: Vor der Lampe geblasenes Glas 1957–1987* (Kunstsammlungen der Veste Coburg, 1987). Also interesting are comparisons with the work of Albrecht Greiner-Mai in Lauscha; see the exhibition catalogue *Albrecht Greiner-Mai* (Glasmuseum Lauscha, 2007).

18 See above all the models of the *Bilbao* series in the New York exhibition catalogue *Tagliapietra*, nos. 2, 8, 14, and back cover, and the *Dinosaurs*, nos. 3, 7, 9, and front cover, 2001–2004.

19 Henny Wallstab, who accompanied her husband on all his travels, kindly told me about this. There is a videotape at Pilchuck, however, which documents the complicated work of montage at the lamp, and Tagliapietra has confirmed the similarity of the montage technique to the process he uses in some of his works.

20 This refers to the old legend that glassmakers leaving Murano to work outside were killed as traitors. However it is known that as early as the first half of the sixteenth century Venetian glassmakers were working unharmed in foreign countries—mostly on the invitation of princes or noblemen who wanted to have their own workshops *à la façon de Venise*.

MAKING A GOBLET IS A LANGUAGE

Dante Marioni

When you watch Lino Tagliapietra blow glass you are observing a genuine master glassblower. I say that even though I've always felt that the word "master" is overused in our field. For me, only a few individuals deserve that title and they pretty much all live and work on the island of Murano. And even for Murano, Lino has an unusual skill set that allows him to make very large works as well as fine and delicate Venetian-style stemware with aplomb. In contrast, most Muranese glassmakers tend to be more specialized and usually only shine in one particular discipline, whether it is making goblets, *zanfirico* canes, or solid sculpting at the furnace. Lino seems to be physically predisposed to the act of glassblowing. He is not overly tall in relation to his large wingspan, he has big, strong hands and very natural athletic grace, and, of course, crazy-good reflexes. He would have made a good motorcycle racer.

There is no way to attain such a level of glassblowing accomplishment without two primary ingredients—passion and unlimited access to a furnace, such as employment in a glasshouse where one can practice, practice, practice, because there is no substitute for handling molten glass, and starting out at age eleven doesn't hurt either! If you observe Lino's movement, he often appears so casual and relaxed—although focused—that at times it's surprising that the objects turn out so . . . well, perfect. But Lino would not tell you that he was a "natural"—in truth, he had to work at it a lot. The passion that he had and continues to have paves the way for his unbelievable proficiency at glassblowing.

Another highly influential factor in his development happened because as he was learning Lino had ample opportunity, over several decades, to observe real masters at work, starting with Archimede Seguso, his first mentor, and later with "Nane Catari" Ferro and Enrico Moretti. Lino is so reverent of those men and the *maestri* who came before them and who passed on their experience and knowledge. He has a profound sense of humility rarely found in artists of his stature.

Years of repetitive motion instill muscle memory—movement becomes instinct. The fluid transition from furnace to the glassblowing bench, so important in making the most of the heat one puts into the piece, takes years in the making. Gathering additional glass on a molten bubble that is still moving can be a frightening prospect for anyone who is less than experienced. And the simple act of evenly trimming excess glass off the rim of a piece after it is transferred to the punty may be daunting for even those individuals with lots of time logged at the glassblower's bench. You can see Lino perform these and plenty of other far more difficult feats every time he picks up a blowpipe.

As a young American student I always made certain to be present whenever Lino was in the Northwest. The Pilchuck Glass School was his home away from home on the West Coast, just as the Haystack Mountain School of Crafts in Maine was in the east. He could be found at either or both schools during the summers of the 1980s and 1990s. Everyone wanted to watch Lino; there simply was nothing close to that experience available elsewhere. I didn't have the chance to meet or watch Lino that historic summer of 1979 when he first came to Pilchuck to work with Benjamin Moore, but my Dad, Paul Marioni, was there and he was effusive in the tales he told me about the *maestro*'s feats. I finally met Lino in the summer of 1983 when, as a nineteen-year-old production glassblower at the Glass Eye studio, I spent two weekends observing and assisting him a little. It was an eye-opener, to say the least.

In the late 1970s and early 1980s Lino did not speak much English. Asking questions was not always an option for his students, so paying attention and watching closely were of paramount importance. I enrolled in his 1985 class at Pilchuck and remember that he stopped by my bench as I was puntying up a bowl with a blown foot; all he said was "Good." I stood up to take the piece to the fire and when I sat back down to begin opening it up Lino returned and uttered the first sentence I heard him say in English: "Mistake not to trim." Well, I had no intention of ruining the piece—one that a moment before he had said was good—by trying to trim the lip. However, it was at that moment I began to realize how important it was to do just like Lino, to emulate his every move, whether I fully understood what I was doing or not. By absorbing his disciplined values instead of taking an easier approach one eventually begins to understand and "find the feeling" for the glass.

In those early days when Lino was teaching workshops at Pilchuck, Haystack, or the Glass Eye he would demonstrate mostly traditional Venetian blown forms—pitchers and bowls, vases and goblets . . . lots of goblets. Everyone especially loved watching him make goblets because he is, of course, quite good at it. One of the first things he told me, an eager

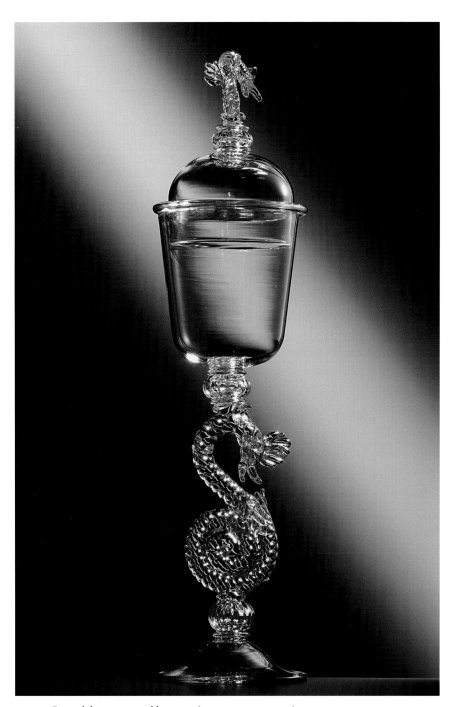

FIG. 43. Covered dragon-stem goblet, 1992. (CAT. 121, PL. 116, 117)

teenager, was that if you make goblets in the Venetian way for seven years while working with the same assistant, you can make anything. That may be a bit of an oversimplification, but the truth is that Venetian-style goblet making requires the mastery of a plethora of different moves done rapidly and on-center—and, above all, with a light touch. Making goblets all day long also affords one the chance to finish a dozen or two pieces; making larger works takes much longer. Goblets also force you to develop an eye for proportion. The goblet is to the glassblower what the teapot is to the ceramist—the embodiment of almost every challenge. Many of us who blow glass go through a period when that's all we want to do. Having a real *maestro* over your shoulder while learning is something that we came to take for granted as Lino tirelessly taught workshops around the world. Making a goblet is a means to an end; it is a language. Lino enabled us to take those skills and find our own ways.

I had the good fortune to travel and assist Lino on numerous occasions through the 1990s. One particular summer (1992) he made a lot of goblets while instructing at both Pilchuck and Haystack. Several of the good ones are at my house, and there is one in particular that he gave to me and that I have spent a lot of time studying. It is a very traditional-looking dragon-stem vessel. He made a lot of different goblets that summer, many of his own design, but in my opinion this goblet represents Lino at the height of his latter-day, technical goblet-making prowess. In other words, it is *tight*: perfectly proportioned, small in scale, very fine and delicate, with a precisely fitted lid topped by a tiny dragon. I watched and assisted him in the making of it and the whole time I was aware that he was "in the zone"—really focused. As I said, he'd made a lot of goblets that summer and he was sharp.

One of the most compelling aspects of Venetian goblet making is that the necessary implements and techniques have remained basically unchanged for centuries. A sparse set of hand tools is all that comes between the maker and the glass in the creation of something symmetrical, light, balanced, and often highly ornate. Another key element is the working harmony established between the main glassblower and the assistant(s). In essence, these things define Venetian glassmaking: skilled individuals working as a team using age-old tools and methods. Natural gas and electricity for the furnaces have been the only significant technological advancements. The early days of American Studio Glass saw many artists working solo at the furnace; this is certainly possible, but it's extremely limiting. It didn't take long for us Americans to recognize the power of the Muranese traditions that Lino shared.

Lino's work is produced the same way today as it was back then, although it is obviously a lot more complex—technically and aesthetically. The tools he uses to make almost everything are what anyone else would use—nothing fancy, an assortment of shears, large tweezers, wooden paddles, jacks, and a clump of folded-up wet newspaper to shape the

FIG. 44. Dante Marioni watching Lino work, Pilchuck, 1992

blown form. Lino's team, the assistants who have worked with him over the last decade or so, has grown relatively large due to the intricacy of the work. As many as eleven or twelve men and women stay pretty busy, but no one is working as hard as Lino. Glassblowing is physically demanding, especially when things get large. Even with his tremendously skilled help Lino moves a lot of hot glass around all day long. His economy of movement while doing so is another reflection of the decades spent at the furnace and leading the team.

There are always assistants preparing colors and gathering glass to form the patterns he frequently uses in the work. And someone is always helping the *maestro* turn the pipe as it is rolled back and forth on the rails of the bench while he shapes the glass. This same individual will often carry the piece back to the fire, reheat the object, and then carry it back to Lino for more work. Someone else is there to help with the details: applying the gas torch to keep parts of the piece hot, protecting Lino's arm from the heat with a wooden paddle, fixing up the wet newspaper, arranging the tools on the bench in an orderly manner, and sometimes blowing into the pipe. A different person will make and present the punty to Lino when it is time to transfer a piece off the blowpipe for finishing. When the objects are especially large there will usually be someone else whose primary job is to open and close the doors on the glory hole, making the transition back to the fire for reheating proceed that much faster. This same person is often responsible for loading the finished work into the annealing oven for a slow cycle of cooling. That pretty much covers the activity on one side of the hot shop.

Lino often incorporates multiple bubbles as well as canes of glass and *murrine* in his work to create colored bands, lines, and other design elements. Canes are typically made up of small thin rods of contrasting colors. On the other side of the hot shop there might be up to eight people making the canes by heating up the colored rods, pulling and stretching them out, chopping them up, and then arranging them on an iron plate for warming. Someone else is probably gathering glass on another pipe, inflating a bubble, and rolling it over the heated canes and *murrine* to pick them up and smooth them into the surface of the glass.

Several of those decorated bubbles might be being made and kept hot at the same time. Each is opened up and then carefully joined to the rim of another to create bands of color, a technique known as *incalmo*. I have always really admired Lino's pinpoint accuracy when bringing things together—whether they are the components of a goblet or the edges of *incalmo* bubbles. A less than perfect shot rarely happens and his ability to correct and move forward when it does is inspiring.

Once all the colored bands are joined together into one composite bubble Lino will often turn or change the axis by simply opening a hole in the inflated form and transferring the whole thing to a different pipe. This shift can make the color lines align vertically rather than horizontally, or it can send them off at an angle. Lino has employed this technique for

42

FIG. 45. T-shirt: "Are you sure Lino done it this way?" around 1988 (CAT. 43)
The question posed on this T-shirt represents a joke between Richard Marquis and Dante Marioni. At the time, young Marioni was so diligent in emulating Lino's glassblowing techniques that Marquis made a play on the title of a popular Waylon Jennings song about country singer Hank Williams, "Are You Sure Hank Done It This'a Way?" When the shirts came back from the printer the "a" had mistakenly been omitted.

decades, going back to his days at Effetre International on Murano where he was the director of design as well as resident *maestro*. It has become a Lino Tagliapietra signature and is widely copied the world over.

Another technique that Lino has embraced is referred to as "Pilchuck '96." During the summer of 1996 when Lino's brother-in-law, the famous *maestro* Checco Ongaro, returned to Pilchuck he demonstrated how to make a piece that he executed for many years while employed at the Venini factory on Murano. It was a small, leaf-shaped dish designed by the Swedish artist Tyra Lundgren for Venini in 1938. To make this piece Checco had to fashion the *filigrana* canes onto a bubble and then change the axis of the cane pattern. To make a long story short, this particular method for changing the axis was a revelation to Lino and when he saw the potential of using it in his work he proceeded to adapt it in a new and different way. The thin, unbroken, and typically black lines that often run from top to bottom of Lino's pieces are the "Pilchuck '96" technique come to life. It is a complex and advanced practice and unique in the way Lino uses it. He has the ability to draw from memory much of what he was exposed to on Murano as well as to invent new techniques as he goes along. The innovation of the "Pilchuck '96" is a stellar example of the interpretive ability that has become a hallmark of Lino's style. He is thinking about these things all the time.

For all of the ability that Lino possesses in his hands, he holds an equal, if not greater, amount of knowledge about glass in terms of its history and the composition of the material itself. In the early 1970s, American Studio Glass artists were introduced to commercially available colored glasses, mostly produced in Germany by Klaus Kugler. For the first time we had a broad palette of colors to work with—numbering around two hundred. This took the chemistry out of the equation and let people focus on ideas, rather than how to melt their own colors. Almost everyone embraced these bars of densely colored glass and used them in a wide variety of ways, and we still do. Not too many people practice the art of melting their own color. Lino, however, chooses to do so and he fabricates almost all the colors that you see in his work. He says that he prefers the colors that were developed on Murano and he's continuing to refine them here in the States. He thinks they are "softer, more human, more . . . Venetian" than the readymade ones, which are now manufactured by four or five companies internationally. By making the colors himself he maintains control over the hues in a way that very few others can.

Having this ability, this depth of knowledge, is just one of the many ways that Lino is, I believe, more complete than any of us Studio Glass artists can ever hope to be. For all the experimentation, practicing, and innovation of techniques that we do as individuals, and no matter how well we get our fingers to work the glass, there is no way that we'll be able to catch up in terms of insight and inherent resources. Lino's understanding of the material itself, coupled with all the virtuosity of his hot glass manipulation—and, above all else, his creativity—makes him not just exceptional, but truly unique. There is not a single day in the studio that I do not think to myself, "How would Lino do it?"

DANTE MARIONI was born in California and comes from a family of artists. He began blowing glass in 1979 at age fifteen. Over many years of practice and learning from Lino and other artists, Dante Marioni has become one of the most accomplished glassblowers in the United States. He teaches and exhibits his work worldwide and lives in Seattle with his wife Alison and son Lino.

PLATES

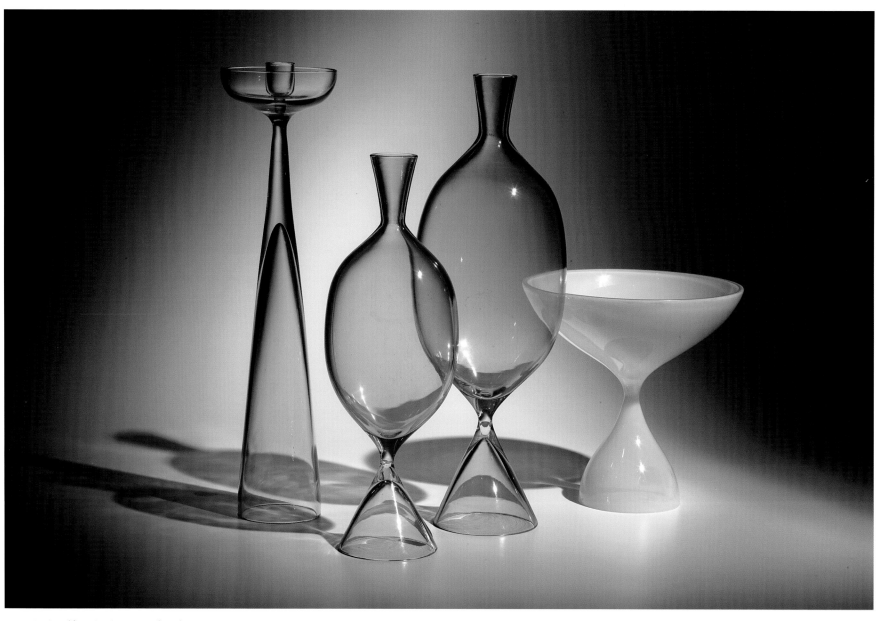

PL. 1. Designed by Giorgio Ferro and made
by Lino Tagliapietra, Candlestick, two Flask
Vessels, Chalice, 1960 (CAT. 1)

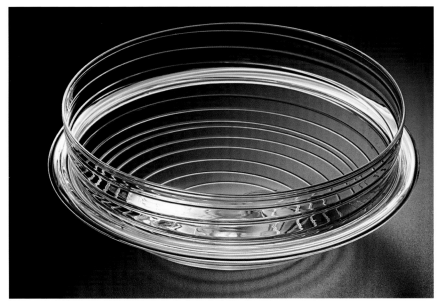

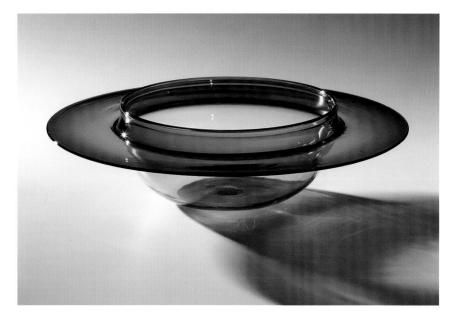

PL. 2. "Roman Technique" Bowl, 1969
A variation of the ancient method used to make
this early piece was used for the *Saturneo* design.
(CAT. 3)

PL. 3. *Saturneo*, 1969 (CAT. 2)

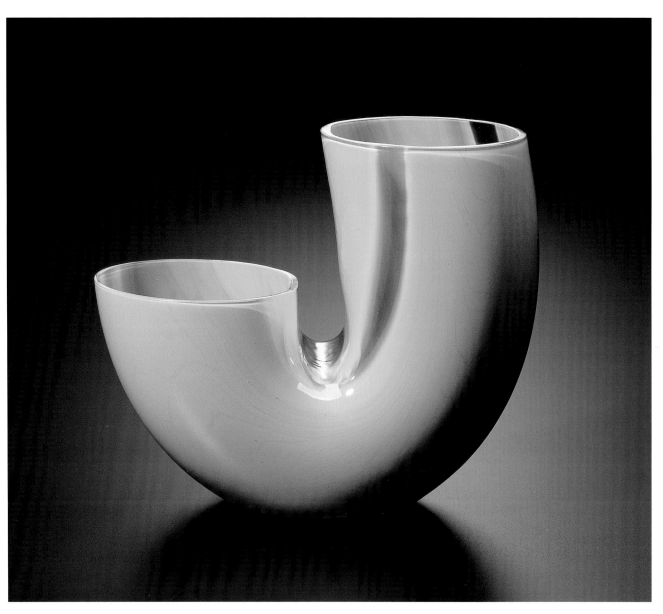

PL. 4. Vessel, around 1970 (CAT. 5)

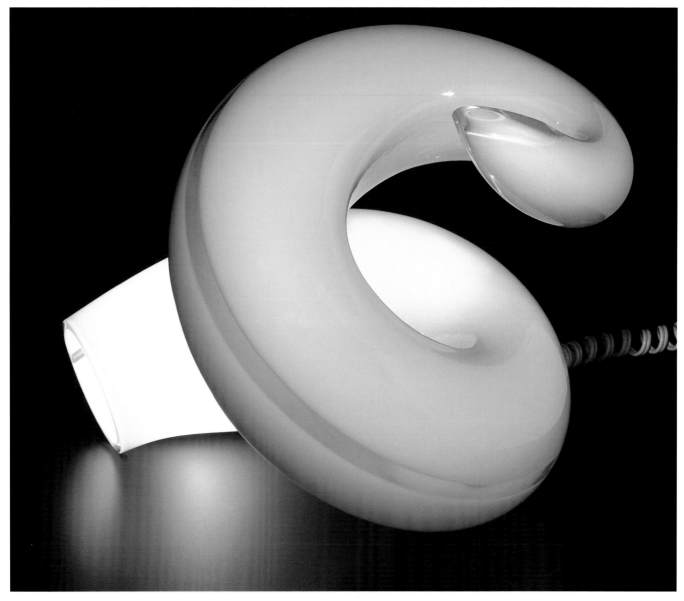

PL. 5. *Varigola* Lamp, 1970 (CAT. 6)
While the glass was still hot, the stripe was "scraped"
through the white to reveal the clear glass underneath.

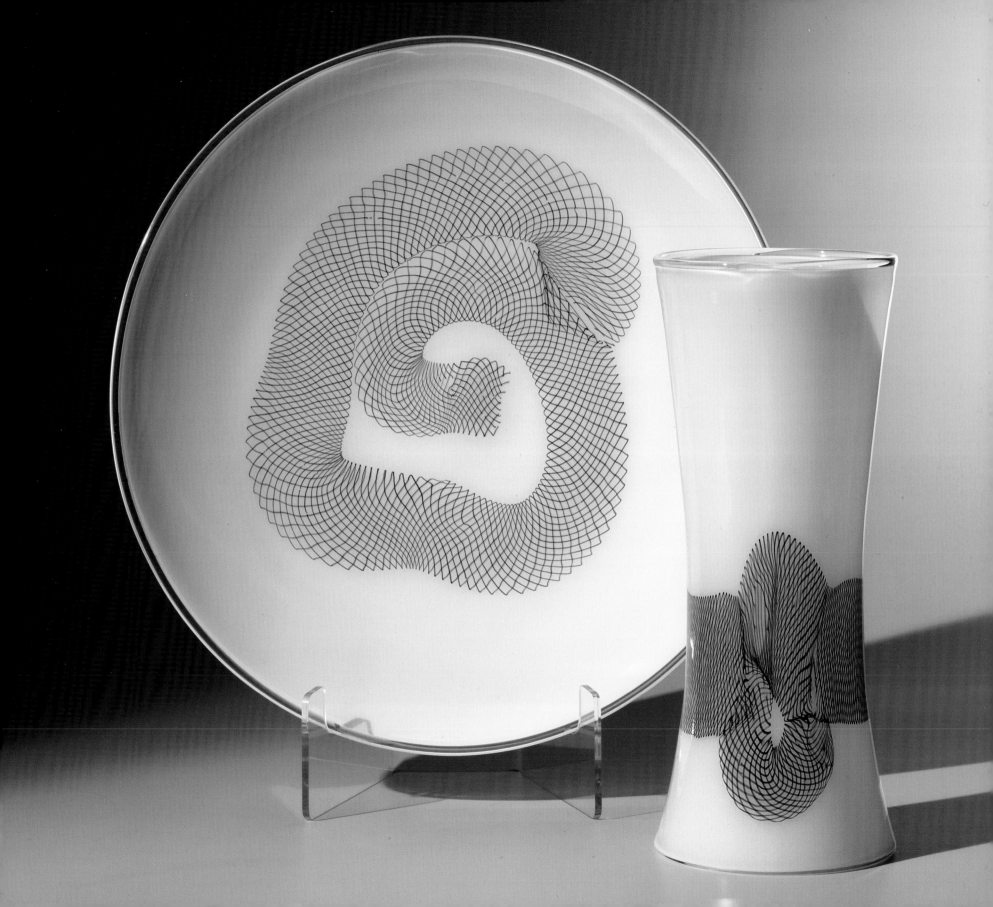

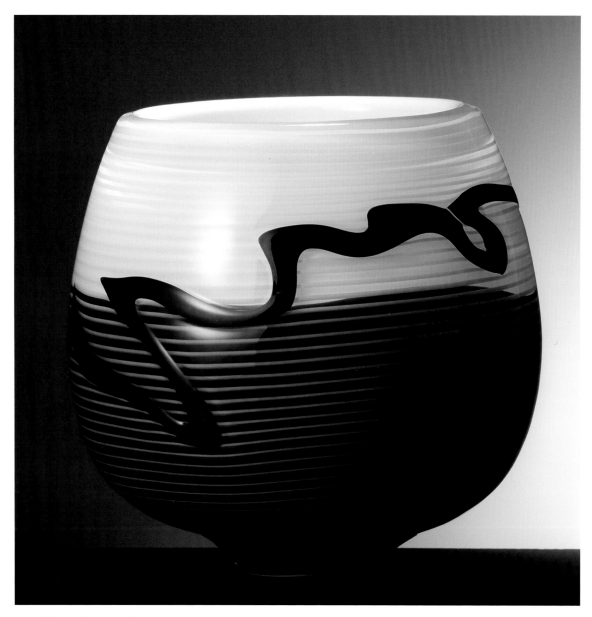

PL. 8. Lino Tagliapietra and A. D. Copier,
Vessel, 1981 (CAT. 9)

Opposite: PL. 9. Lino Tagliapietra and
A. D. Copier, Vessel, 1981 (CAT. 10)
This piece was made during the third and last
session of the Scuola Internazionale del Vetro
(International School of Glass), Murano, as was
the similar one with the heavy dark trailing.

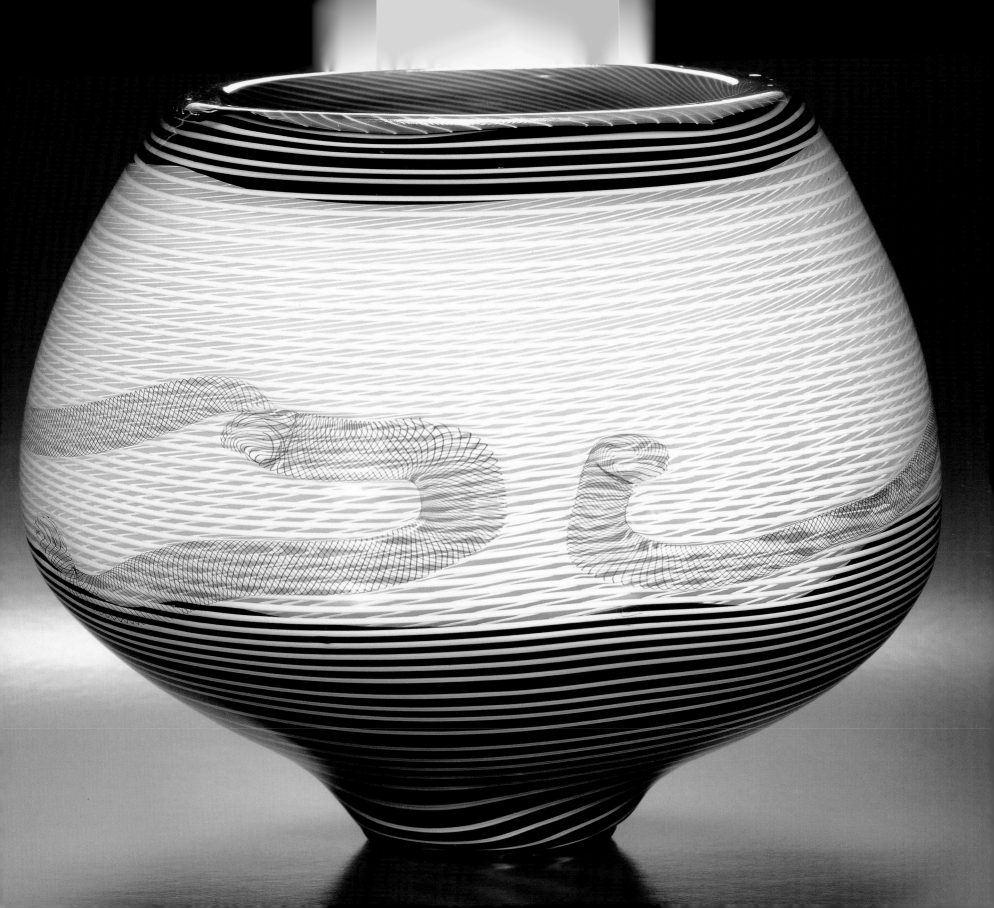

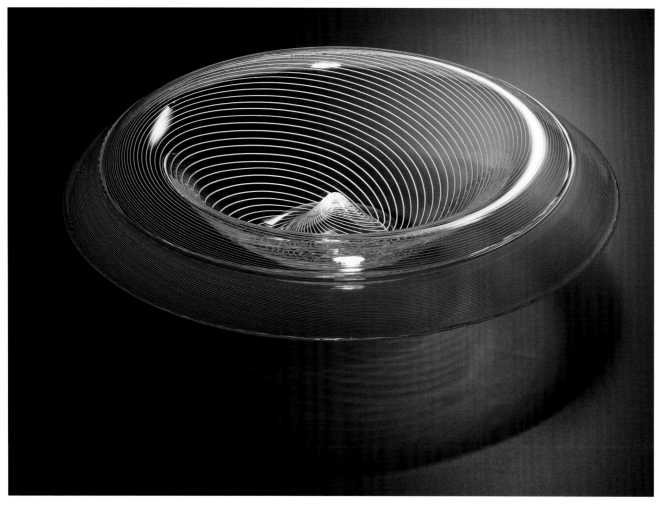

PL. 10. Lino Tagliapietra and A. D. Copier,
Low Bowl, around 1981 (CAT. 11)

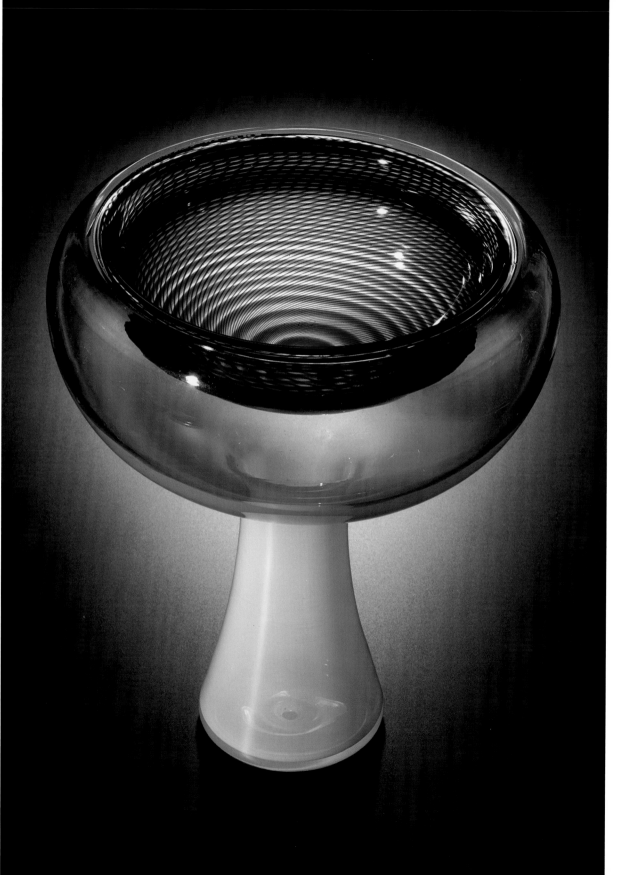

PL. 11. Lino Tagliapietra and
A. D. Copier, Footed Vessel,
1981 (CAT. 12)

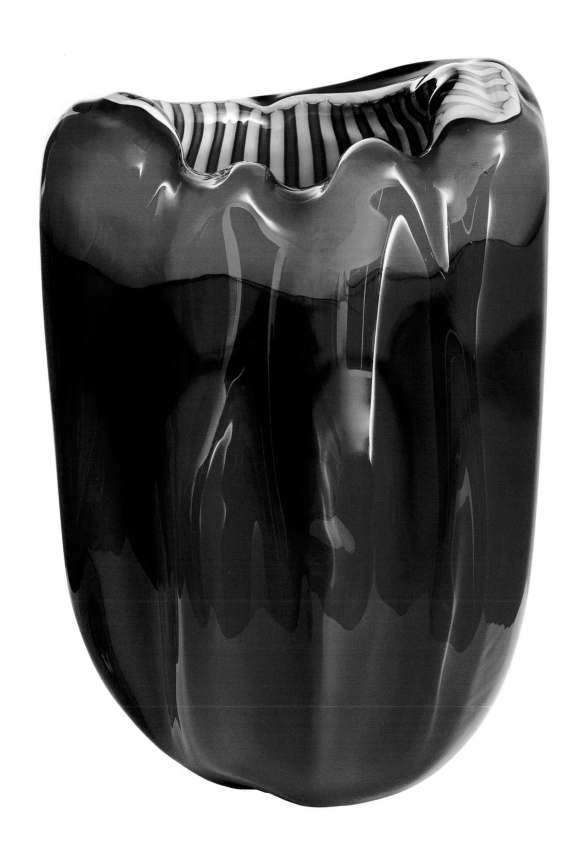

PL 12. Lino Tagliapietra and
A. D. Copier, Vessel, 1984
(CAT. 13)

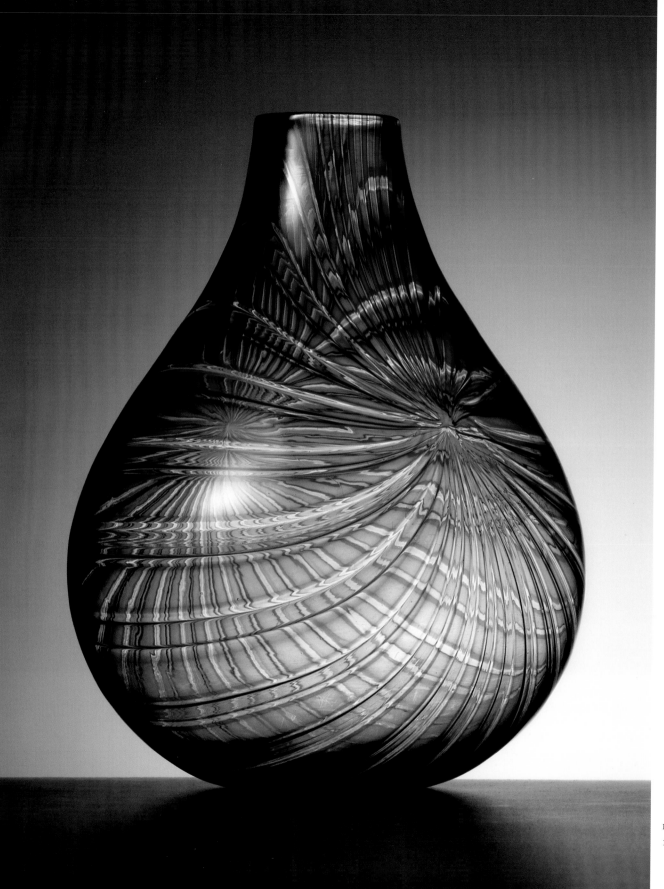

PL. 13. *Samarcanda* Vessel, 1981 (CAT. 14)

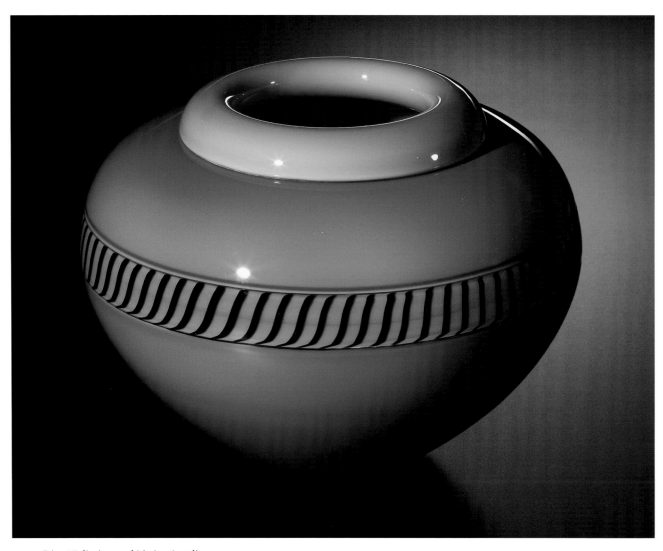

PL. 14. Lino Tagliapietra and Marina Angelin,
Vessel, 1983–1984 (CAT. 23)

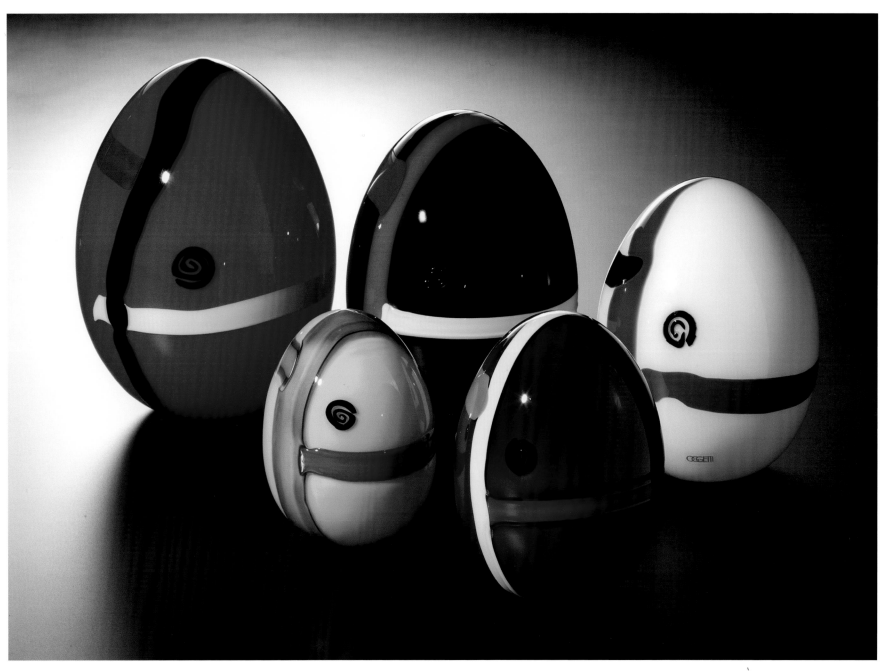

PL. 15. Lino Tagliapietra and Marina Angelin,
Five *Eggs*, around 1982 (CAT. 15–19)
The series of five eggs in bold colors was produced for
distribution by the American firm, Oggetti. This edition
was soon followed by a second one in pastel colors.

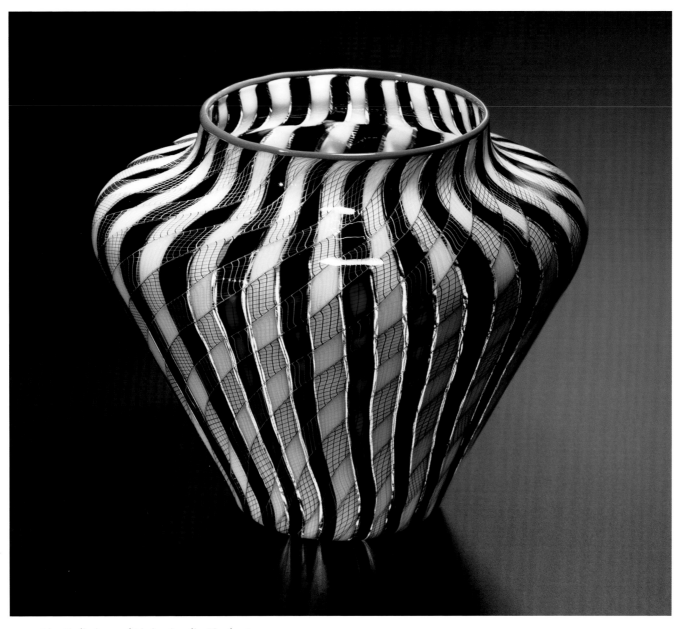

PL. 17. Lino Tagliapietra and Marina Angelin, Vessel, 1983
(CAT. 22, DETAIL, PL. 16)

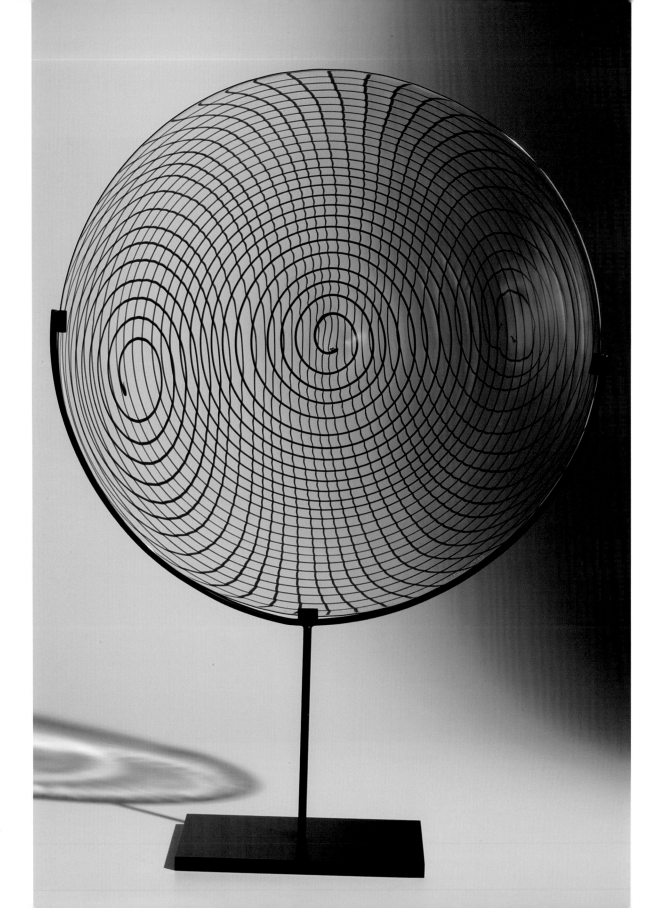

PL. 18. Lino Tagliapietra and
Marina Angelin, *Terra Aperta*
Plate, 1982 (CAT. 20)

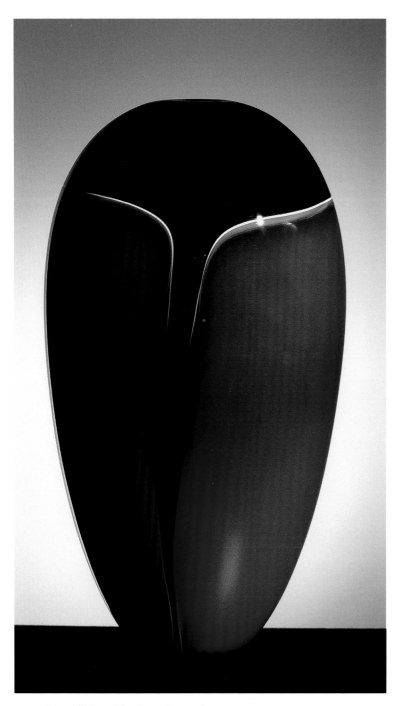

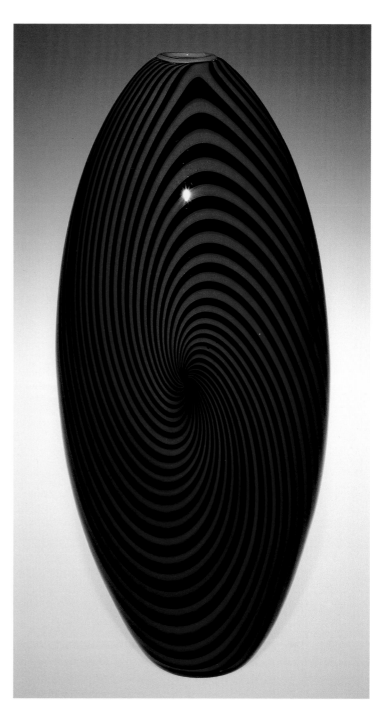

PL. 19. *Noce dell'Amore* Vessel, 1983 (CAT. 21)

PL. 20. Lino Tagliapietra and Marina Angelin, *Psycho* Vessel, designed in 1983, dated 1984 (CAT. 24)

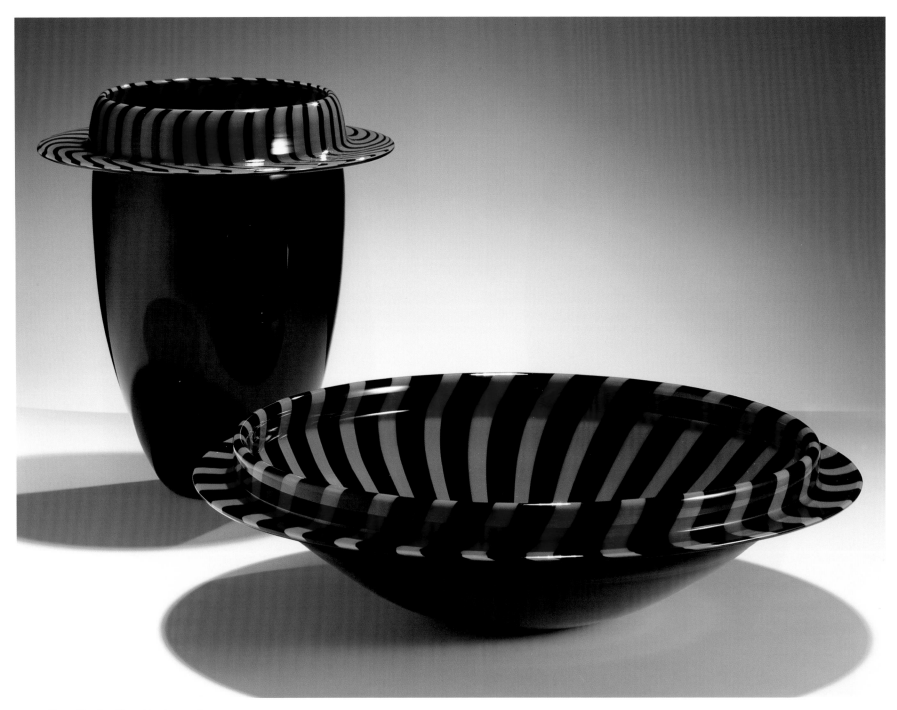

PL. 21. *Kratos* Vessel and Low Bowl, around 1984

(CAT. 28, 27)

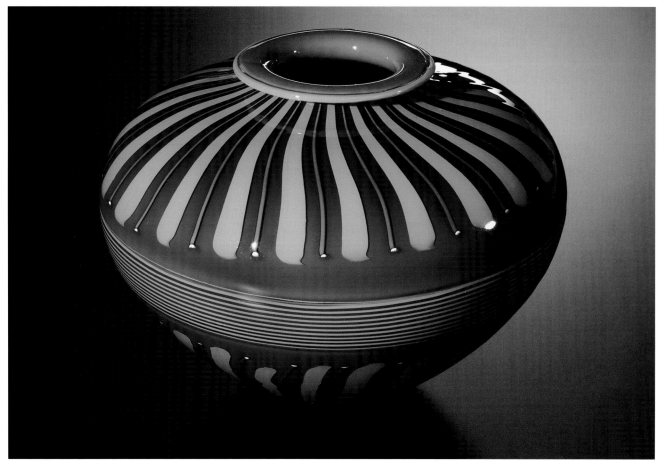

PL. 22. Lino Tagliapietra and Marina Angelin,
Pueblo Vessel, 1985 (CAT. 30)
Production of this series was limited due to the
color instability of the brown glass.

Following pages:
PL. 23. *Teodorico* Platter, 1985 (CAT. 29)
Although this design was included in the Effetre
International production catalogue, only around
five examples were produced due to the difficulty
of fabrication.

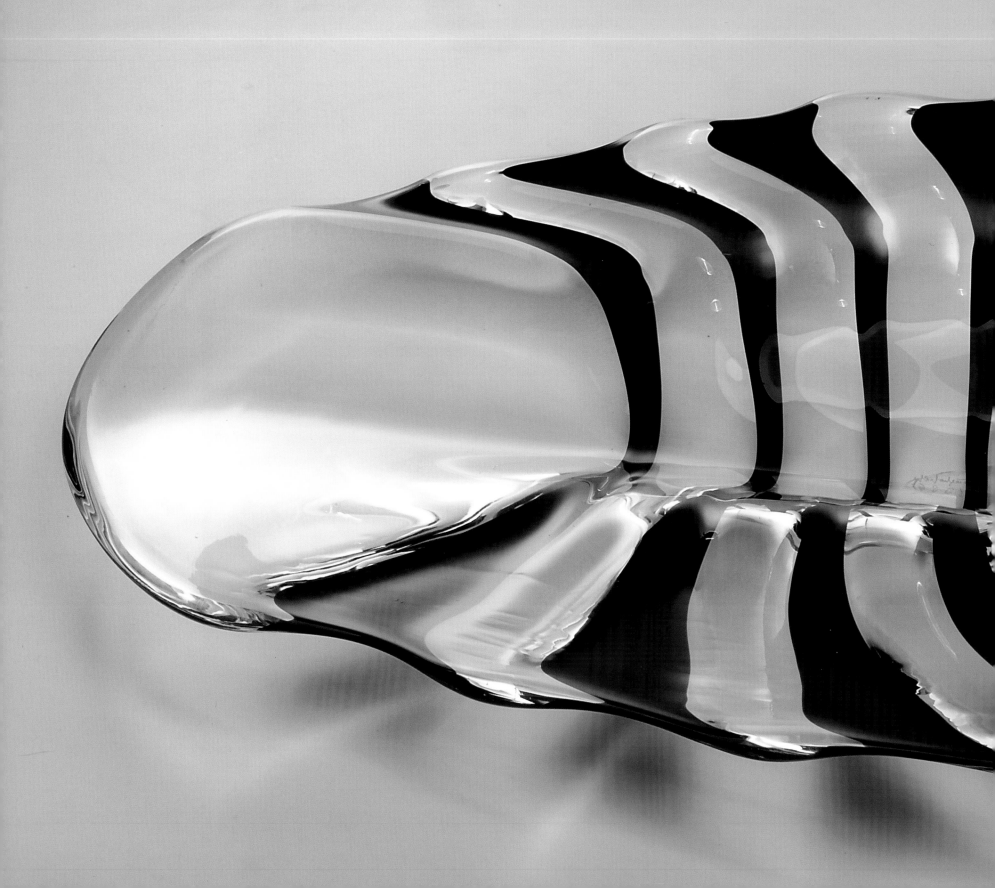

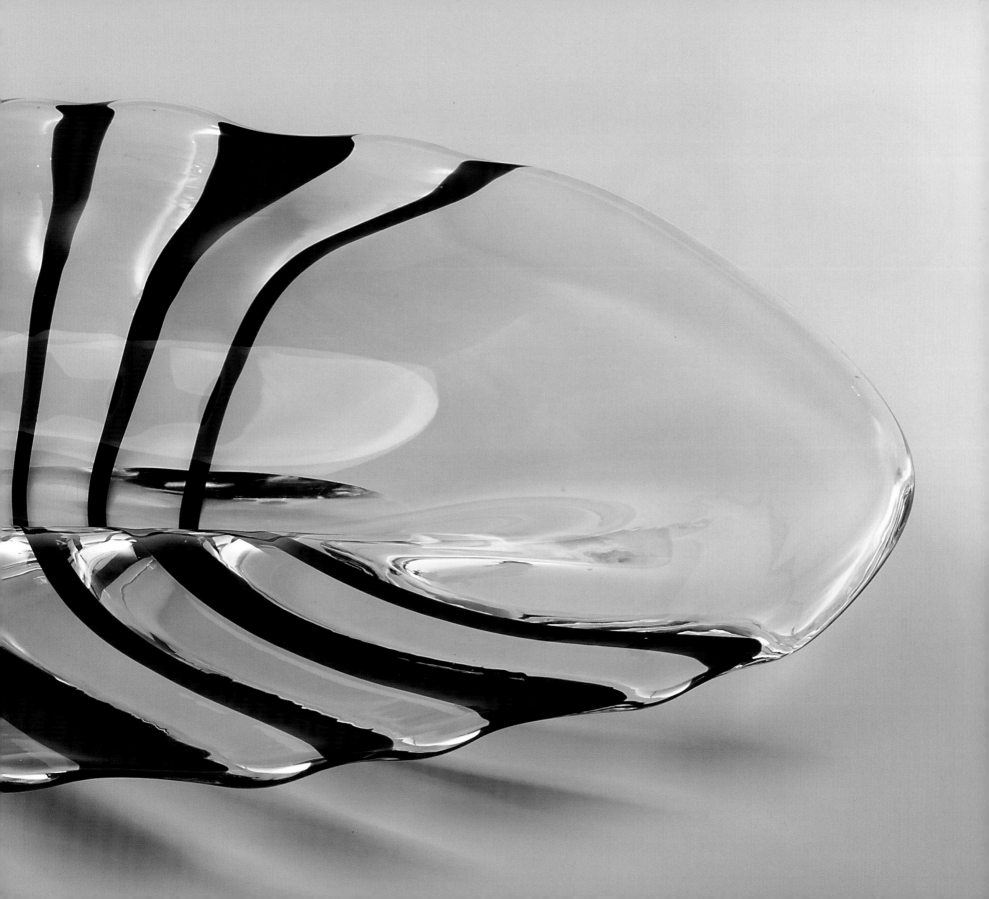

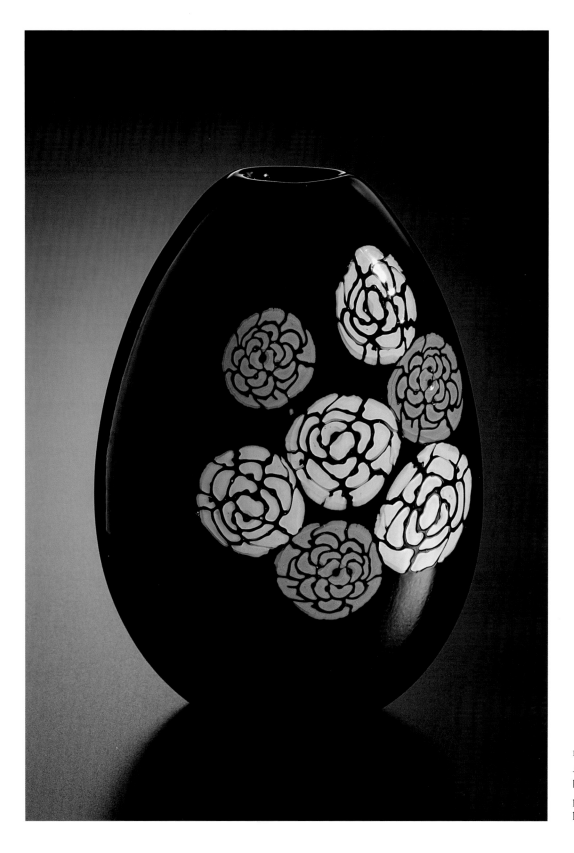

Opposite:
PL. 24. Selection of *murrine* cane slices, various dates (CAT. 32)

PL. 25. *Rosa* Vessel, 1985 (CAT. 31) A Valentino dress design admired by Lina Tagliapietra inspired this piece, which was previously published under the name of *Saigon*.

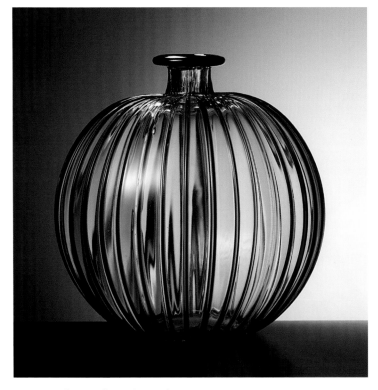

PL. 26. *Rainbow* Vessel, 1985 (CAT. 33)
The raised colored cane decoration on this piece
is a precursor of the later *Borneo* series.

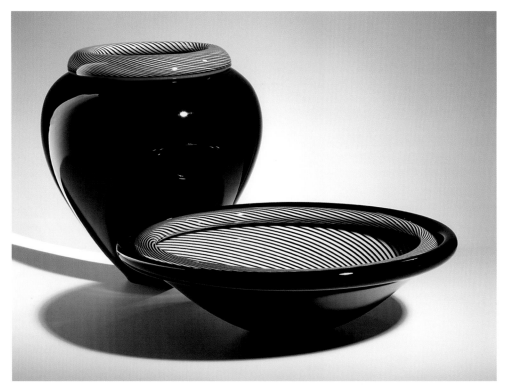

PL. 27. Vessel and Low Bowl with Hollow Folded Rims,
around 1986 (CAT. 35, 34, DETAIL, PL. 28)

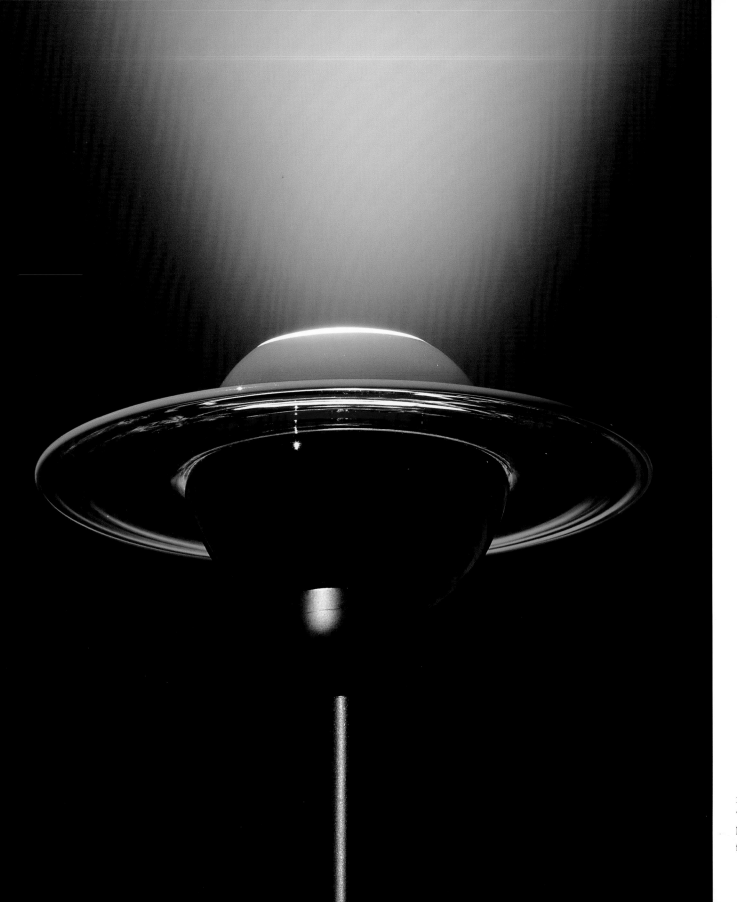

PL. 29. *Saturno* Lamp, around 1987 (CAT. 38)
This popular series of small lamps exemplifies
how Lino's signature *Saturno* design was adapted
for commercial production.

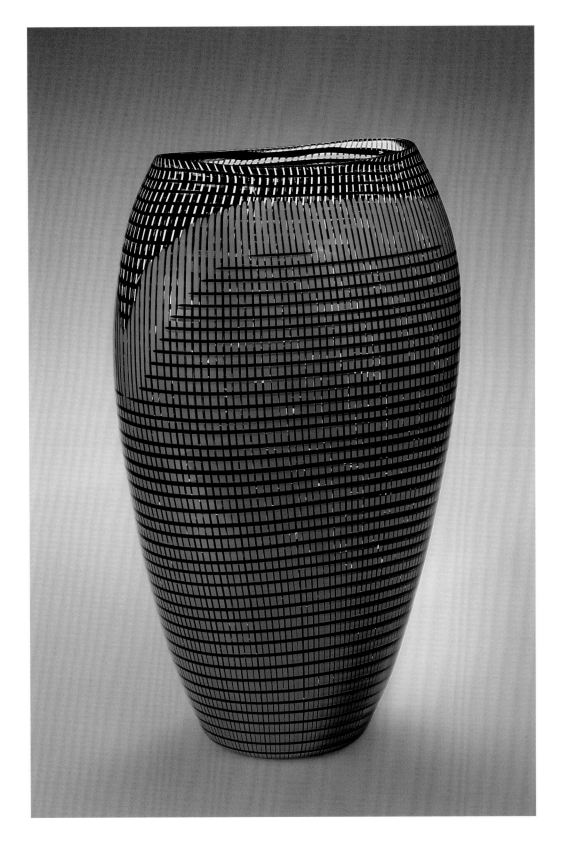

PL. 30. *Tessuto* Vessel, around 1986
(CAT. 37)

Opposite: PL. 31. *Giada* Plate, around 1986
(CAT. 36, DETAIL)

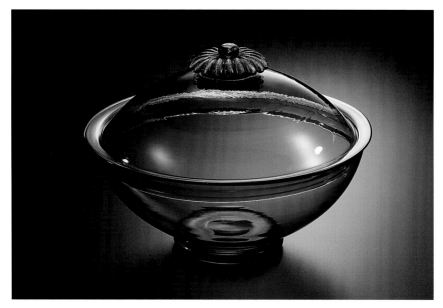

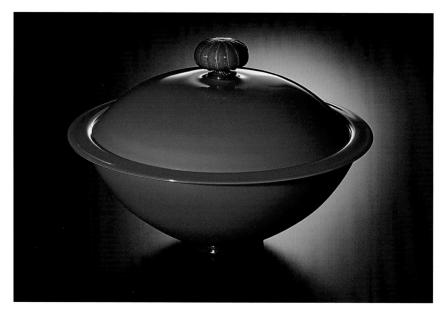

PL. 32. Covered Bowl with Artichoke Flower
Handle, around 1987 (CAT. 39)

PL. 33. Covered Bowl, around 1987 (CAT. 40)

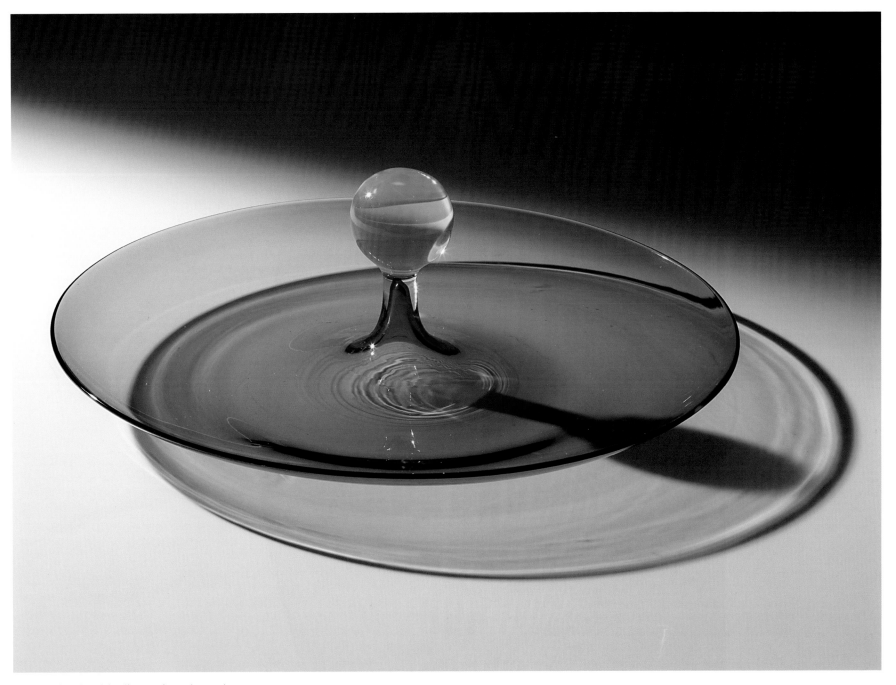

PL. 34. Dish with Solid Ball, around 1987 (CAT. 41)

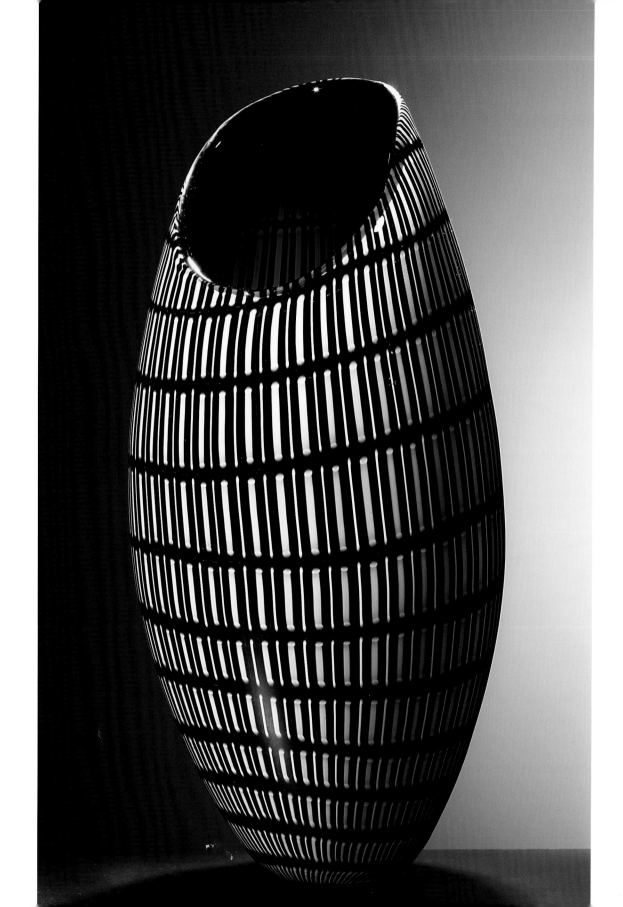

PL. 35. *Canetto* Vessel, 1988
(CAT. 42)

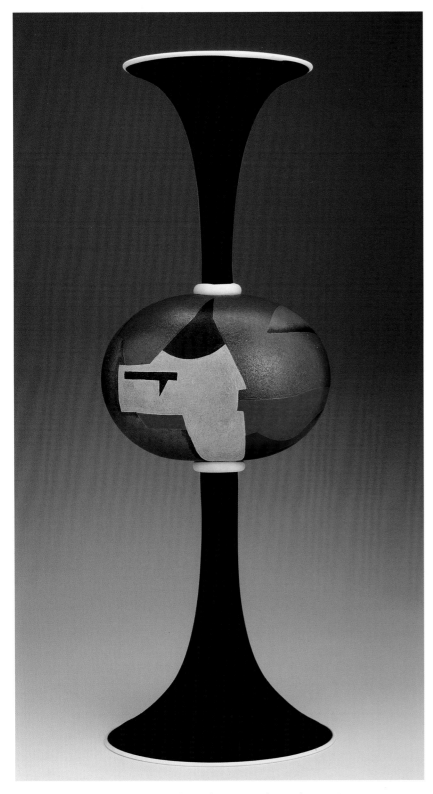

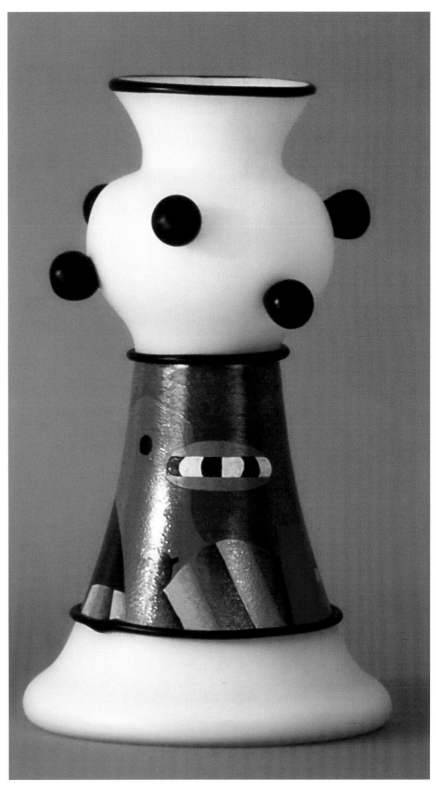

PL. 36. Lino Tagliapietra and Dan Dailey, *Viale*, 1989–1993 (CAT. 44)

PL. 37. Lino Tagliapietra and Dan Dailey, *Faro*, 1989–1993 (CAT. 45)

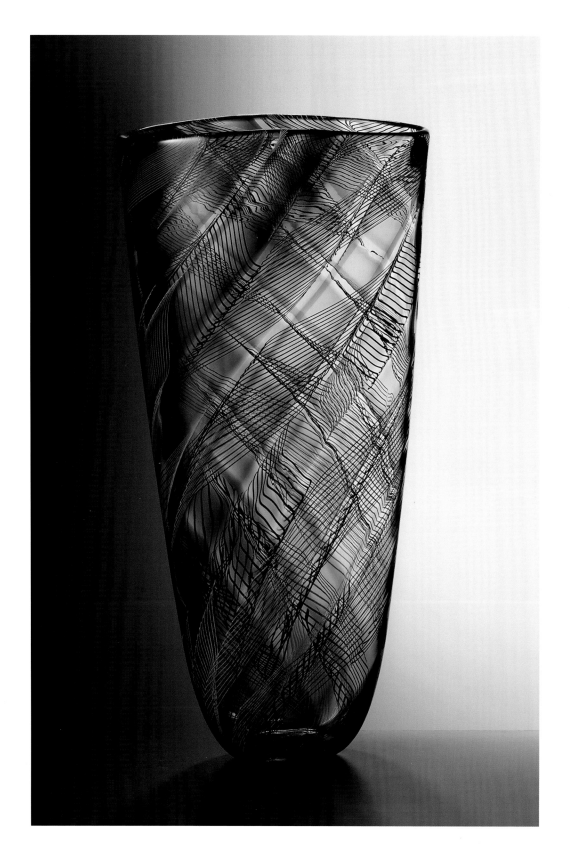

PL. 38. Vessel, 1990 (CAT. 46)
This piece was made during Lino's
residency at the Centre International
de Recherche sur le Verre et les Arts
Plastiques (CIRVA), Marseilles,
France, not long after he had fully
retired from industry.

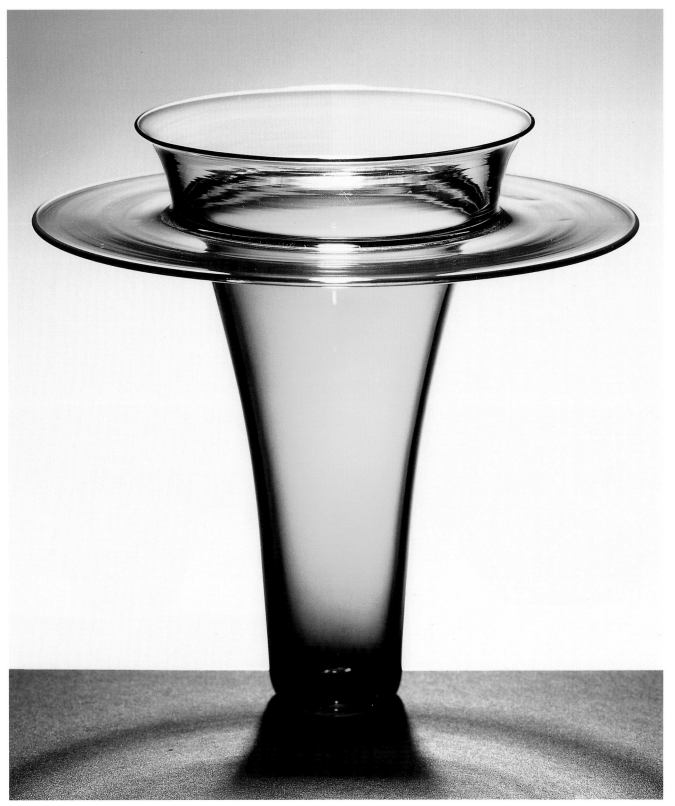

PL. 39. *Saturneo*, 1990
(CAT. 47)

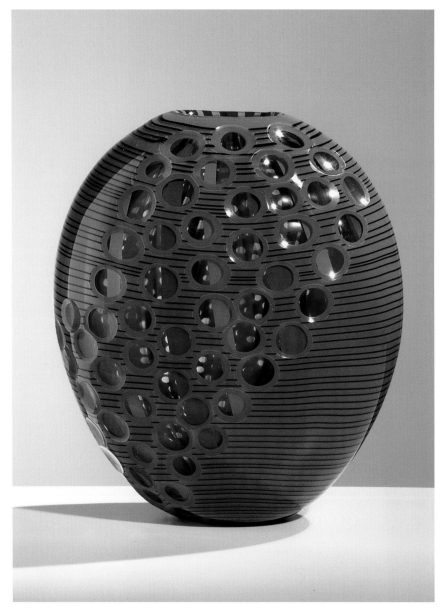

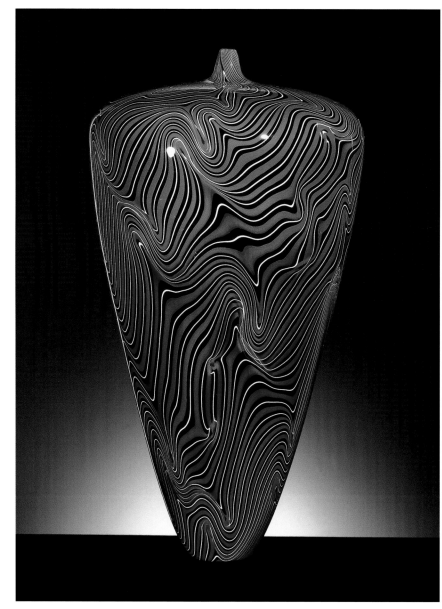

PL. 40. Red *Occhi* Vessel, 1991 (CAT. 48)

PL. 41. *Hopi*, 1993 (CAT. 50)
This early *Hopi* example was produced before
the characteristic broad shoulder and narrow
base of the series were fully exaggerated.

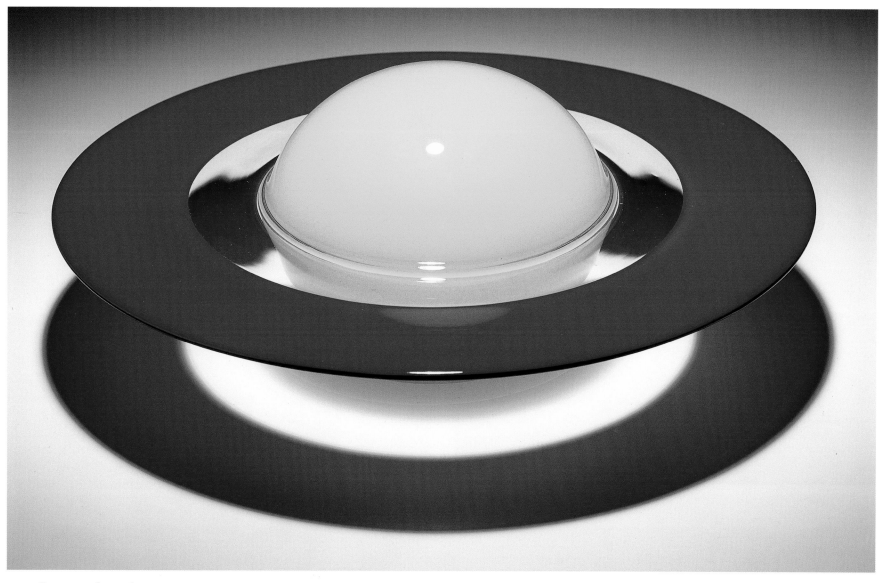

PL. 42. *Saturno*, 1993 (CAT. 49)

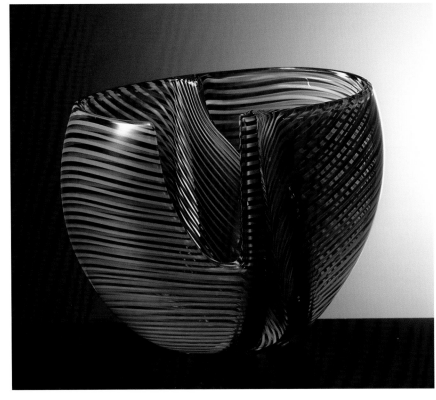

PL. 43. *Alfabeto: "E,"* 1993 (CAT. 51)
The rim of this piece forms the letter "E" in
honor of Lino Tagliapietra's late sister-in-law
Antonietta "Etta" Ferro Tagliapietra. With
three other vessels it spelled "E-T-T-A."

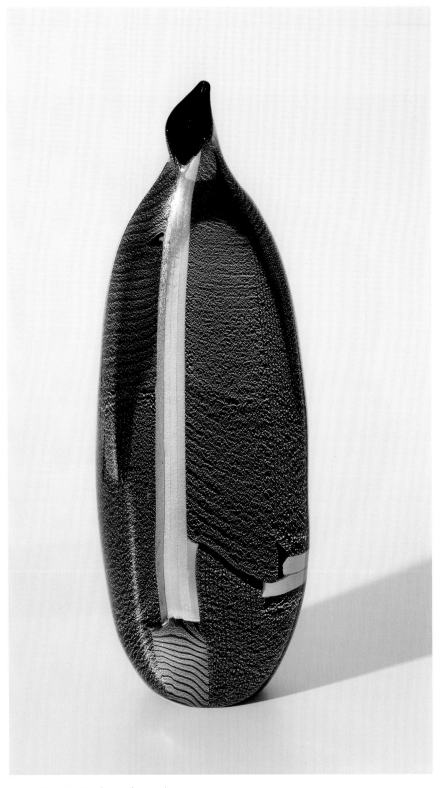

PL. 44. *Faraónico* Vessel, 1993 (CAT. 52)

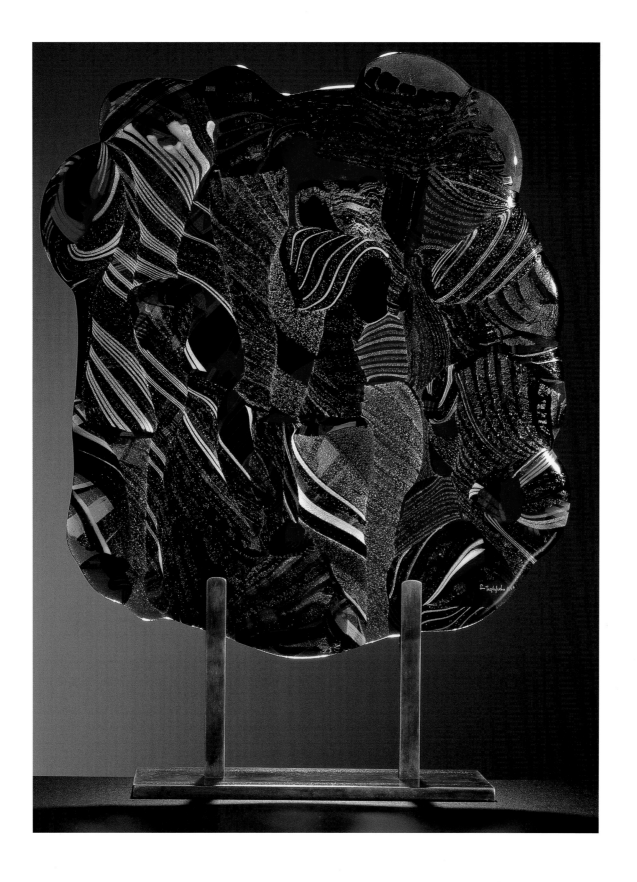

PL. 45. *Decroico* Panel, 1993 (CAT. 53)

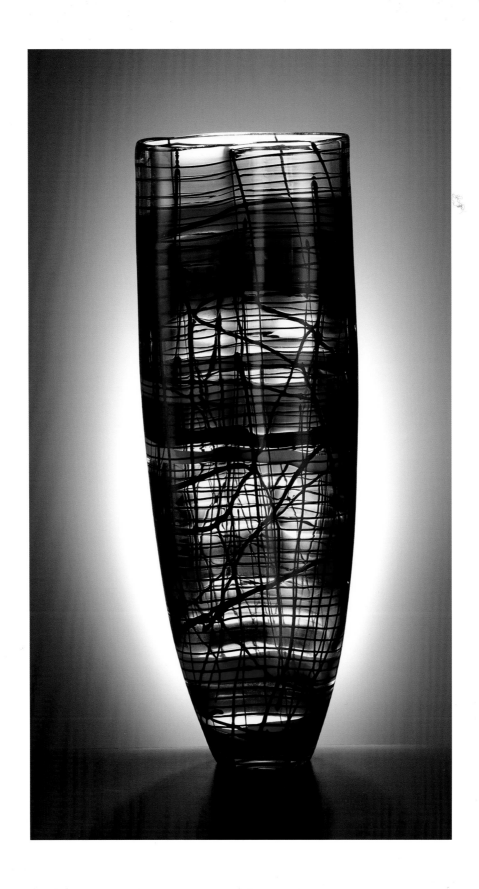

PL. 46. *Notte del Redentore* Vessel, 1995
(CAT. 54, DETAIL, PL. 47)
This piece was inspired by the spectacular
fireworks over Venice on the eve of the annual
Redentore festival. *Redentore* refers to Palladio's
magnificent church that was built in thanks for
the end of the plague of 1576.

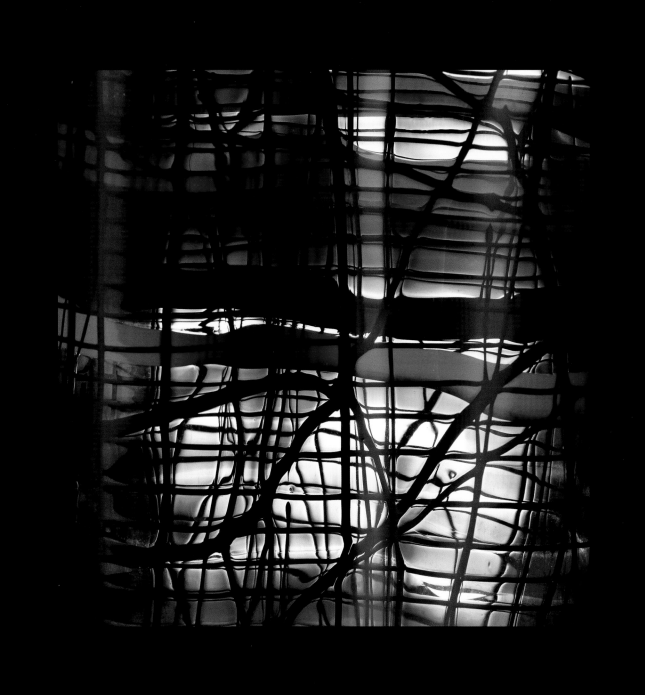

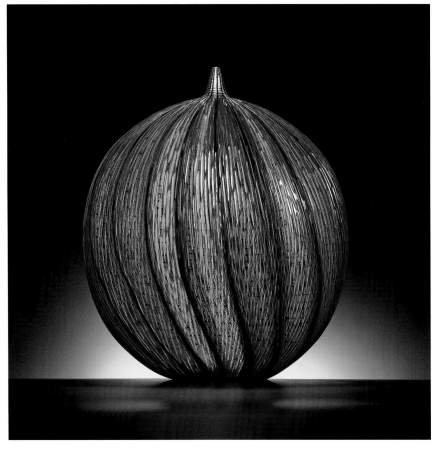

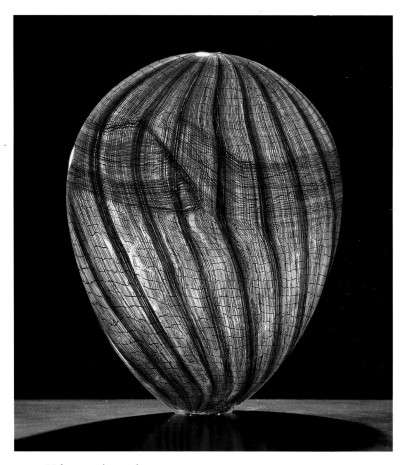

PL. 48. *Mukilteo*, 1996 (CAT. 55)

PL. 49. *Madras*, 1996 (CAT. 56)

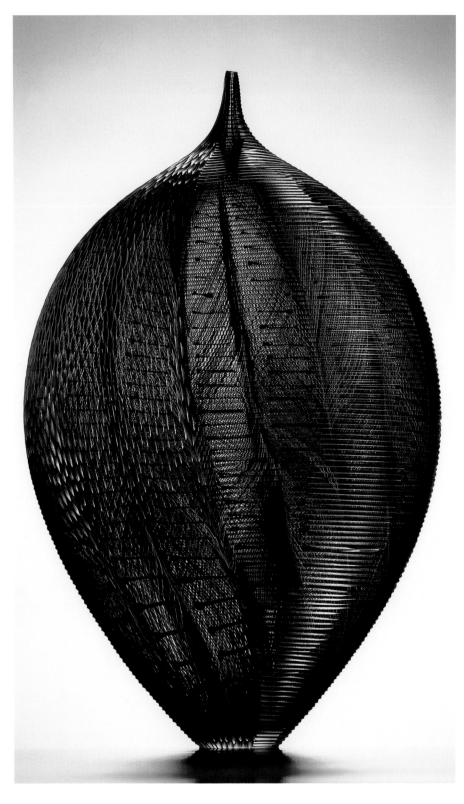

PL. 50. *Madras*, 1998 (CAT. 57)

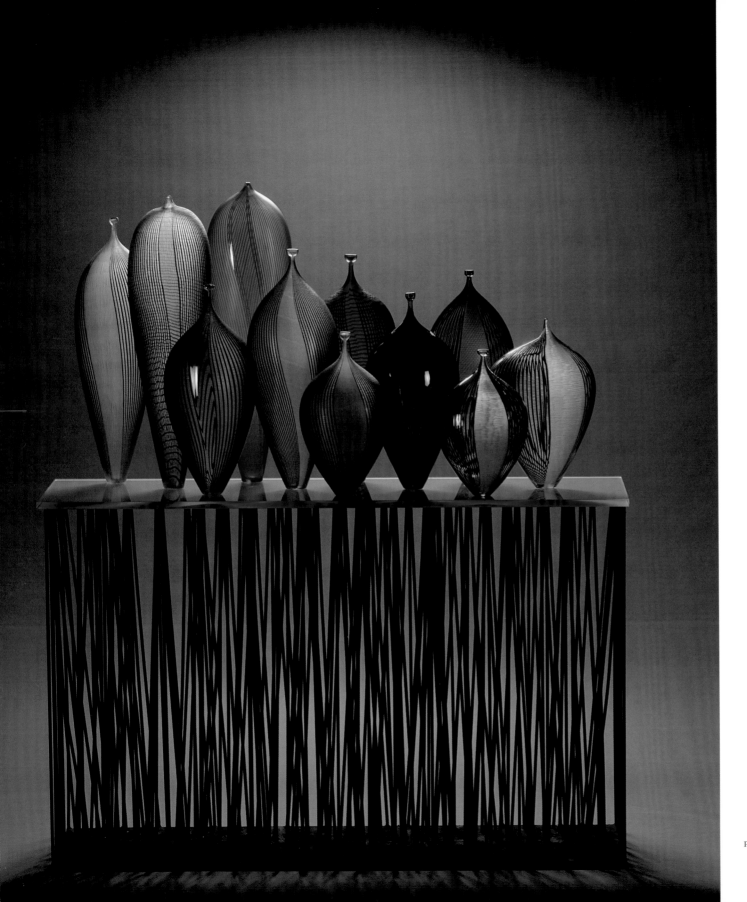

PL. 51. *Manhattan Sunset*, 1997 (CAT. 58)

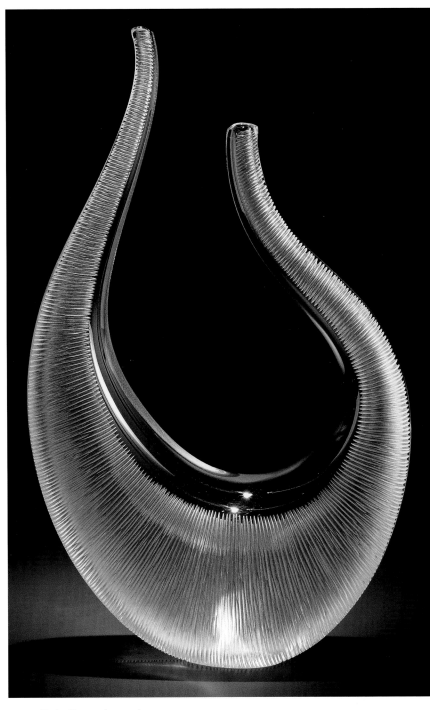

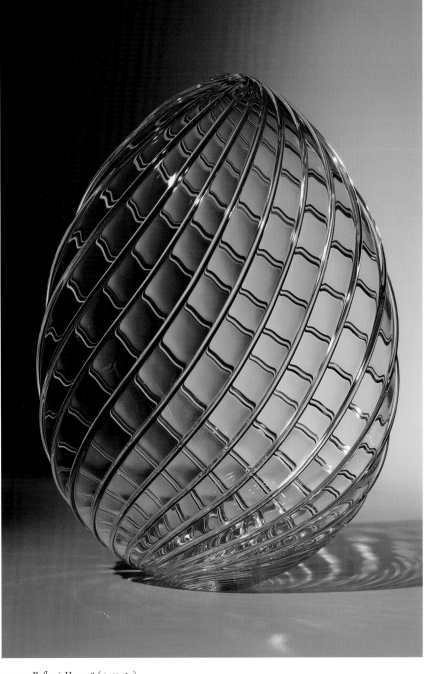

PL. 52. *Fenice II*, 1998 (CAT. 59)

PL. 53. *Reflessi II*, 1998 (CAT. 62)

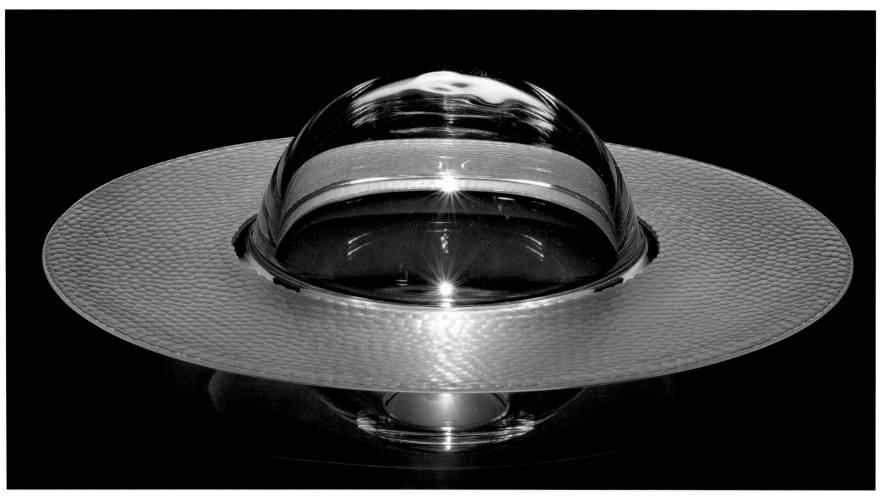

PL. 54. *Saturno*, 1998 (CAT. 60)

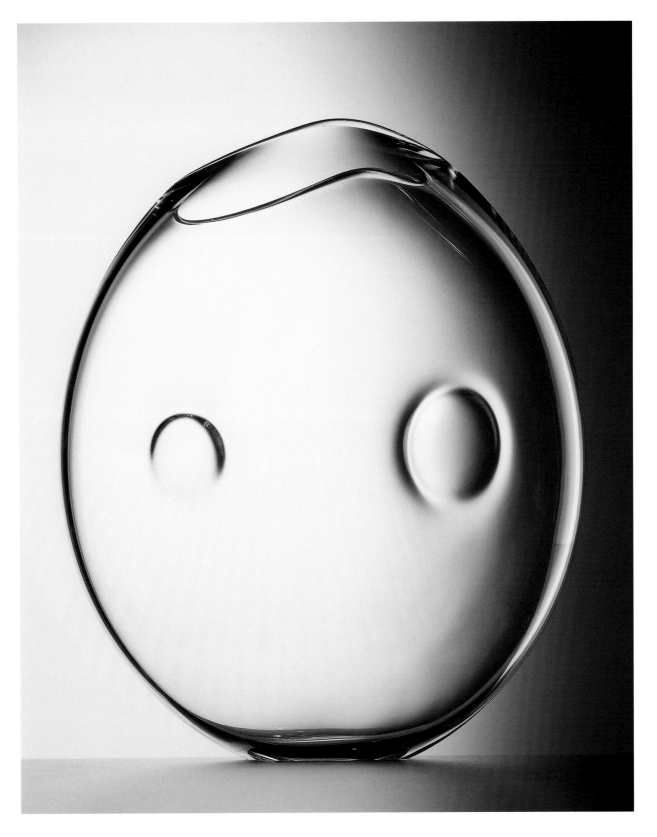

PL. 55. *Akira I*, 1998
(CAT. 61)

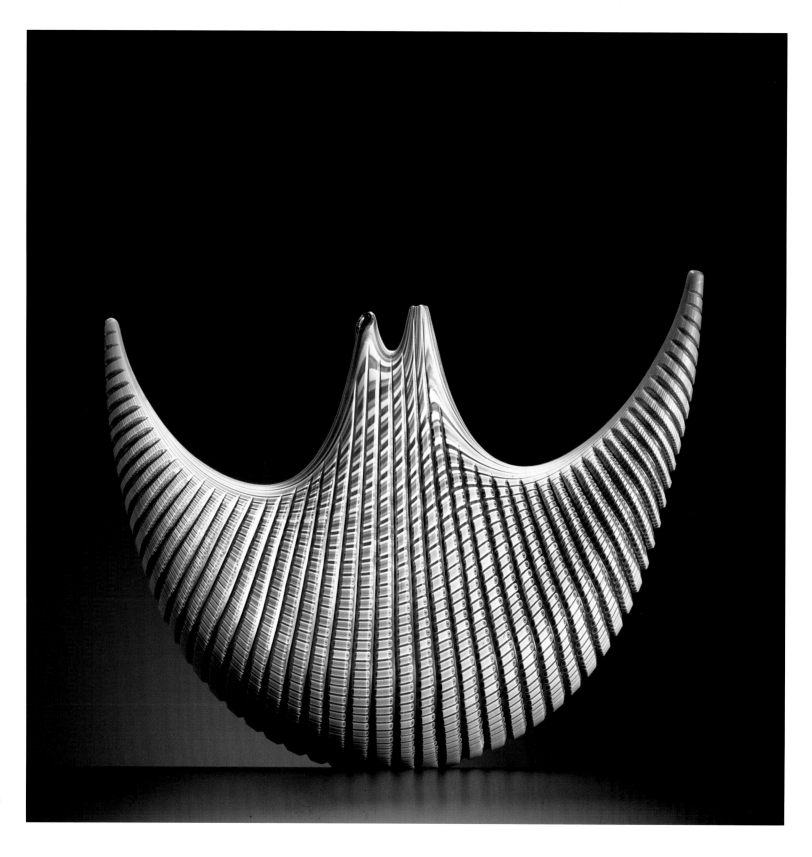

94

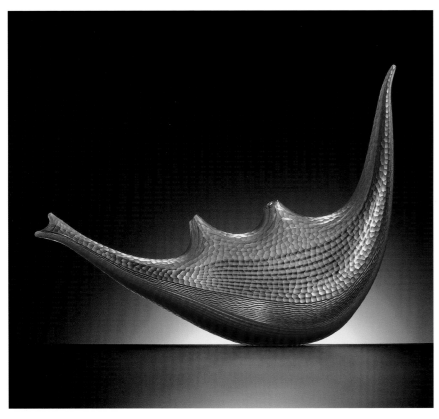

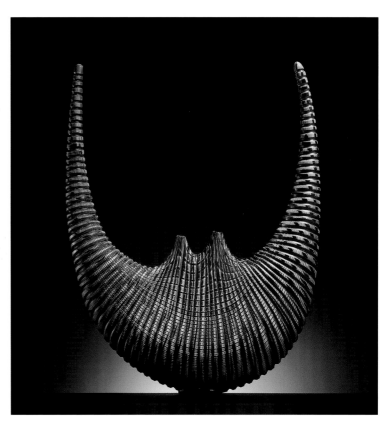

PL 57. *Batman,* 1998 (CAT. 63)

PL. 58. *Batman,* 1998 (CAT. 65)

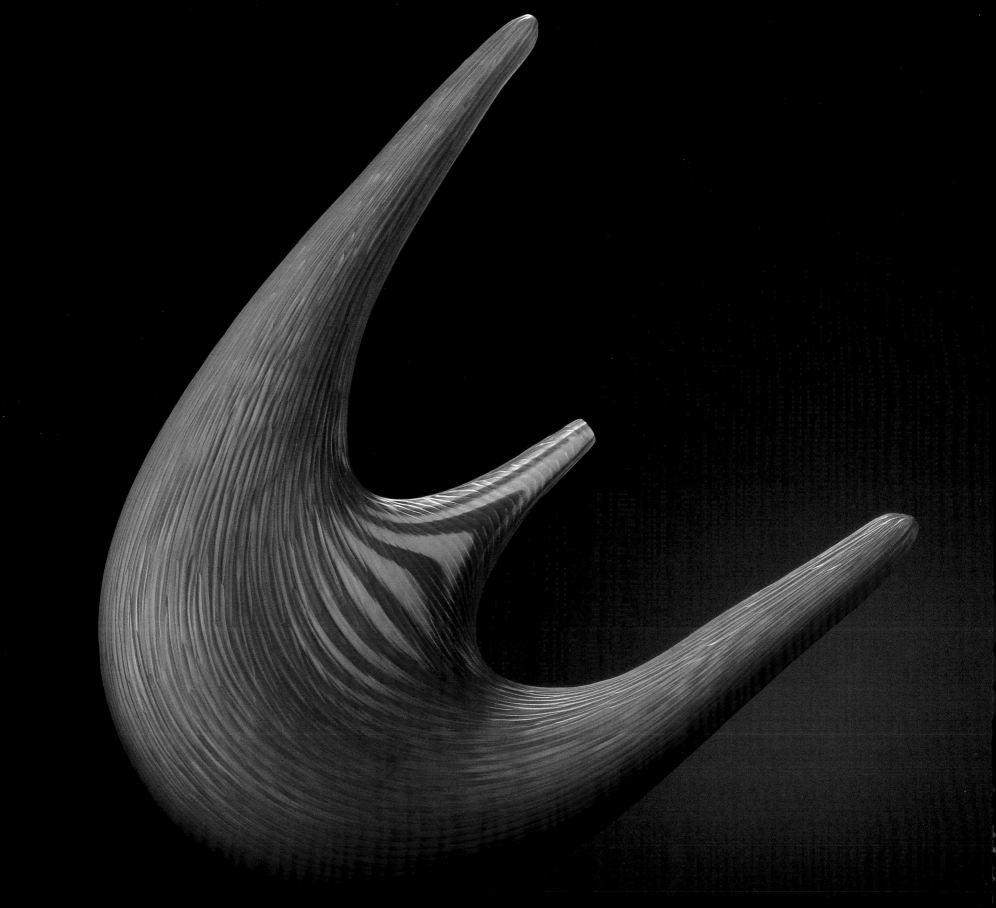

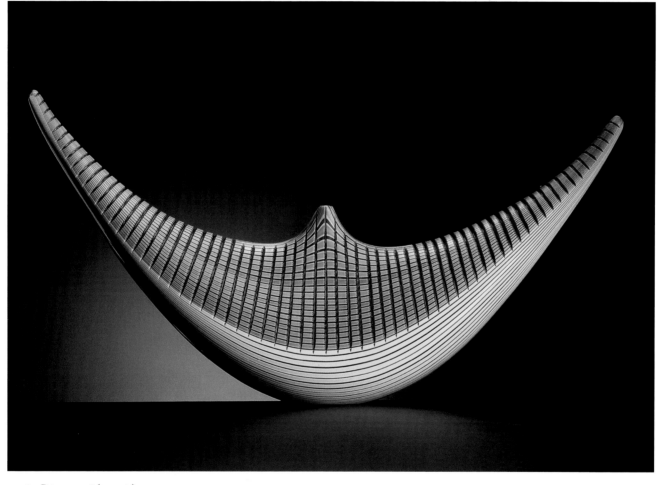

PL. 60. *Batman*, 1998 (CAT. 67)

Opposite:

PL. 59. *Batman*, 1998 (CAT. 64)

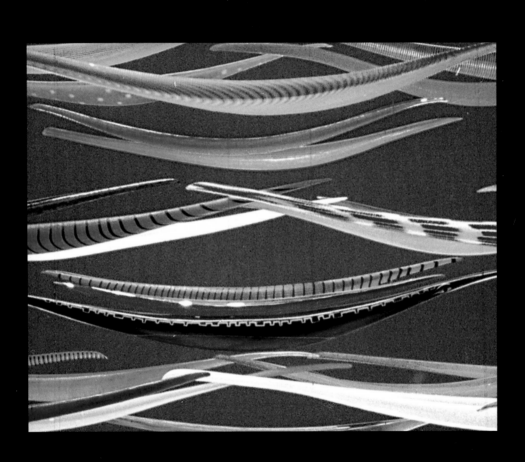

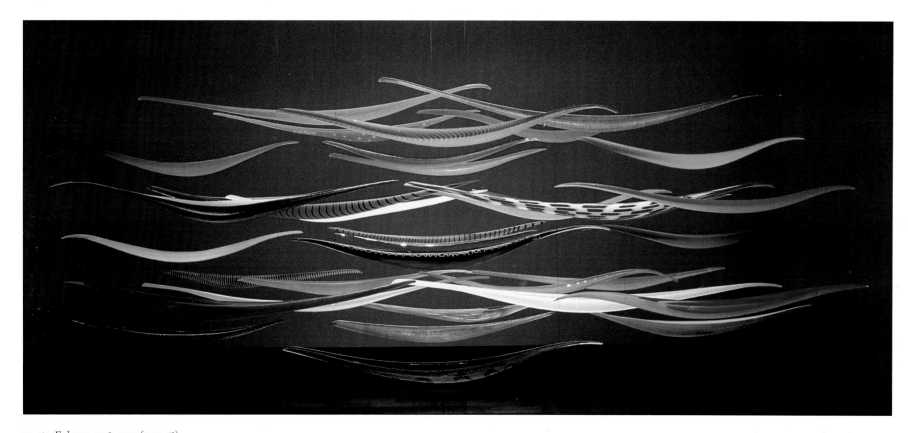

PL. 61. *Endeavor*, 1998–2003 (CAT. 68)

"I had the idea to do boats for many years. I seriously started making them in 1995. The shape is very organic. I especially liked the boats designed by the Vikings. I also like many things about the canoe, not the canoe of native North Americans, but of the people of the Amazon. It has a very simple shape and a very long point." —Lino Tagliapietra, from "Conversation" with curator Annegreth Nill, in *The Art of Lino Tagliapietra: Concerto in Glass*, Columbus Museum of Art, 2003.

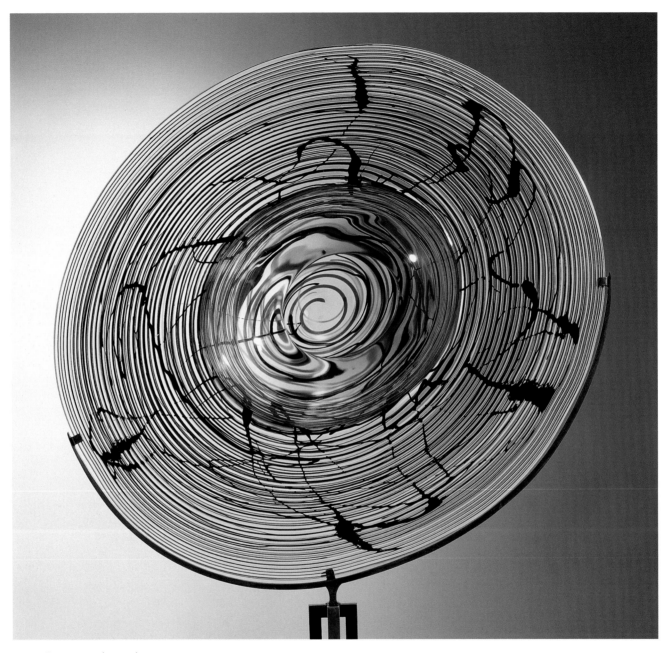

PL. 62. *Saturno*, 1998 (CAT. 70)

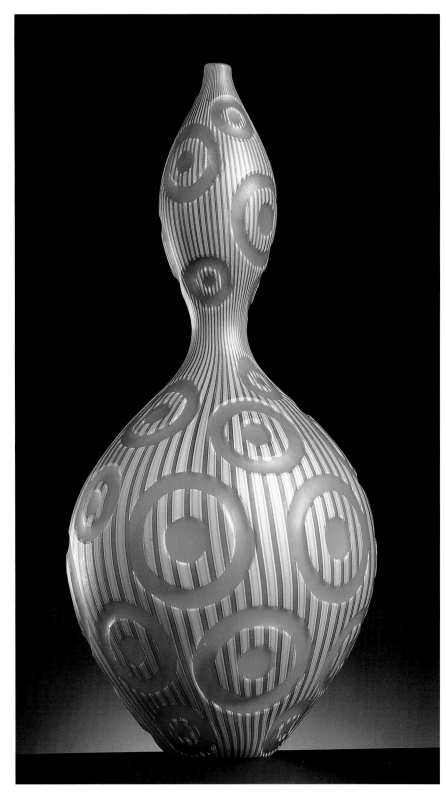

PL. 63. *Tholtico*, 1998 (CAT. 71)

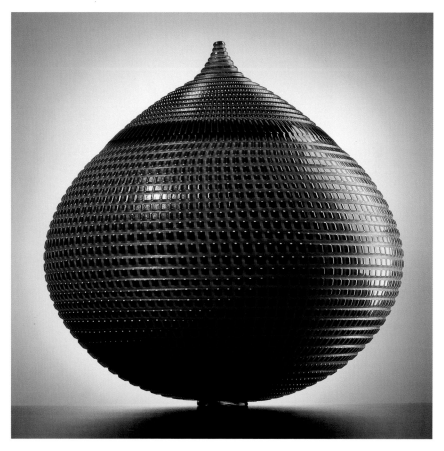

PL. 64. *Tholtico*, 1999 (CAT. 72)

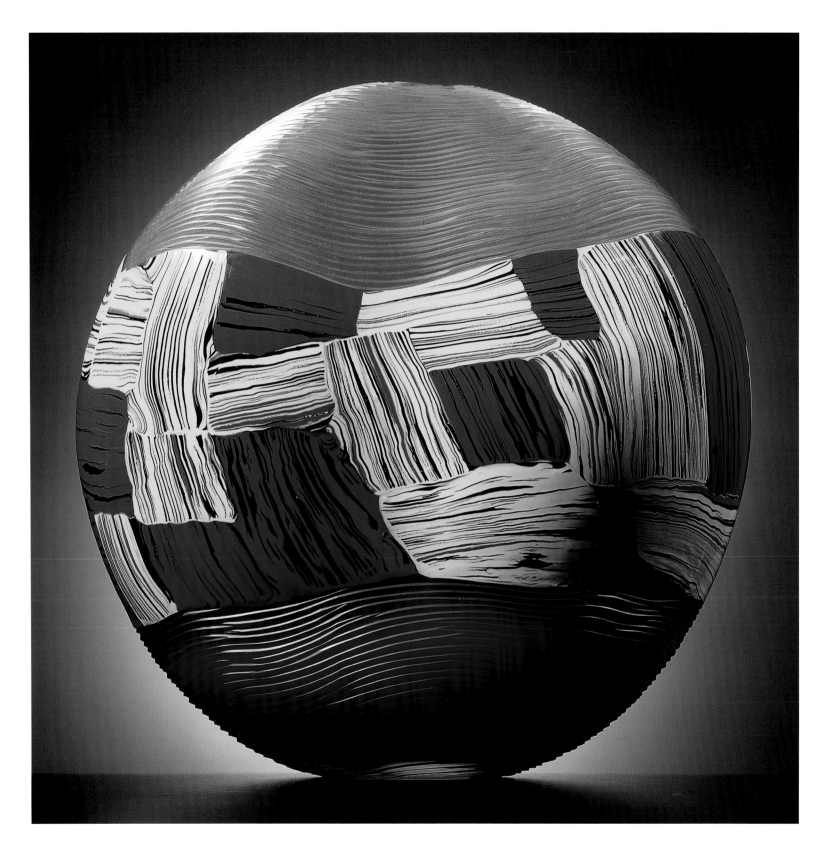

PL. 65. *Provenza*,
1999 (CAT. 73)

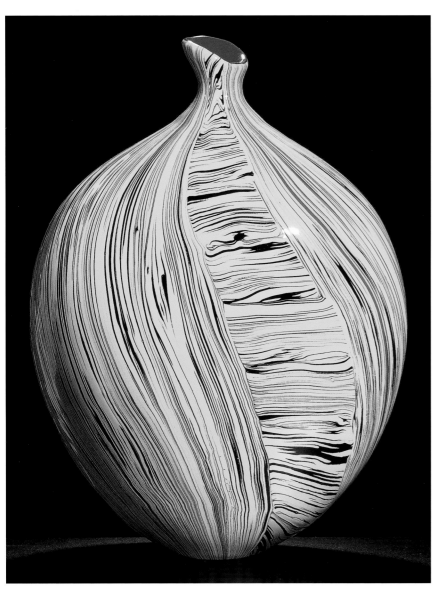

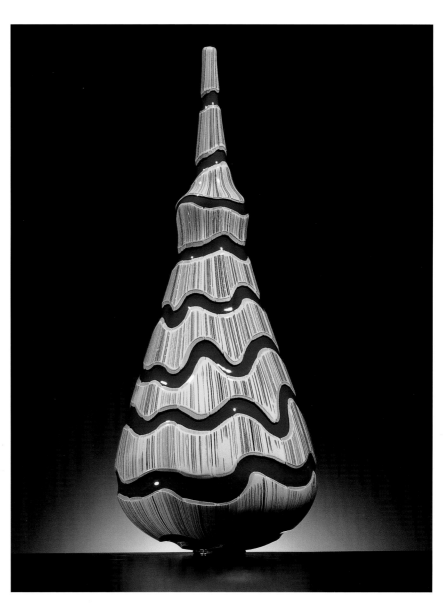

PL. 66. *Provenza,* 2000 (CAT. 74)

The appearance of the *Provenza* series was inspired
by the brushstrokes of painter Paul Cézanne.

PL. 67. *Provenza,* 2006 (CAT. 75)

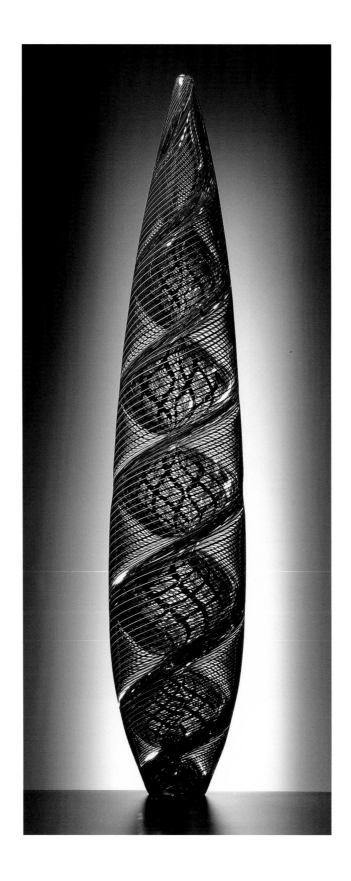

PL. 68. *Spirale*, 1999 (CAT. 76)

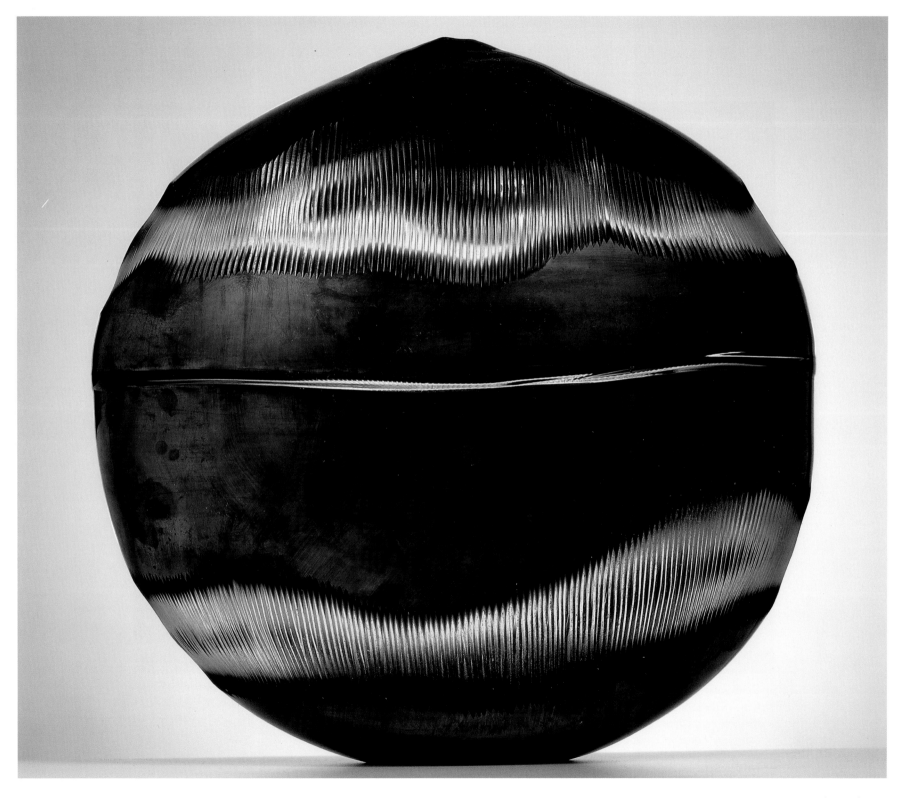

PL. 69. *Etna*, 1999 (CAT. 77)

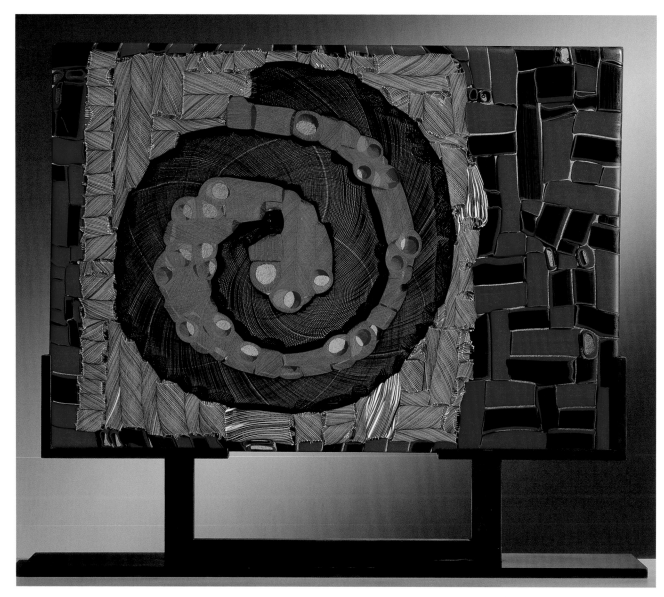

PL. 70. *Bisanzio*, 1999 (CAT. 78)
Bisanzio is the Italian translation of the Latin
word Byzantium, the ancient name for the city
now known as Istanbul. Ornate and abstracted
naturalistic forms such as this coiled snake are
often found in Byzantine art.

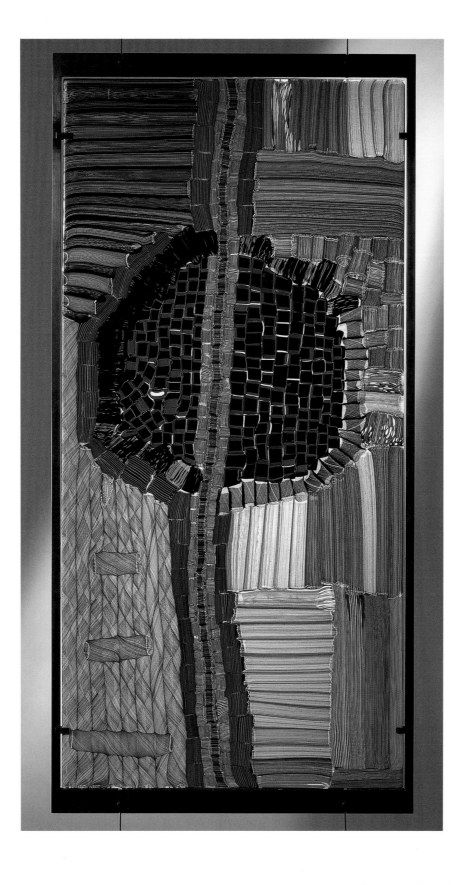

PL. 71. *George*, 1999 (CAT. 79)

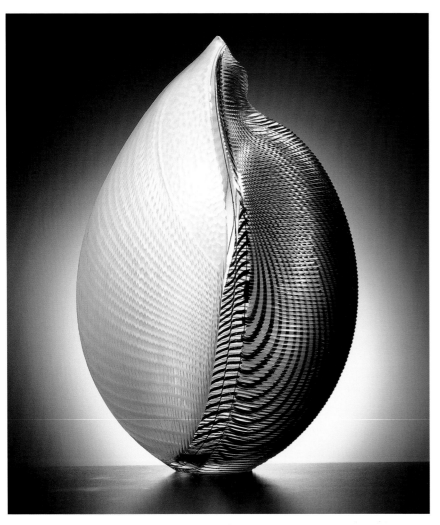

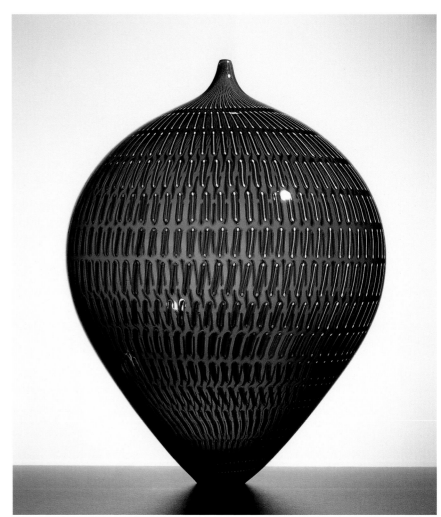

PL. 72. *Nubia*, 2000 (CAT. 81)

PL. 73. *Trullo*, 2000 (CAT. 82)

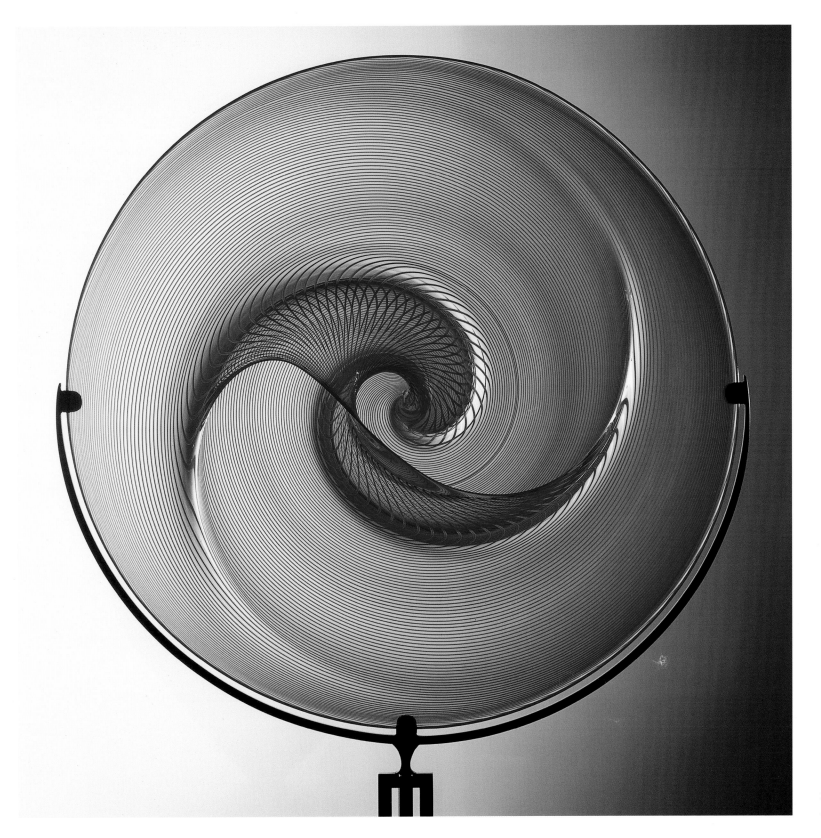

PL. 74. *Natoalos,*
2000 (CAT. 80)

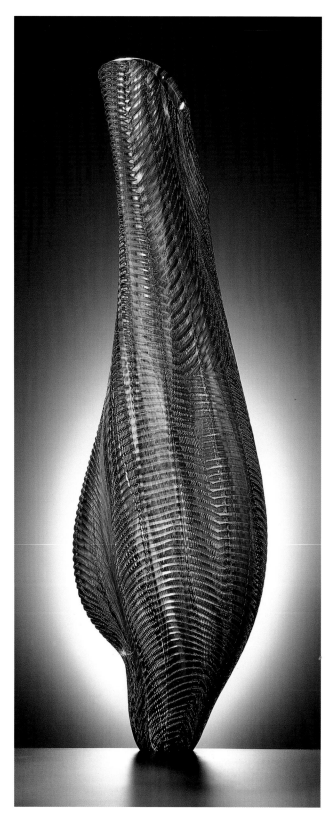

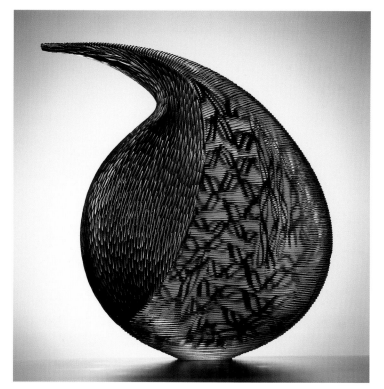

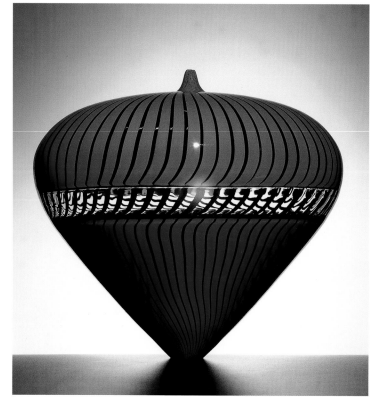

Clockwise from left:
PL. 75. *Venere in Seta*,
2000 (CAT. 83);
PL. 76. *Cornacchia*, 2000
(CAT. 84);
PL. 77. *Hopi*, 2001
(CAT. 86)

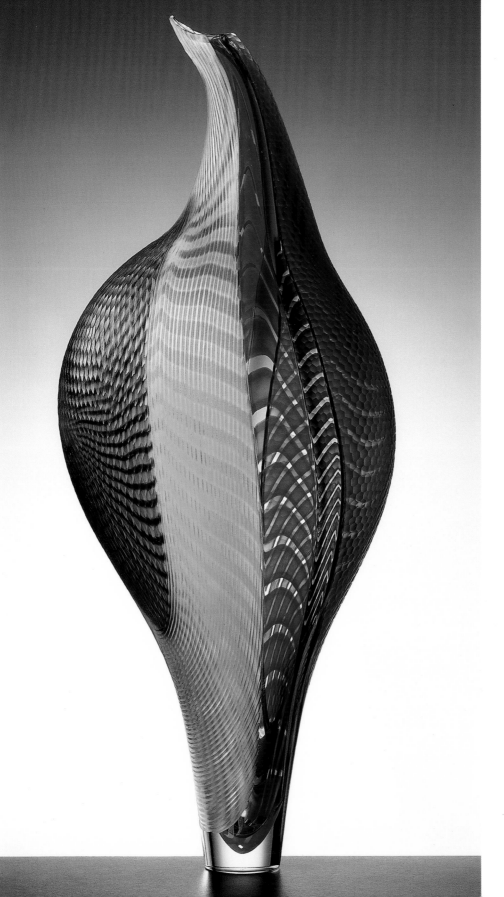

111

PL. 78. *Bilbao*, 2001 (CAT. 85)
The *Bilbao* series originated before Lino visited that Spanish city. Upon seeing a photograph of architect Frank Gehry's museum there, with its many shell-like components, Lino was inspired to create pieces with numerous *incalmi* sections of different patterns and colors. This *Bilbao* takes a birdlike form.

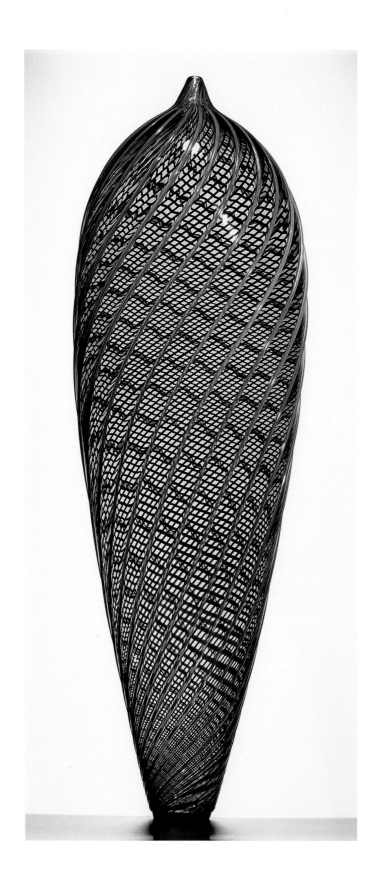

PL. 79. *Borneo,*
2001 (CAT. 87)

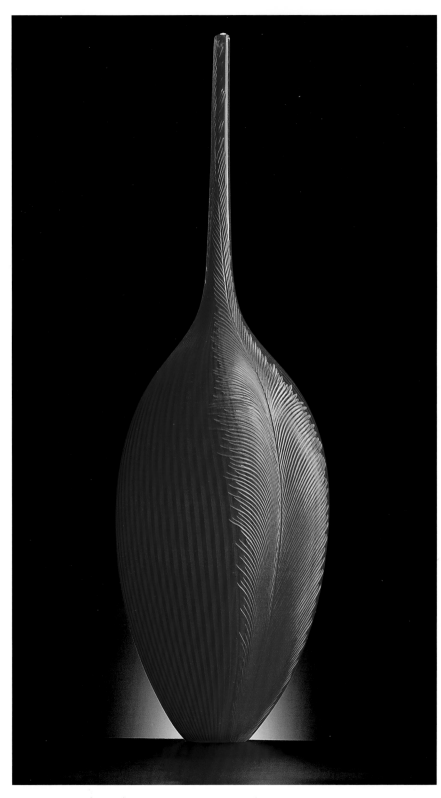

PL. 80. *Eve*, 1998 (CAT. 69)

PL. 81. *Curaçao*, 2002 (CAT. 89)

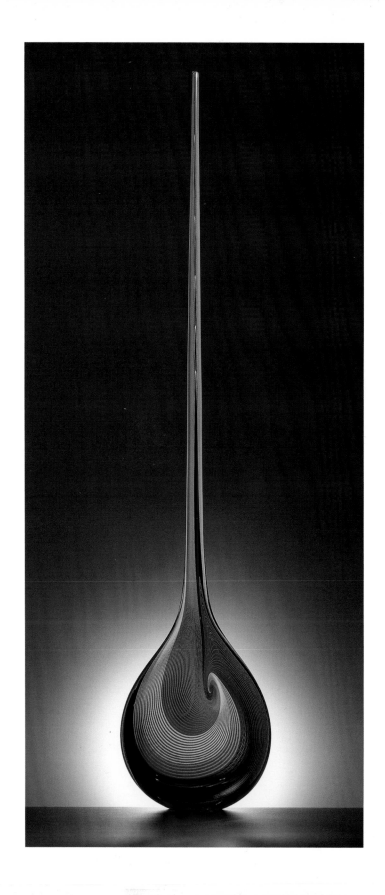

PL. 82. *Angel Tear*, 2002 (CAT. 88)

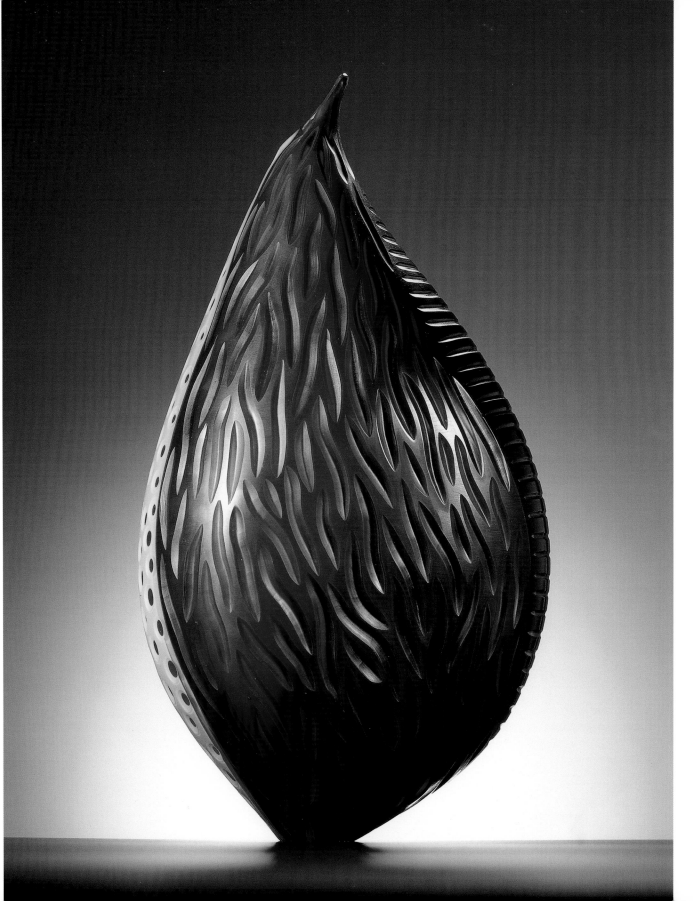

PL. 83. *Puffin,* 2002
(CAT. 90)

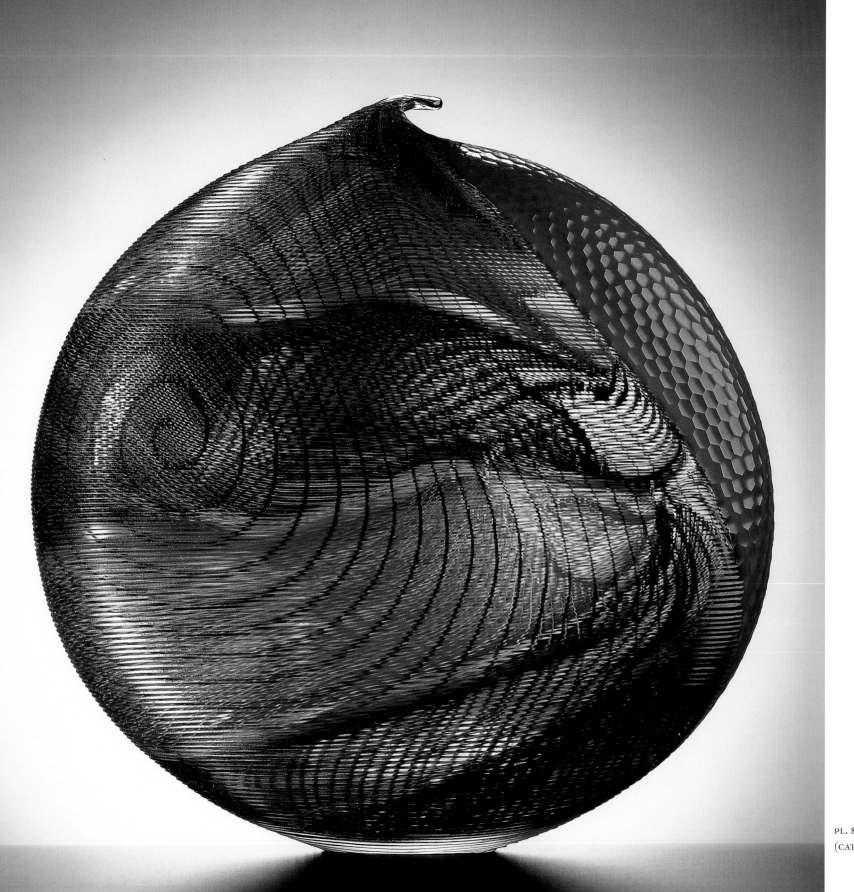

PL. 84. *Riverstone*, 2002
(CAT. 91)

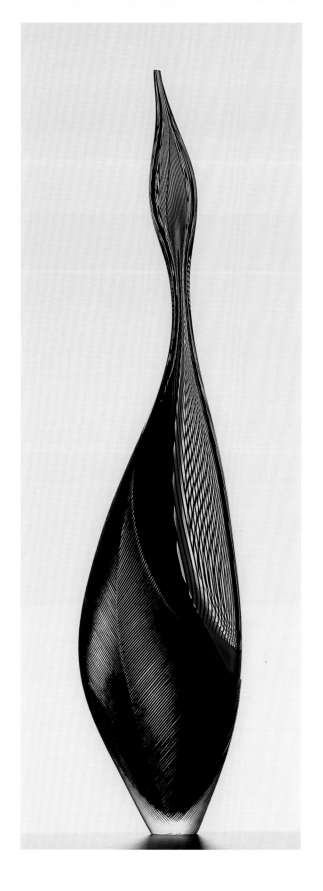

PL. 85. *Oca*, 2002 (CAT. 92)

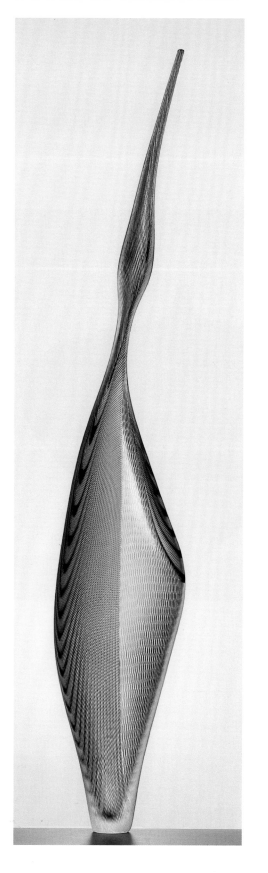

PL. 86. *Oca*, 2002 (CAT. 93)

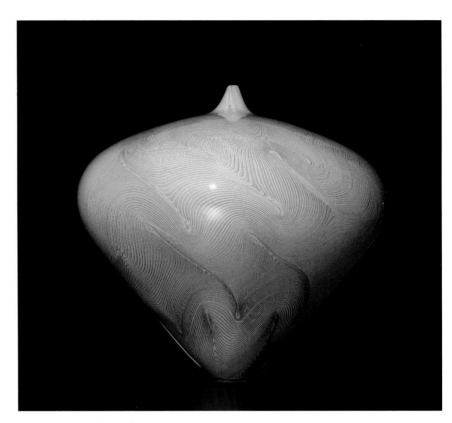

PL. 87. *Hopi,* 2003 (CAT. 95)

PL. 88. *Hopi,* 2003 (CAT. 96)

Opposite:

PL. 89. *Hopi,* 2003 (CAT. 94)

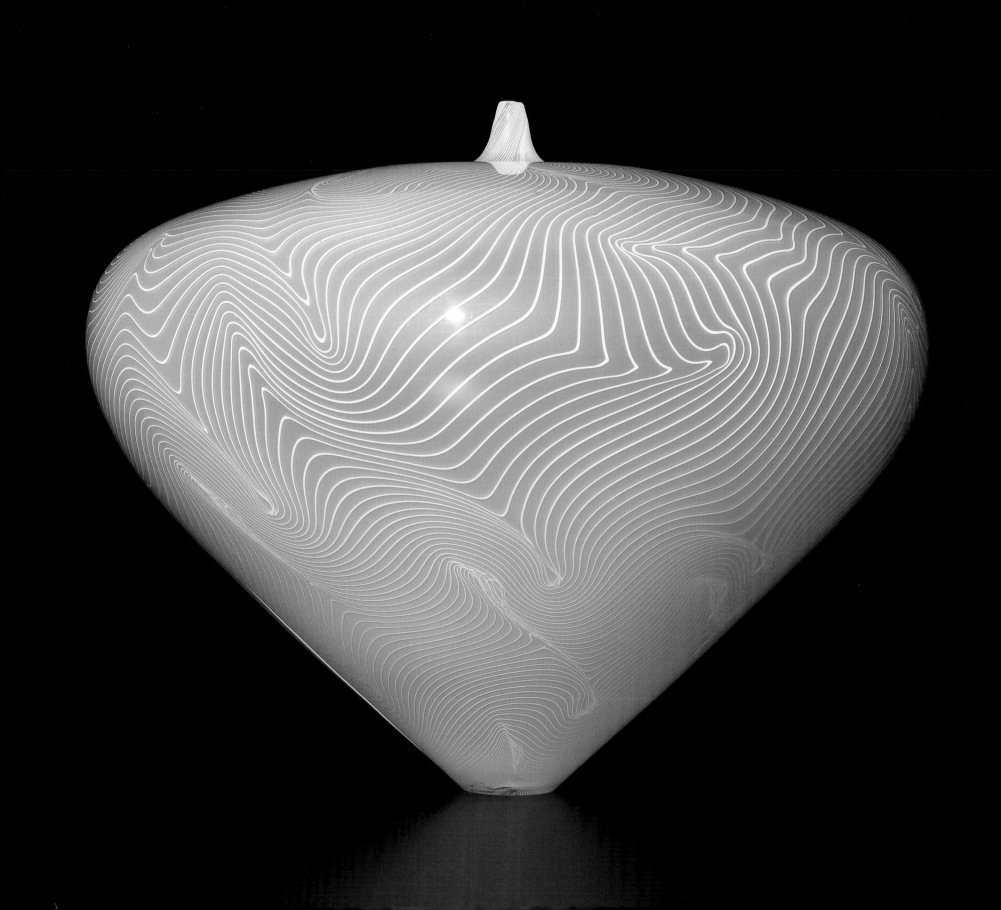

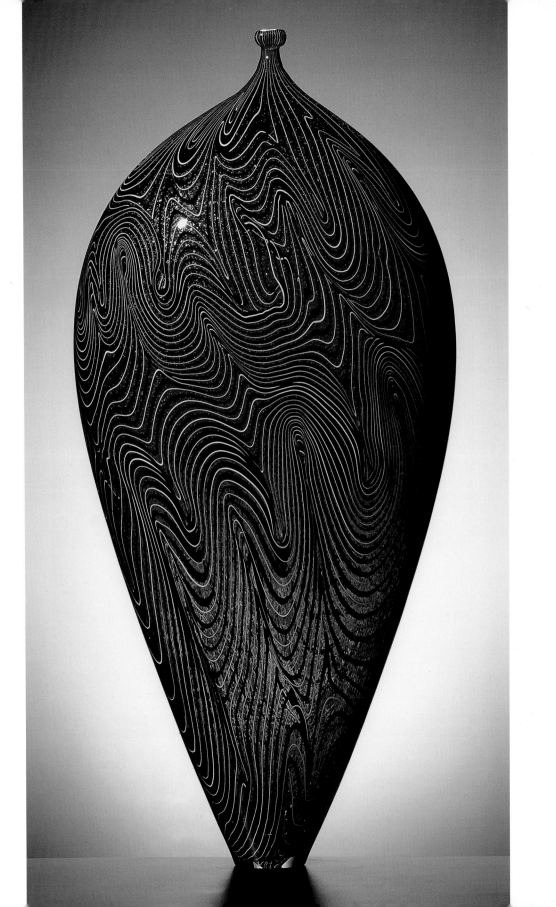

PL. 91. *Atlantis*, 2003
(CAT. 97, DETAIL, PL. 90)

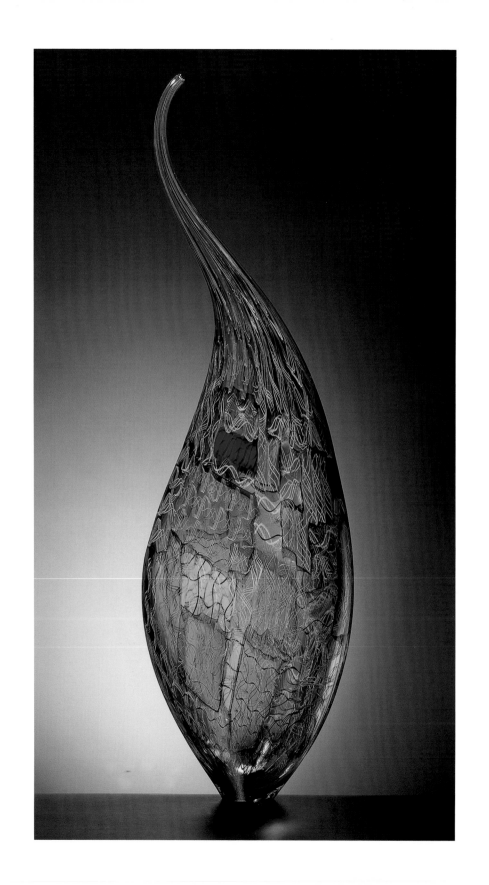

122

PL. 92. *Silea*, 2003 (CAT. 98)

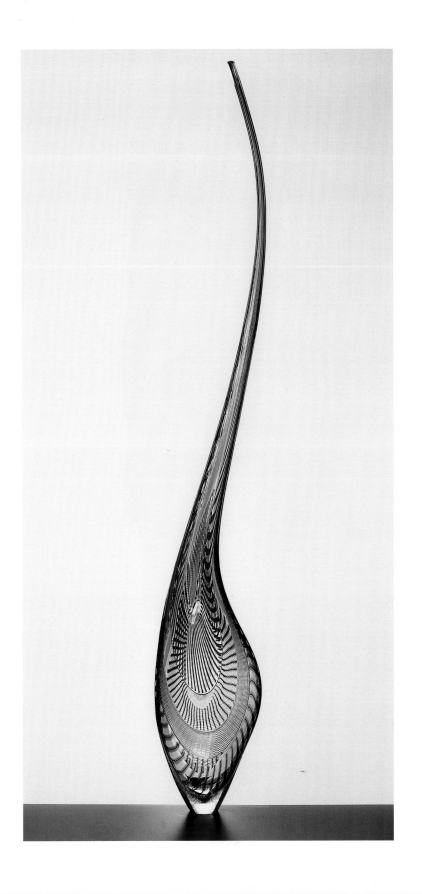

PL. 93. *Dinosaur,* 2004 (CAT. 99)

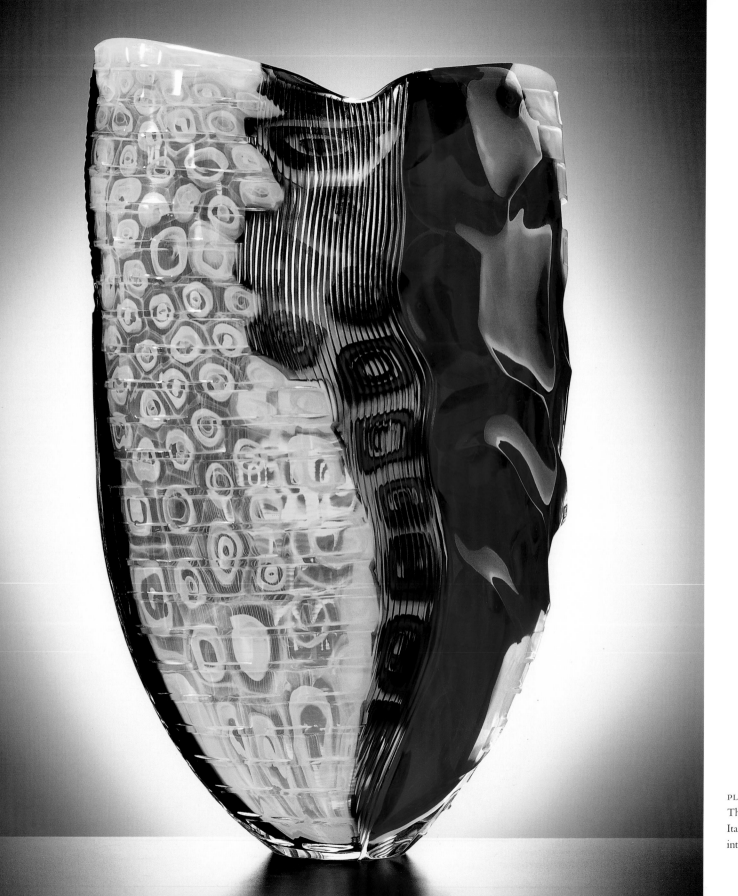

PL. 94. *Stromboli*, 2004 (CAT. 100)
The *Stromboli* series, named after a volcano in
Italy, was inspired by the effects of lava dripping
into the sea.

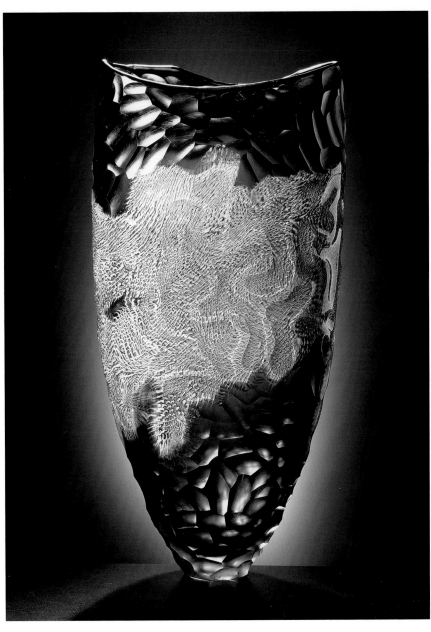

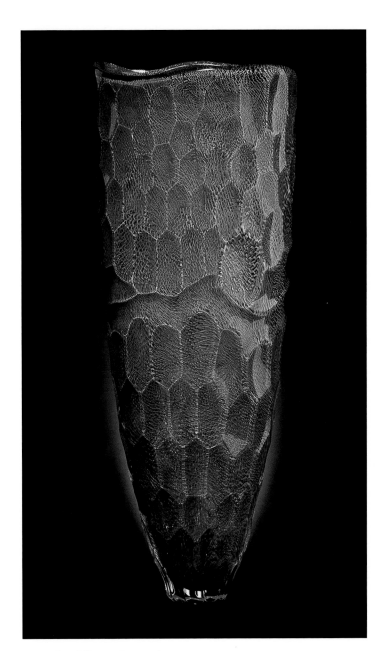

PL. 95. *Stromboli*, 2004 (CAT. 101)

PL. 96. *Stromboli*, 2004 (CAT. 102)

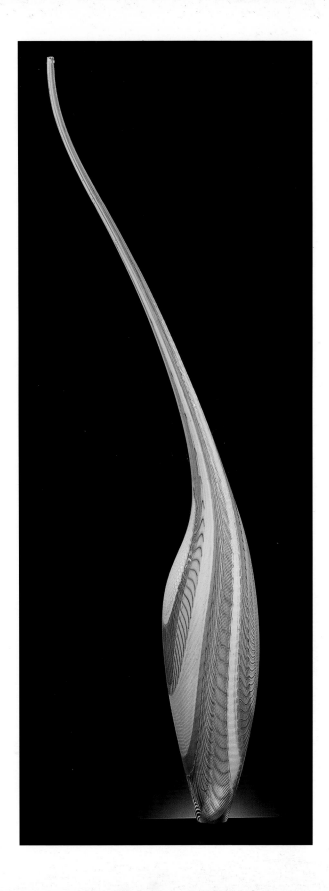

PL. 98. *Dinosaur,* 2006
(CAT. 104, DETAIL PL. 97)

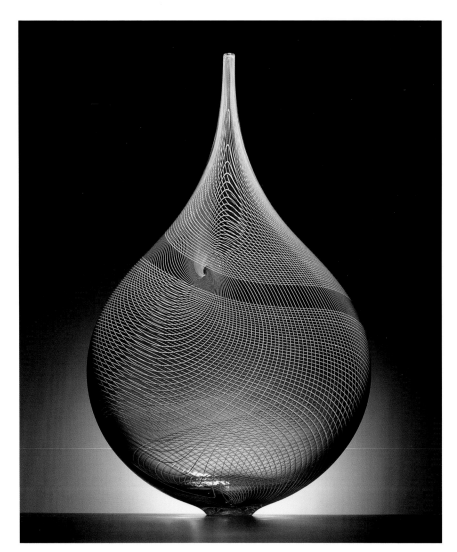

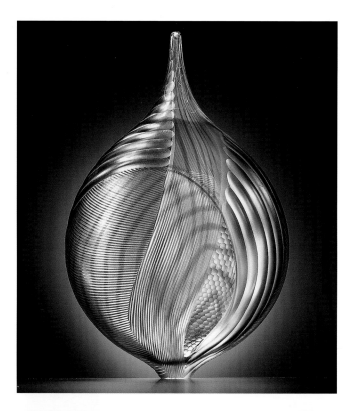

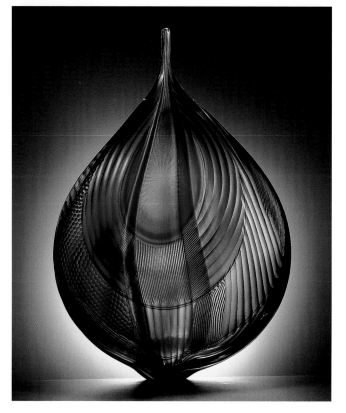

Clockwise:

PL. 99. *Cello*, 2006 (CAT. 103);

PL. 100. *Mandara*, 2006 (CAT. 105);

PL. 101. *Mandara*, 2006 (CAT. 106)

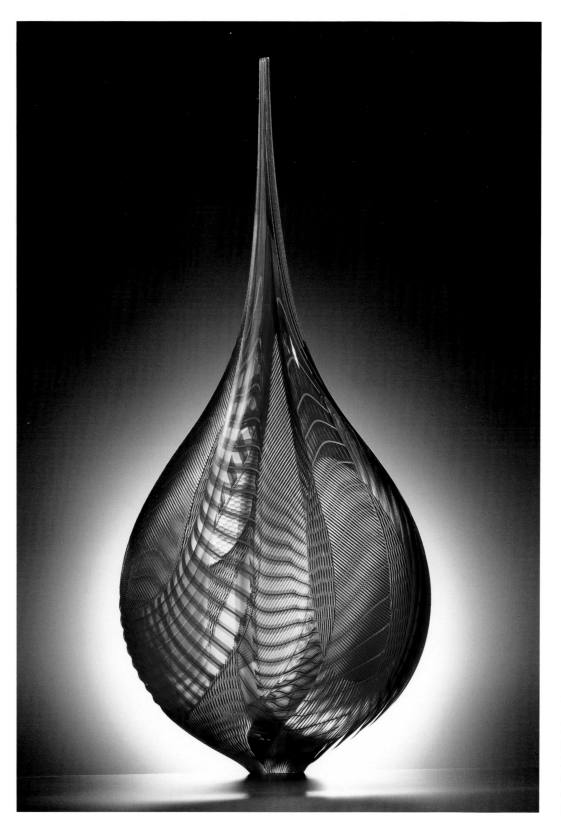

PL. 102. *Mandara*, 2006 (CAT. 107)

Following pages:
PL. 103. *Fenice*, 2006 (CAT. 108)
In addition to suggesting the plumage
of the mythical Phoenix, the curves
of the *Fenice* series are inspired by
Islamic calligraphy.

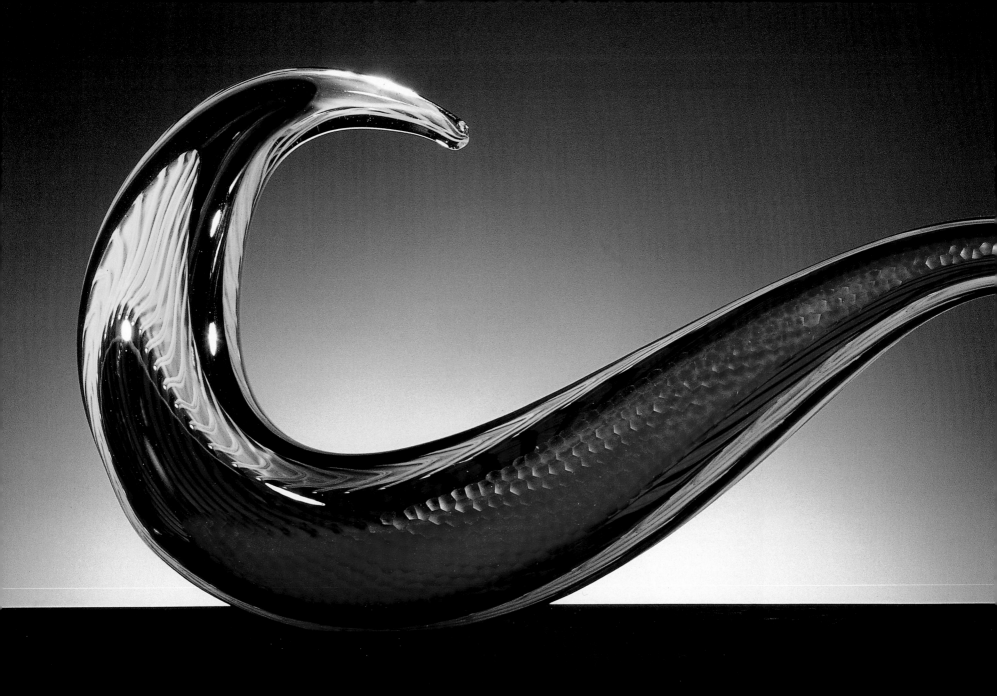

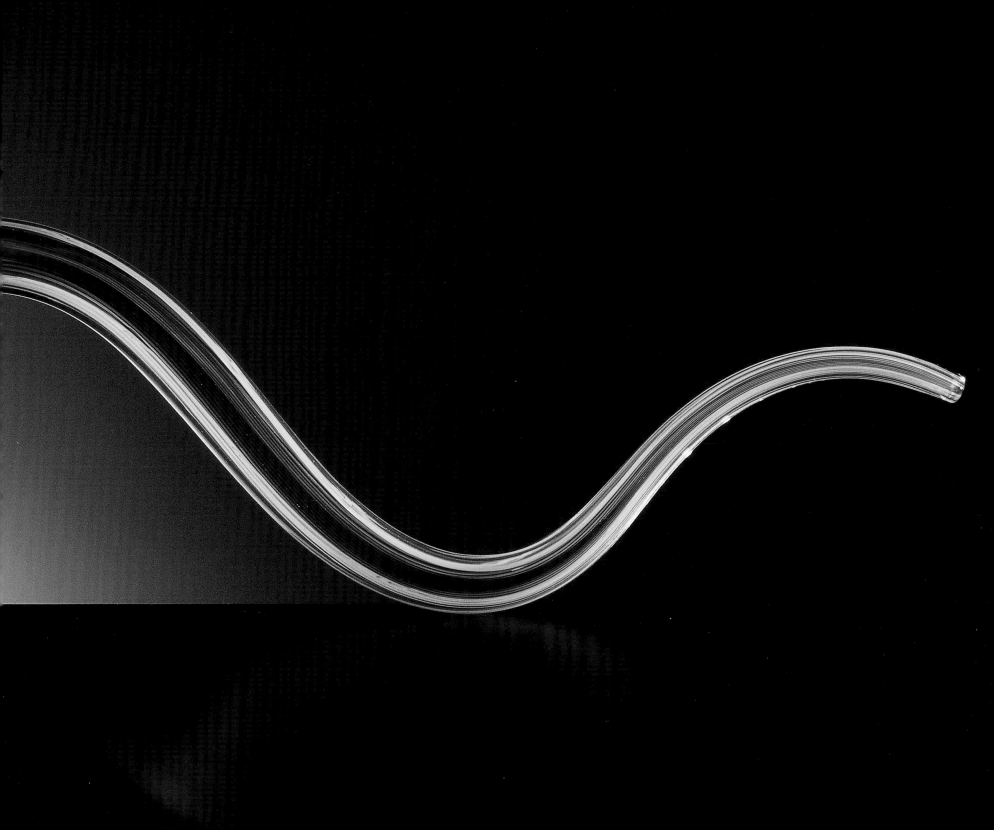

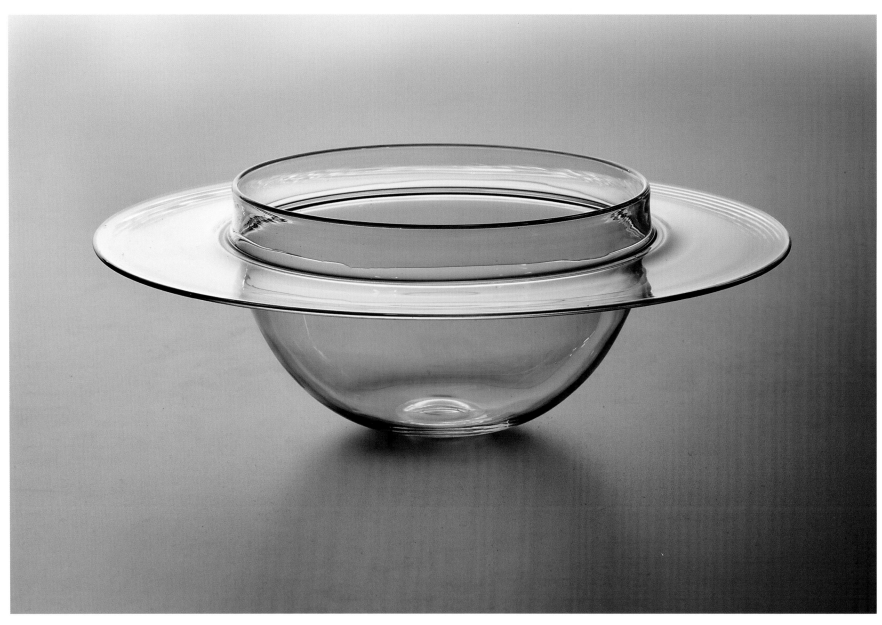

PL. 104. Small *Saturneo*, 2006 (CAT. 109)

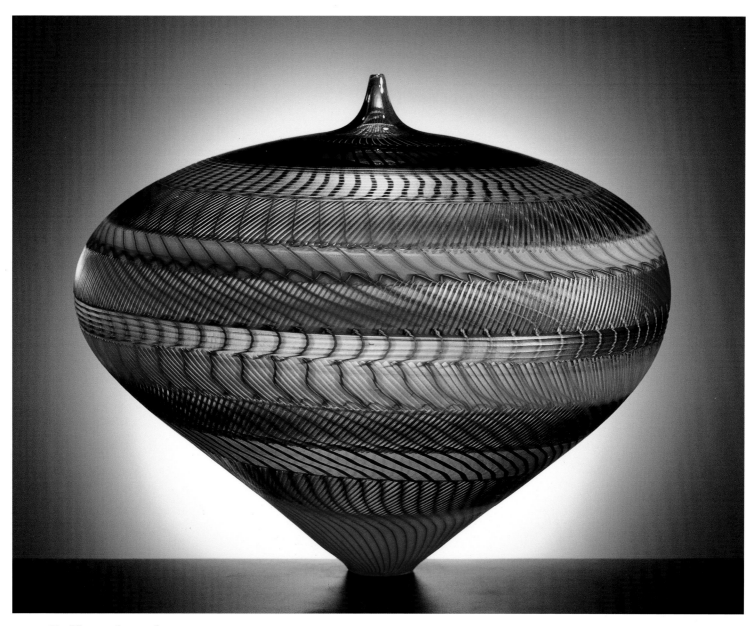

133

PL. 105. *Piccadilly*, 2006 (CAT. 110)

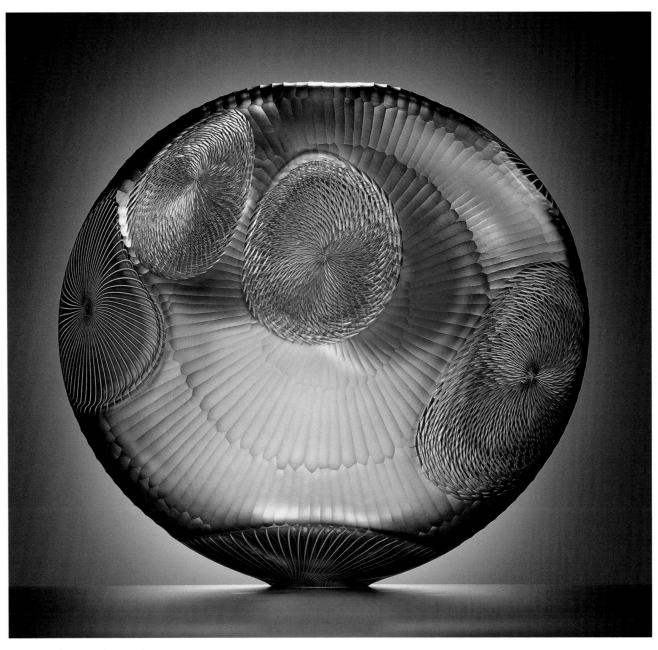

PL. 106. *Medusa*, 2006 (CAT. 111)

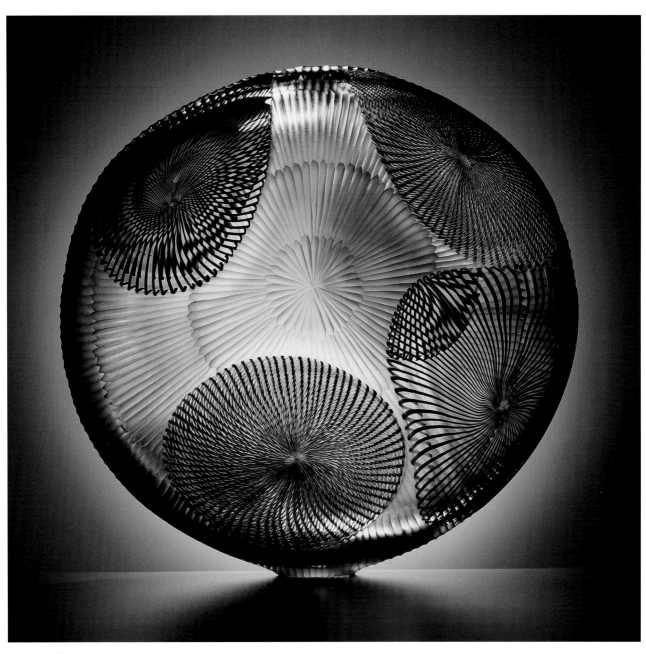

PL. 107. *Medusa*, 2007 (CAT. 112)

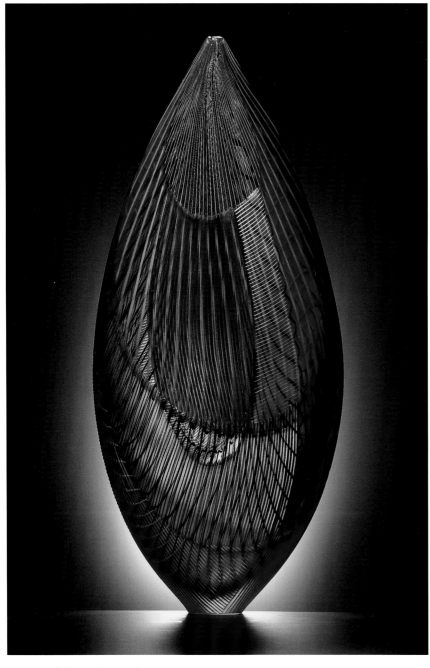

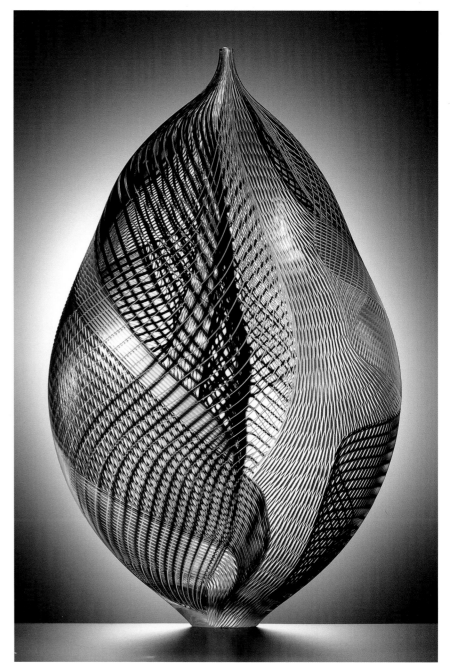

PL. 108. *Makah,* 2007 (CAT. 113)

PL. 109. *Ostuni,* 2007 (CAT. 114)

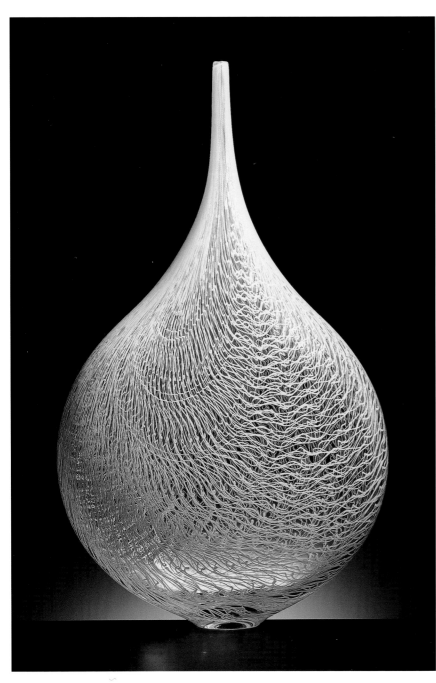

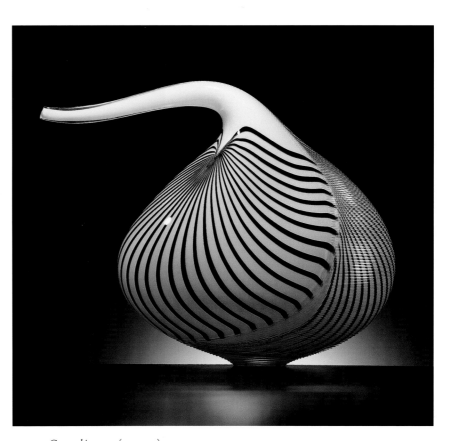

PL. 111. *Cornacchia*, 2007 (CAT. 115)

PL. 110. *Asola*, 2007 (CAT. 116)
The layered filigree canework of the *Asola* series
elaborates upon the *Merletti* (Lacework) vessels
of Archimede Seguso from the 1950s.

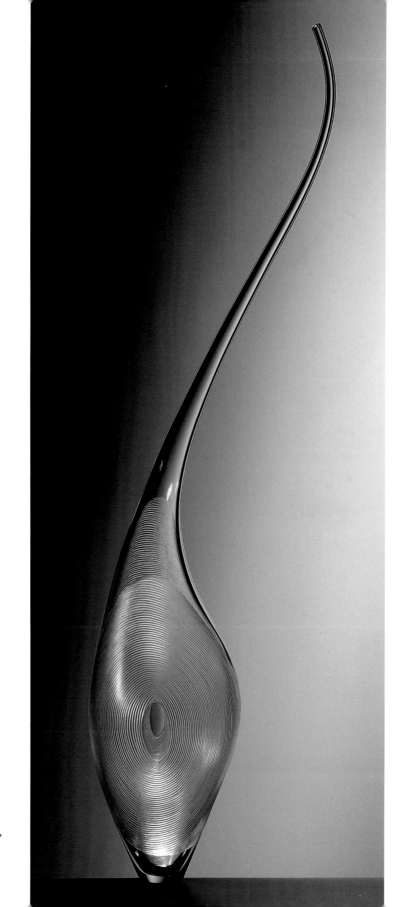

138

PL. 112. *Dinosaur*, 2007 (CAT. 117)
This restrained and elegant piece, a recent departure from
the usual colorful appearance of the *Dinosaur* series, was
blown in the Hot Shop of the Museum of Glass, Tacoma,
Washington in May 2007.

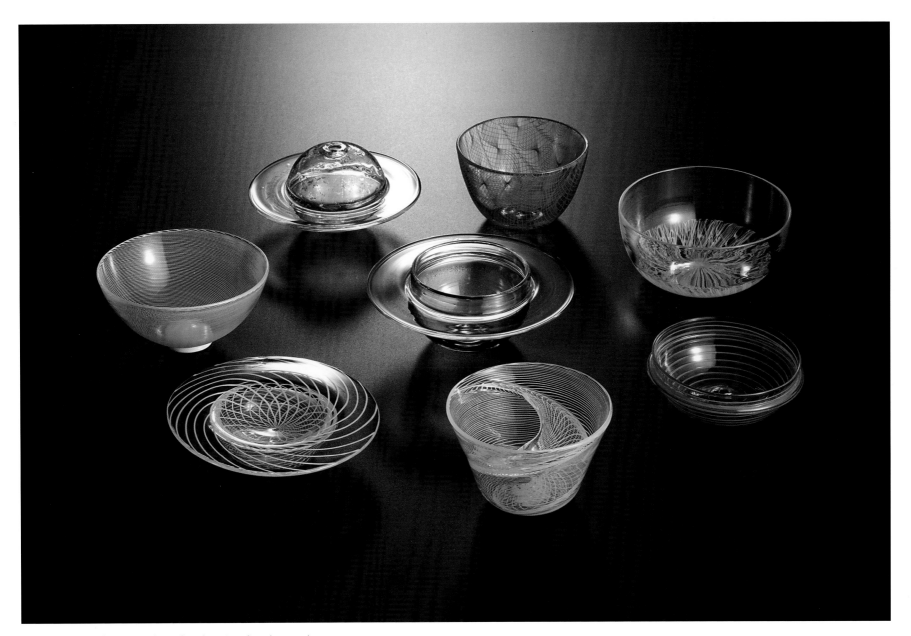

PL. 113. Selection of *Bonboniere* (party favors), various dates (CAT. 118)
Lino has always made miniature versions of his work as gifts for family
and friends. They commemorate special occasions, including his mar-
riage to Lina Ongaro and the birth of their children.

139

Following pages:
PL. 114. Selected goblets from the
George R. Stroemple Collection,
1991–1994

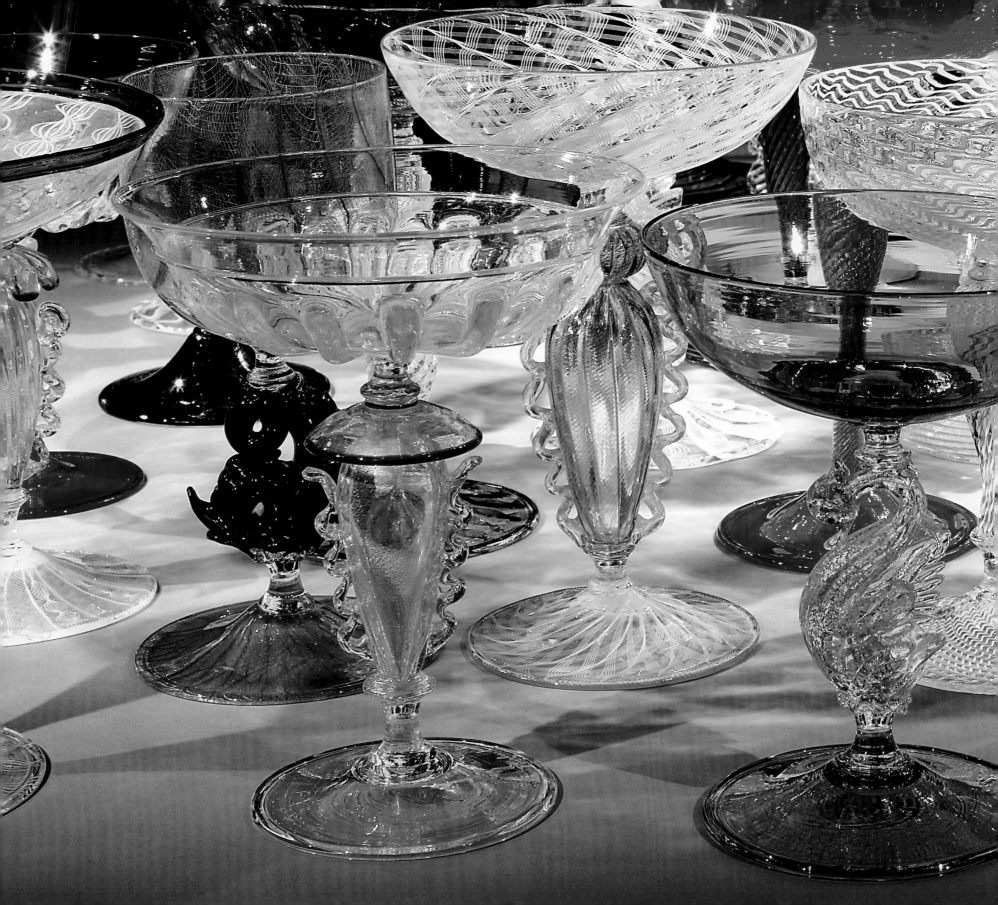

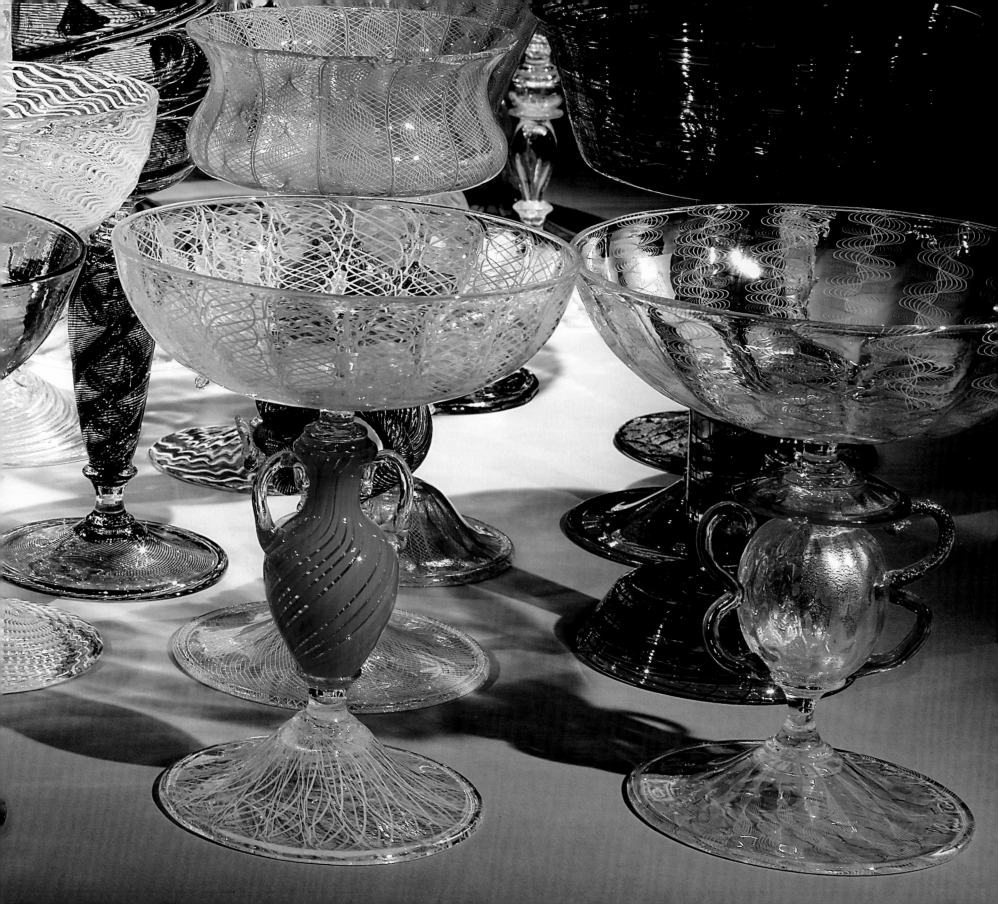

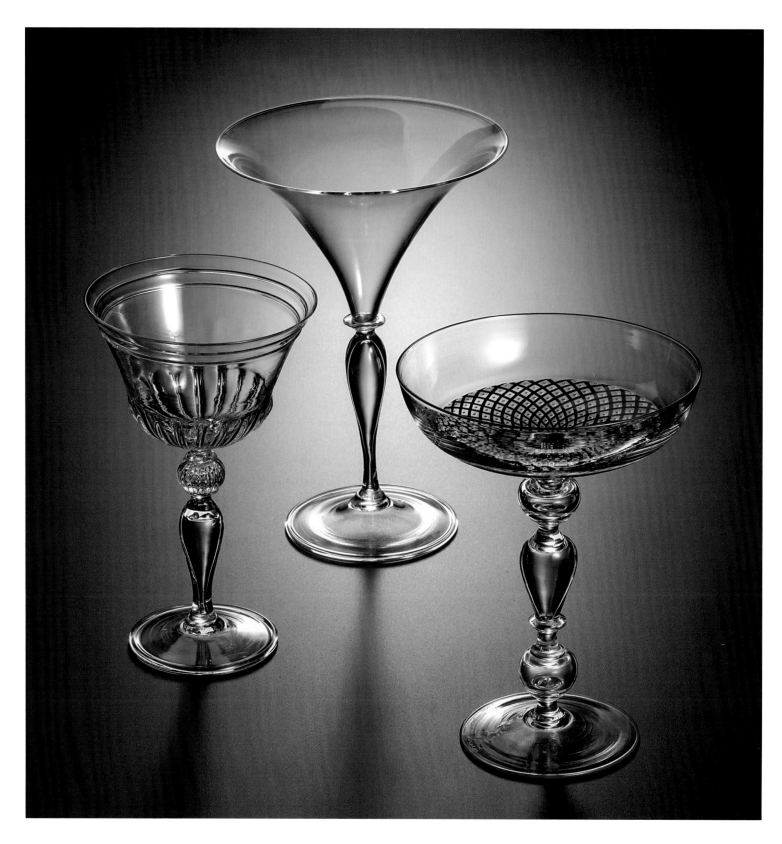

142

PL. 115. From left:
Goblet in late 16th- to
early 17th-century design,
1983 (CAT. 120);
Goblet, mid-16th century
design, around 1997
(CAT. 122);
Goblet, around 1989
(CAT. 123)

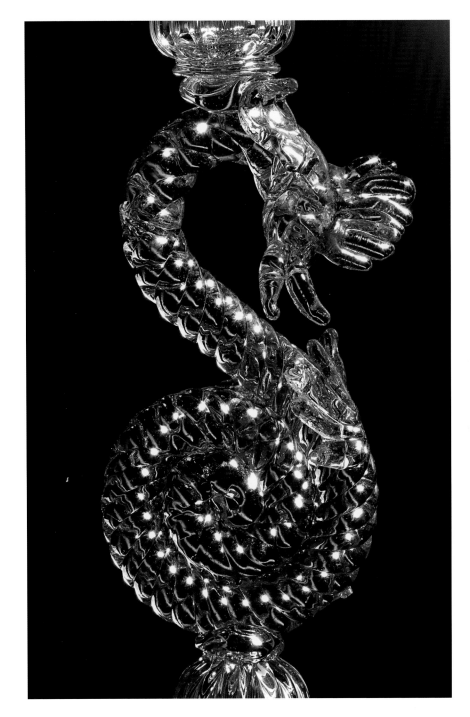

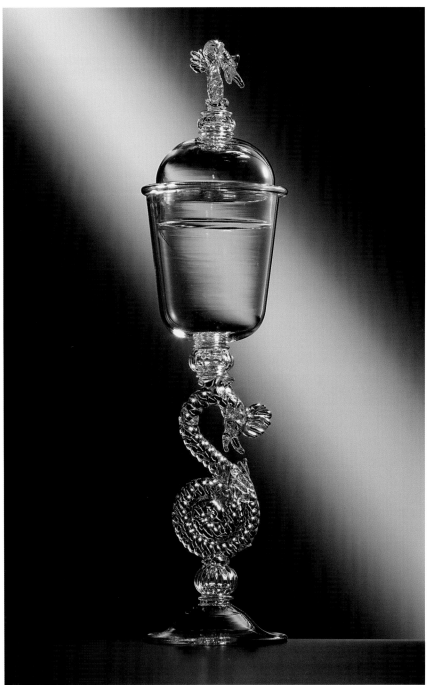

PL. 117. Covered dragon-stem goblet, 1992. (CAT. 121, DETAIL, PL. 116)

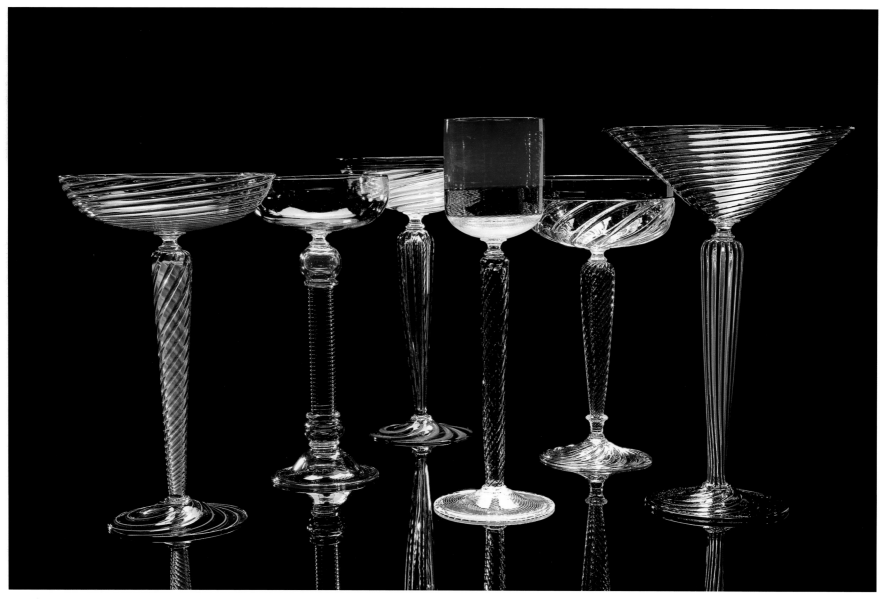

144

PL. 118. Goblets, 1991–1994
(CAT. 142, 140, 139, 150, 143, 144)

Opposite: PL. 119.
From left: Feather-stem Goblet, 1991–1994 (CAT. 158);
Goblet, 1991–1994 (CAT. 160);
Swan-stem Goblet, 1991–1994 (CAT. 133)

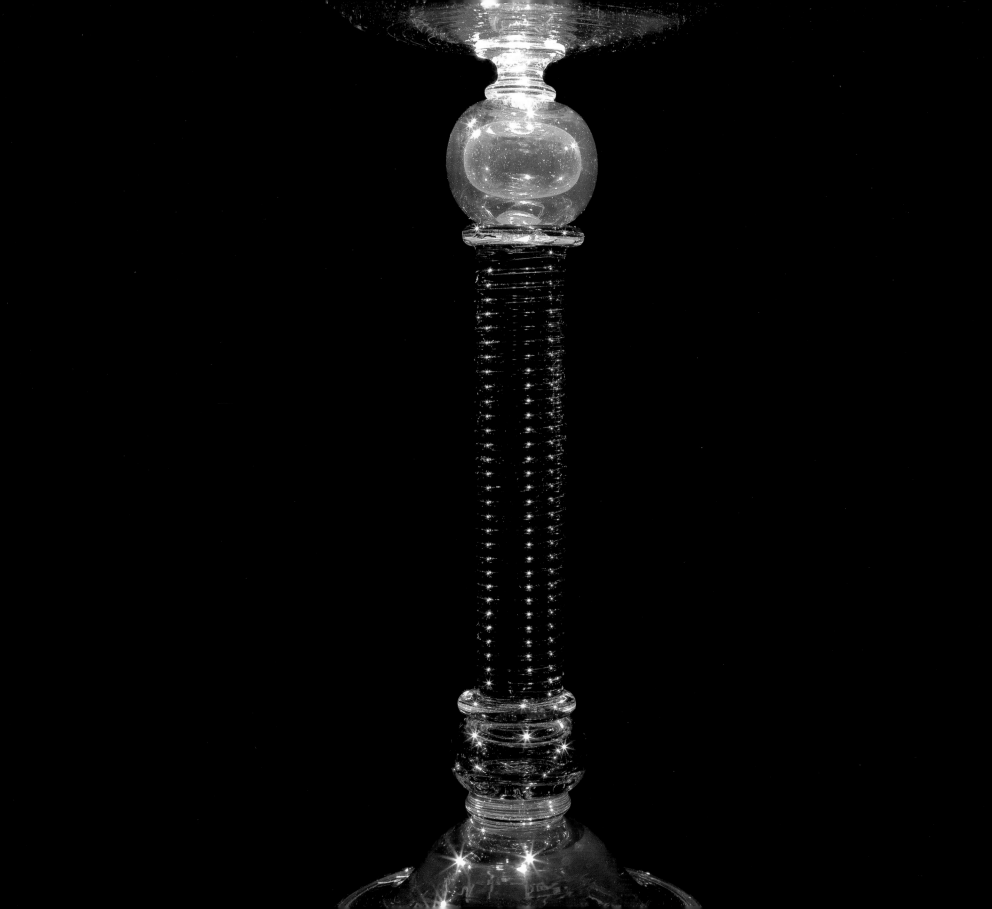

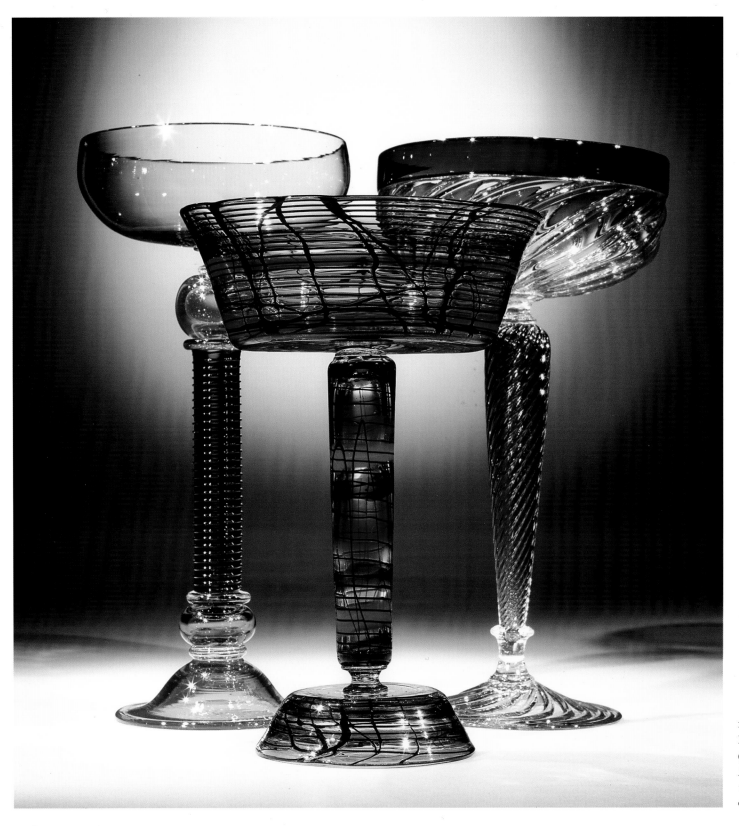

PL. 120.
From left: Goblet, 1991–1994
(CAT. 140, DETAIL OPPOSITE);
Notte del Redentore Goblet,
1991–1994 (CAT. 134);
Goblet, 1991–1994 (CAT. 143)

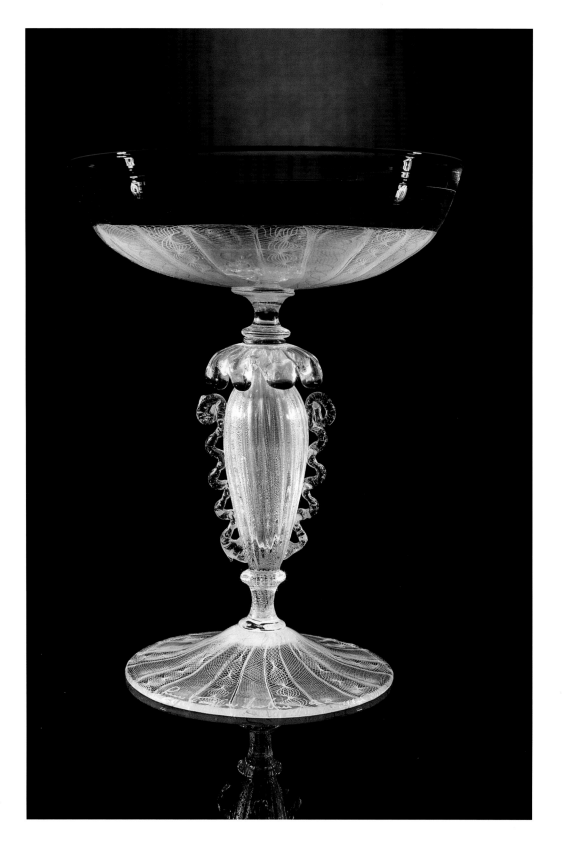

148

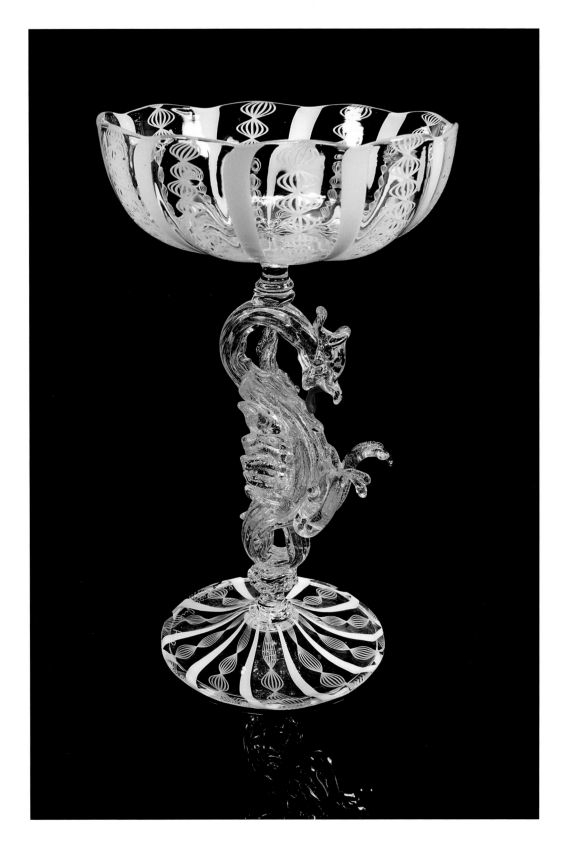

PL. 122. Dragon-stem Goblet, 1991–1994 (CAT. 125)

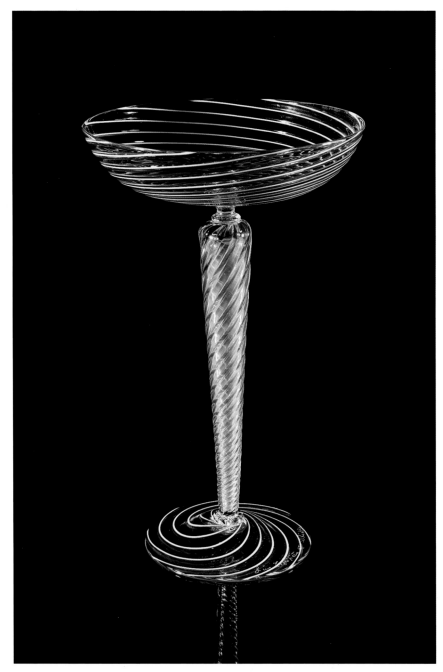

PL. 123. Goblet, 1991–1994 (CAT. 142)

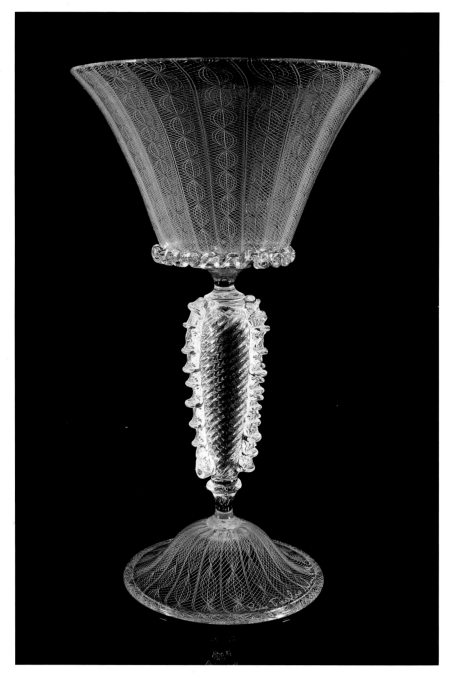

PL. 124. Goblet, 1991–1994 (CAT. 132)

Opposite: PL. 125. From left:
Goblet, 1991 (CAT. 165); Goblet, 2003 (CAT. 169);
Goblet, 2000 (CAT. 168); *Saturno* Goblet, 1995
(CAT. 164); Goblet, 1999 (CAT. 167);
Dolphin-stem Goblet, 1997 (CAT. 166)

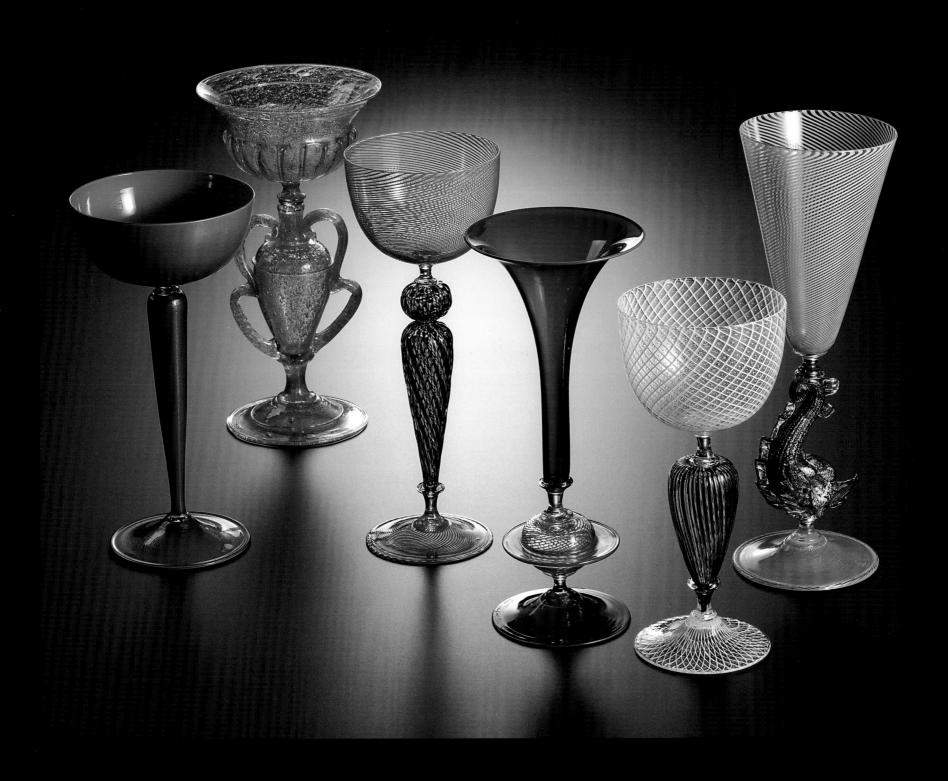

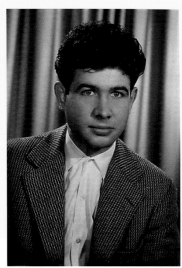

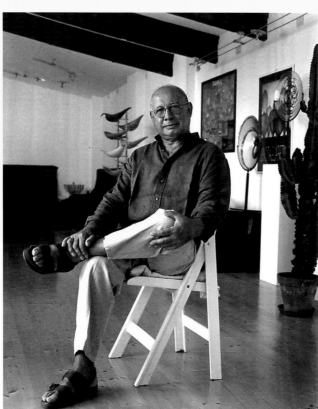

Clockwise from top left:
FIG. 46. Age one, 1935;
FIG. 47. Making a goblet with
Dante Marioni observing, Pilchuck,
1992; FIG. 48. Archimede Seguso's
former glasshouse, Campo del
Cimitero; FIG. 49. In the Murano
studio, around 1998; FIG. 50. Age
nineteen, 1953

LINO TAGLIAPIETRA:
CHRONOLOGY

Susanne K. Frantz

1925

Marriage of fisherman Albino Tagliapietra (1896–1966) and Clementina Zane (1897–1990), a lacemaker, on the island of Burano in the Venetian lagoon. First son, Silvano (1926–2003), is born on Burano.

During the 1920s, Albino's sister, Maria, marries glassblower Giuseppe Barovier. He was one of five glassblowers on the island of Murano who formed an economic partnership with Paolo Venini. Venini established an independent company (Vetri Soffiati Muranesi Venini e C.) after his partnership with Giacomo Cappellin ended in 1925. Giuseppe began at Venini at a young age; later, because of illness he stopped blowing glass and did other jobs in the factory. Rino Tagliapietra (son of Albino's brother Vittorio) also became a master glassblower at Venini and then Fratelli Toso.

1926

When Silvano is six months old, Albino and Clementina move from Burano with Albino's mother Orsola to the island of Murano. Albino goes to work at Venini with his brother-in-law Giuseppe and is employed to cold work glass and assemble chandeliers. Four more sons are born to Albino and Clementina, but none survive past the age of two years.

1929

The American economic crisis helps provoke an international economic depression. The United States was one of the most important markets for glass from Murano. In order to enhance competitiveness the quality of some of the glass production is lowered.

1934, AUGUST 10

The last child of Clementina and Albino, Lino Giuseppe Tagliapietra, is born in the family's apartment located on Murano's Glassblower's Channel (*Rio dei Vetrai*). When Lino is about nine months old the family moves to a house in Campo San Bernardo where Lino lives until he is married.

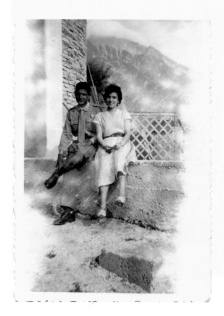

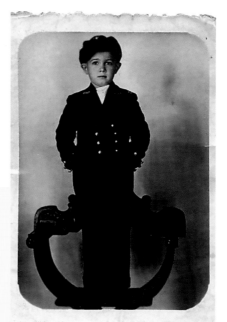

Clockwise from left:
FIG. 51. Lino's birthplace (center);
FIG. 52. First communion, San Pietro Martire, Murano, 1940; FIG. 53. Calle Bertolini, behind the glass factories; FIG. 54. Lino in military uniform with Lina, around 1954

1942

Conditions are difficult on Murano during the Second World War and there are shortages. In 1942, to conserve fuel and electricity, the government issues a decree banning the manufacture of glass, china, and ceramic articles not intended for daily use.

Around this time Lino first takes particular notice of the glowing furnaces and the activities of the glassblowers at A.Ve. M. (Arte Vetraria Muranese).

1943

At age nine Lino is taken ill and is kept out of school for one year.

1945

The post–World War II Venetian glass industry is damaged; only an estimated ten out of fifty-two factories remain in production. Companies lacked coal and wood, sand and silica, ingredients for color making, and were coping with barely surviving markets and transportation systems. Nevertheless, a great demand soon emerges for lighting elements needed for reconstruction; the economy continues to grow through the 1950s with the United States as Murano's biggest customer.

At approximately age ten Lino ends his formal education. He works for a few months in a shop for the repair of furniture and windows, then as an informal helper at the factory of Giuseppe "Beppo" Toso. Shortly thereafter he begins a full-time unpaid apprenticeship with glassblower "Piccolo" Rioda, an independent *maestro* who rents space in various glassmaking facilities. Lino works

with him at Archimede Seguso's (1909–1999) newly established factory on Ramo Barovier, Campo del Cimitero. It was the site of Antonio Seguso's (Archimede's father) workshop until 1932 and was very near the Tagliapietra home. Rioda's glassblowing team is made up of three positions: *maestro* (master, lead glassmaker—Rioda), *servente* (first assistant—a position shared by Alfredo Luca and "Ciuri" Rosetto), and Lino's spot, *garzonetto* (boy—apprentice, general helper). Most of their work entails making components for decorative mirrors. Stays with Rioda almost one year working 7:00 a.m. to 5:00 p.m. Monday through Saturday (sometimes overtime until 11:00 p.m.), and for five hours on Sunday.

1946, JUNE
At age eleven, Lino is engaged as a full-time general employee (*assunto*) at Vetreria Archimede Seguso and earns his first monetary compensation, 250 lira (the equivalent of slightly less than one dollar) per week. Soon after, the Seguso factory moves to Fondamenta Serenella 18. *Maestro* Seguso (nicknamed "Moro Patare") will be renowned for his variations on complex interwoven filigree patterns trapped within the glass, especially the *Merletti* (Lacework) pieces developed around 1947 with *maestro* Enrico Moretti. Lino works directly with Seguso on only a few occasions and spends most of his time as *garzonetto* for *maestro* Attilio Frondi. This is a four-person team (*maestro, servente, serventino, garzonetto*).

1952–1954
Between the ages of 18 and 20 serves mandatory military service. His absence from the factory forces him to forfeit the place earned in the glassmaking hierarchy. Upon his return to work at Archimede Seguso, Lino must start anew from a lower-ranking position.

1955, DECEMBER
Joins Galliano Ferro (1896–1984), father-in-law of brother Silvano, in Ferro's newly established glass factory, Galliano Ferro Vetri Artistici. Brother Silvano works in the company's management and Giorgio Ferro is the chief designer. Lino continues his glassmaking training as *primo assistente e servente* to *maestro* Giovanni "Nane Catari" Ferro (1911–1998), known for his blown glass flowers and leaves for chandeliers and *galanteria* (decorative items). Lino becomes the company's specialist in goblet making.

1956
At age 21, after ten years in the glass industry, Lino achieves the level of *maestrino*, the term for an aspiring *maestro*. Approximately one year later he is awarded the title of *maestro*.

1959, SEPTEMBER 13
At age 25 marries Lina Ongaro, member of a prominent Muranese family with a five-hundred-year-long history in glass. Her father is a well-known mosaicist. The couple will have three children: Marina (b. 1960), Silvano (b. 1962), and Bruno (b. 1965).

1960
Designs by Giorgio Ferro and made by Lino are exhibited under the Galliano Ferro company name at the *XXX Biennale di Venezia*.

The 1960s are a period of turmoil in the Italian glass industry. It faces increasing international competition and rising costs and is engaged in a constant struggle to be competitive with factories in France, Spain, Czechoslovakia, and Japan. Foreign importers demand increased production and lower prices. Strikes and political protest movements by labor unions (including those for glassmaking) take place throughout Italy, asking for improved working conditions, shorter hours, and higher wages. In an effort to make earnings more fair and uniform, pay scales are equalized or "flattened" so that all workers—regardless of seniority and skill level—are paid at comparable rates. As a result, many experienced workers receive additional wages "under the table" and others leave the glass industry; factories close, and there is a marked decline in quality.

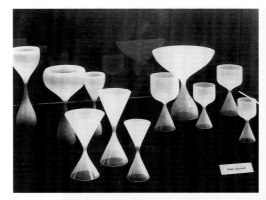

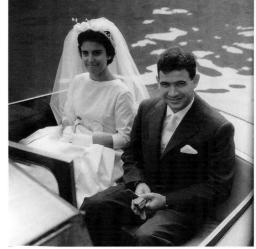

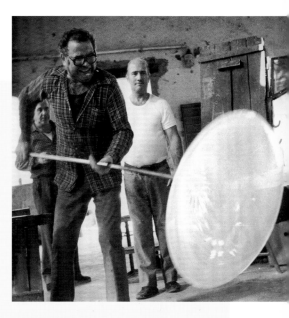

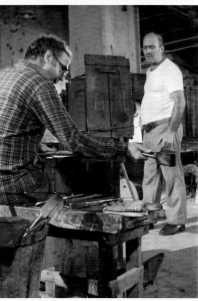

Clockwise from left:
FIG. 55. Objects designed by Giorgio Ferro, made by Lino for Vetreria Galliano Ferro, and displayed at the Biennale di Venezia 1960;
FIG. 56, 57. Working at La Murrina;
FIG. 58. Lina and Lino's wedding day, 1959

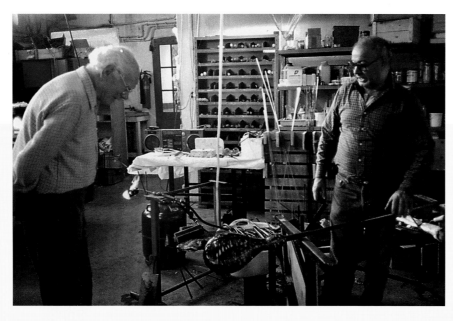

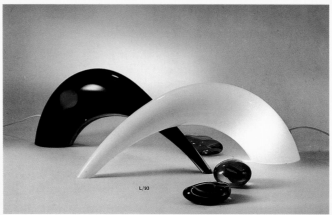

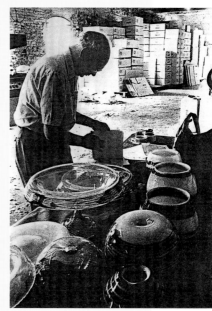

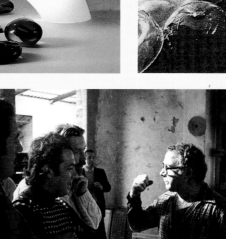

Clockwise from top: FIG. 59. Working with A. D. Copier, 1981; FIG. 60. Copier with collaborative pieces; FIG. 61. Scuola participants, 1976. Left to right: Lino Pirone, Renzo Margonari, Emilio Baracco, and Lino Tagliapietra; FIG. 62. *Formichiere* (Anteater) lamps from La Murrina catalogue, 1973; FIG. 63. Poster for the first Scuola Internazionale del Vetro, 1976

Critical of various objectives, Lino does not join the union although he recognizes its many accomplishments.

1966
Begins developing his own designs during free time—lunch breaks and before work begins in the morning. Creates his first *Saturneo* from one bubble of glass shaped with an extended open neck and a flared "ring." None of his designs go into the production line at Galliano Ferro.

1966, DECEMBER 1–
FEBRUARY 17, 1968
Spends approximately fourteen months working at Venini & C. where he specializes in blowing cups and other vessels. Continues to develop his own concepts, but none of the designs go into production.

1968
Is one of the cofounders of the La Murrina glassworks with Ulderico Moretti and others. Works at Melloni & Moretti from March to October before La Murrina opens in the same facility. As head *maestro* at La Murrina executes concepts of Gianmaria Potenza and other designers. A variation on the *Saturneo* series is exhibited at the *XXXIV Biennale di Venezia* by La Murrina with Pietro Pelzel and Gianmaria Potenza cited as designers. Eventually many of Lino's designs go into production at La Murrina and he collects royalties and joins the ADI—Associazione per il Disegno Industriale (Italian Association for Industrial Design). During his tenure at La Murrina he creates lamp designs such as *Varigola*, *Concorde*, and *Formichiere* (Anteater).

Receives the *Borsella d'Oro* (Golden Jacks), an award marking the first prize in an exhibition

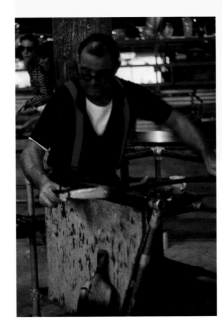

of work by the glassmakers of Murano. He is recognized for a small and fine bowl made in the "Roman fold" technique.

1972
The last year that glass manufacturing is fully represented at the *XXXVI Biennale di Venezia*. During 1972–1973 Lino meets American Studio Glass artists for the first time; Michael Nourot

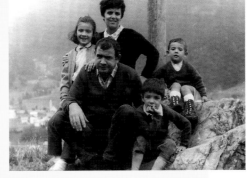

Clockwise from top left:
FIG. 64. Lino on the way home from work, Murano, around 1979; FIG. 65. The Tagliapietra family at Rosetta, in the Dolomite mountains, 1969. Left to right: Marina, Lino, Lina, Bruno, Silvano; FIG. 66. First summer at Pilchuck, 1979

1975
Awarded an honorary knighthood of merit, *Onorificenza di Cavaliere dell'Ordine "al Merito della Repubblica Italiana"* from the Ministry of Commercial Industry and Handicrafts.

and John Milner know of him through his brother-in-law, Francesco "Checco" Ongaro, a *maestro* at Venini.

Awarded a Grand Prix for lighting at the Barcelona Trade Fair for the *Formichiere* (Anteater) lamp design.

1976, OCTOBER 18–30
With brother Silvano and others helps organize and participates in the first two-week "Corso per artisti" (Symposium for Artists) of the Scuola Internazionale del Vetro (International School of Glass). The event takes place at various factories in Murano, the research institute Stazione Sperimentale del Vetro, and at the Museo Vetrario. It is cosponsored by the Centro Internazionale della Grafica and the Stazione Sperimentale del Vetro. One of the aims of the project (with no commercial aspect) was "to revitalize the artistic heritage of Murano and by doing so strengthen the bond already existing between art and artisanship" (*Scuola Internazional del Vetro III Corso per Artisti,* 1983, p. 8). The role of the *maestro*, with the artist, is as a "co-creator of the work of art" and both sign each object.

Over the course of three Scuola symposia Lino will partner with artists Zvest Apollonio (Slovenia), Emilio Baracco (Italy), Andries Dirk Copier (the Netherlands), Riccardo Ghiribelli (Italy), Renzo Margonari (Italy), and Lojze "Luigi" Spacal (Slovenia / Italy).

Around this time he develops the two-bubble spherical *Saturno* design. Variations on his *Saturnos* will soon be put into production as vessels and lighting; in later years the form will evolve into sculptures.

1977
Leaves La Murrina and joins the new firm of Effetre founded by the Ferro brothers: Guido, Ivano, and Mario. Mario Ferro, director of the company, is Lino's brother-in-law—married to Lina's sister, Anna. The company will be divided into three enterprises. Lino is in charge of design and production (later called Artistic

157

and Technical Director) at Effetre International, the branch specializing in high-end handmade lighting and decorative items. As the company's chief glassblower and designer, he makes unique pieces and limited series.

1978, FEBRUARY 27–MARCH 11
Participates in the second workshop for artists of the Scuola Internazionale del Vetro.

American glass artist Benjamin Moore (then Educational Coordinator and Supervisor of the hot glass program at the young Pilchuck Glass School) is working temporarily at Venini and forms a friendship with Checco Ongaro. With the permission of Pilchuck Director Tom Bosworth, Moore invites Checco to demonstrate glassblowing as a Visiting Artist that summer at the school in Stanwood, Washington, north of Seattle. Checco accepts and is accompanied by his wife Rina.

1979
The next summer, Ongaro is invited to return to Pilchuck but declines. He recommends his brother-in-law to Moore and Lino substitutes as a Visiting Artist. At age 45 he travels to Seattle and begins learning English. At Pilchuck from July 29 to August 16 he demonstrates various traditional techniques.

1980
Returns to Pilchuck as Artist-in-Residence (AIR) working with Benjamin Moore. Following the residency, spends one week giving demonstrations at the Glass Eye studio in Seattle owned by Rob Adamson. Lino will be present at Pilchuck as AIR or faculty over the following years: 1983 (AIR), 1985 (teaching with Dan Dailey), 1987, 1991 (with Dale Chihuly, Richard Marquis, and William Warmus), 1993 (with Dante Marioni), 1994 (with Rudi Gritsch), 1995 (with Checco Ongaro), 1996, 1998 (with

Checco Ongaro and Josiah McElheny), 1999 (AIR), 2000 (with Ben Edols), and 2003 (with Checco Ongaro).

1981, MAY 4–16
Participates in the third (and final) workshop for artists of the Scuola Internazionale del Vetro. Works for the first time with renowned Dutch glass designer Andries Dirk Copier (1901–1991) at the Effetre International factory. The two will collaborate in Murano three more times: in

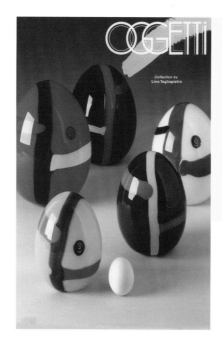

autumn 1981, November 1984, and April 1985. Begins signing his name on designs for Effetre International. Traditionally, only the name of the factory is on the work.

His work is included in the 1981 exhibition *Vetri Murano Oggi* organized by Rosa Barovier Mentasti and is seen by Robert and Nancy Frehling, owners of the American firm Oggetti.

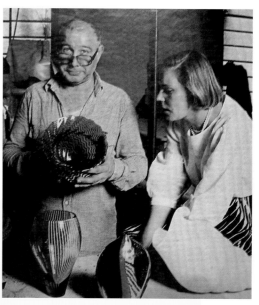

FIG. 67. Advertisement for Oggetti, around 1982; FIG. 68. With Marina Angelin (Orfeo vessel in foreground), 1986

In 1982 the company begins commissioning work from Effetre International.

1982–1986
Collaborates with Venetian psychologist and designer Marina Angelin on designs for Effetre International.

1984
First representation in the annual competition published by the Corning Museum of Glass, *New Glass Review* (5). An experimental work, the *Psycho* vase designed with Marina Angelin, is selected. The following year, *New Glass Review* (6) includes his *Space City*.

1986
Beginning of transitional period from full-time work in the glass industry, to freelance glassmaker, and eventually to independent artist.

1987, JULY
Executes *Ring* series (based on the opera cycle by Richard Wagner) for Thomas S. Buechner at the Haystack Mountain School of Crafts, Maine.

1988
First major museum exhibition: *By the Light of the Lagoon: Textiles by Norelene, Glass by Tagliapietra (Uit het licht van de Lagune: Textiel van Norelene, glas van Tagliapietra)* at Museum Boymans-Van Beuningen, Rotterdam, the Netherlands, curated by Dorris U. Kuyken-Schneider.

Residency at the Centre International de recherche sur le Verre et les Arts plastiques (CIRVA), Marseilles, France.

Begins work for Dale Chihuly at Chihuly's Van de Kamp studio in Seattle on what will be called the *Venetians*, inspired by Italian glass designs from the first third of the twentieth century. Lino is assisted by a team of leading Seattle area glassmakers: Martin Blank, Paul Cunningham, Benjamin Moore, William Morris, and Richard Royal.

1989
Ends all work for Effetre International, which ceases independent production and is consolidated within the rest of the company.

Collaborates with artist Dan Dailey at a rented facility in Murano and then at the Creative Glass Center of America at Wheaton Village,

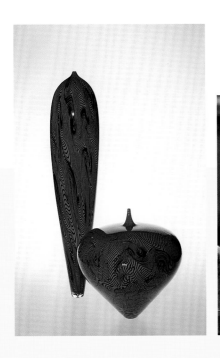

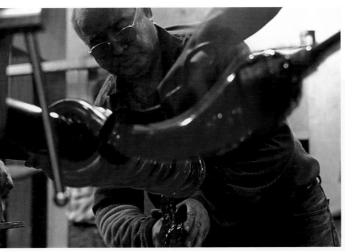

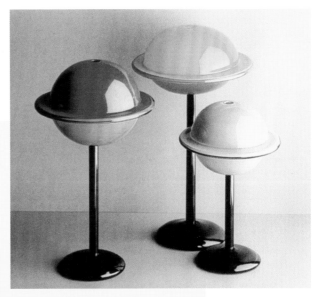

Effetre International in Murano, Italy

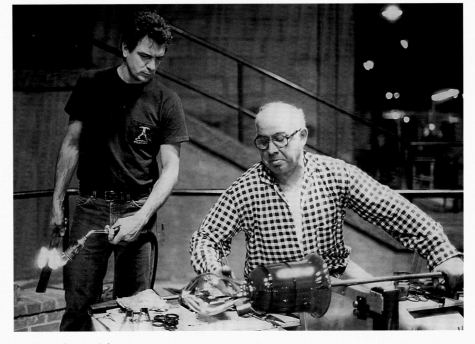

Clockwise from top left:

FIG. 69. *Hopi*, 1996 Rakow Commission; FIG. 70. Hotworking a coil for a *Venetian*, assisted by Richard Royal, 1988; FIG. 71. *Space City*, 1984; FIG. 72. Working with Dan Dailey, 1989; FIG. 73. Drawings by Copier of pieces made with Lino Tagliapietra, around 1982. Haags Gemeentemuseum, Gemeentemuseum Van Reekummuseum Apeldoorn, 1982

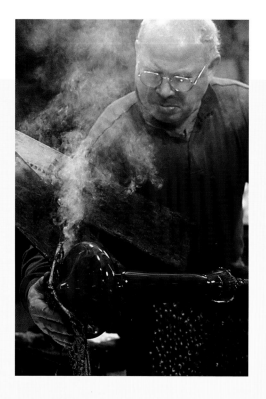

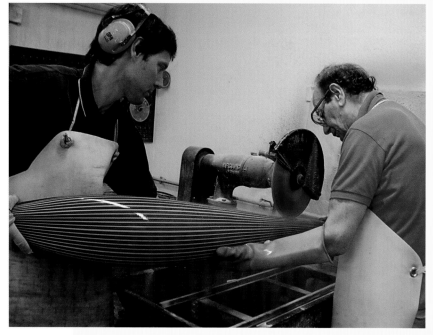

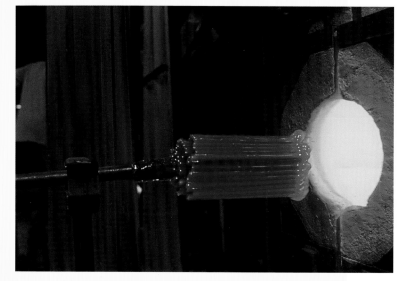

Clockwise from top left:
FIG. 74. At the bench; FIG. 75. Lino the chef; FIG. 76. Fusing individual cane lengths into one composite cane for *La Carta dei Sogni*;
FIG. 77. Guido and Lofredo Fabbris cutting an *Endeavor* boat with a diamond wheel, 2007

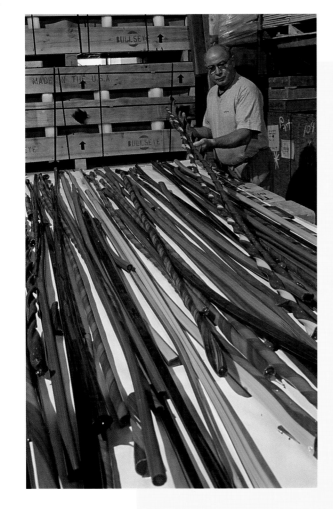

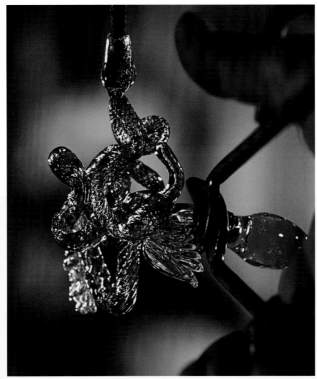

Clockwise from left:
FIG. 78. Finished cane lengths,
Bullseye Glass; FIG. 79. Hotworking
a dragon / serpent goblet stem;
FIGS. 80, 81. Two stages of stretching
the composite *filigrana* cane

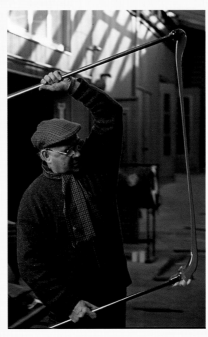

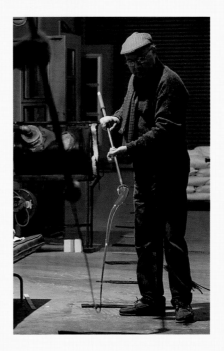

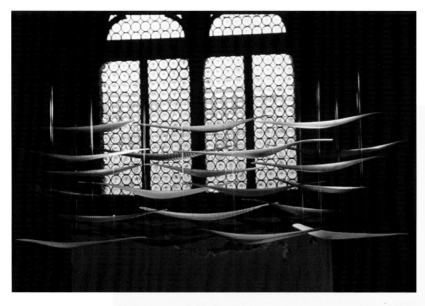

Clockwise from left:
FIG. 82. *Flying Boats* installed in the Palazzo Ducale, Venice, 1998; FIG. 83. Assembling the *Bisanzio* panel at Bullseye Glass, 1998; FIG. 84. With Justice Sandra Day O'Connor, Centre College, 2004; FIG. 85. Assembling a *La Carta dei Sogni* panel

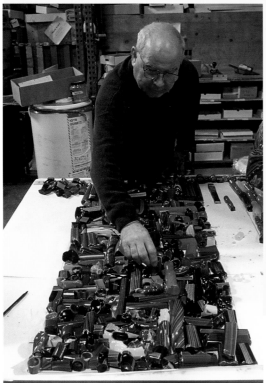

Millville, New Jersey (under the auspices of a joint Fellowship). The blown glass objects are inspired by works seen in the exhibition *Glass of the Caesars* at the Corning Museum of Glass. The entire series of fifty blown and enameled sculptural vessels is completed in 1993. Works with Chihuly in Seattle on the *Ikebana* series.

1990
Final collaboration with Copier. The session takes place in the Netherlands at De Oude Horn studio owned by Leerdam Glassworks designer Willem Heesen in Acquoy (near Leerdam). Lino is assisted by Bernard Heesen and Richard Price.

First inclusion with own designs in an international museum survey exhibition: *World Glass Now '94*, Hokkaido Museum of Modern Art, Sapporo, Japan.

1991–1993
Works intermittently with the firm EOS Design del Vetro established in 1986 by Ludovico Diaz de Santillana and his children Laura and Alessandro.

1992
First solo exhibition in Japan: Seibu department store, Tokyo.

1993
Works with Chihuly on *Piccolo Venetians* series.

MID-1990S
Stops collaborating with and working for other artists / designers to concentrate on personal work fabricated at various facilities.

1994
First monograph published on his work: *Lino Tagliapietra: Vetri, Glass, Verres, Glas*, by Giovanni Sarpellon (Venice, Italy: Arsenale Editrice).

1995
Purchases property in Murano for studio and office.

1996
Awarded the Rakow Commission for Excellence in Glass by the Corning Museum of Glass. Also the Urban Glass Award for the Preservation of Glassworking Techniques. As an invited Guest of Honor exhibits *Metamauco (Drowned Island)* installation of multiple blown and cut vessels in the Palazzo Ducale for the first *Venezia Aperto Vetro* international survey exhibition.

First solo exhibition at a gallery in Italy: Galleria Marina Barovier, Venice.

1997
Receives the Glass Art Society Lifetime Achievement Award at the conference held in Tucson, Arizona. Also the Urkunde Goldmedaille (Bavarian State Gold Medal for Crafts), Munich, Germany.

1998
Creates suspended *Flying Boats* installation at second *Venezia Aperto Vetro*.

Two-week residency at the Steuben factory, Corning, New York.

Creates the *La Carta dei Sogni* series of fused mosaic panels at Bullseye Glass, Portland, Oregon.

Receives Libenský Award from the Pilchuck Glass School and the Chateau Ste. Michelle Vineyard and Winery.

2000
A. D. Copier & Lino Tagliapietra: Inspiratie in glas, Inspiration in Glass exhibition at the Gemeentemuseum Den Haag, the Netherlands.

Named Humana Distinguished Professor at Centre College, Danville, Kentucky.

2001
Receives medal for Excellence in Craft Award, the Society of Arts and Crafts, Boston, Massachusetts.

2002–2003
Slowdown of work due to illness.

2004
Honorary Doctor of Humane Letters degree awarded from Centre College, Danville, Kentucky. Receives the President's Distinguished Artist Award, University of the Arts, Philadelphia, Pennsylvania; Artist as Hero Award from the National Liberty Museum, Philadelphia; and the Artist Visionaries! Lifetime Achievement Award from the Museum of Arts and Design, New York City.

2006
Receives the Distinguished Educator Award from the James Renwick Alliance associated with the Renwick Gallery of the Smithsonian American Art Museum, Washington, DC.

2007
Receives the Cristal Award from the Museo del Vidrio, Monterrey, Mexico.

2008
Career survey exhibition: *Lino Tagliapietra in Retrospect: A Modern Renaissance in Italian Glass*, Museum of Glass, Tacoma, Washington, and subsequent tour.

FIG. 86. Lino and Lina, Chateau Ste. Michelle Vineyard and Winery, 1998

CATALOGUE OF THE EXHIBITION

Notes on the object descriptions

With noted exceptions, all objects are designed and made by Lino Tagliapietra. Dimensions are height x width x depth. Some dates and titles differ from previously published material. When precise documentation of design and production dates is lacking, general dates have been provided. What is described as an "experimental design" is a unique object that may have been made in a small number of variations, but that did not go into commercial production. The term "cut" may include either or both *inciso* and *battuto* carving / engraving and their variations. Glass described as "black" may be either a true black or a deep purple. All designs include one or more layers of colorless and colored glasses that are not listed in the descriptions.

1 (PL. 1)
Candlestick, two Flask Vessels, Chalice
Designed by Giorgio Ferro
Vetreria Galliano Ferro, Murano, 1960
Blown opal-white, light green, light amber, and light blue-green glass; original labels
Candlestick: 15 x 4 x 4 (38.1 x 10.2 x 10.2 cm)
Light amber Flask Vessel: 12 ¹/₂ x 4 ¹/₂ x 3 ¹/₂
(31.7 x 11.4 x 19.7 cm)
Blue-green Flask Vessel: 14 ³/₄ x 5 ¹/₄ x 4 ¹/₄
(37.5 x 13.3 x 10.8 cm)
Chalice: 7 ³/₄ x 7 ³/₄ x 7 ³/₄
(19.7 x 19.7 x 19.7 cm)
Collection of Giorgio Ferro / Galliano Ferro

2 (PL. 3)
Saturneo
Experimental design, La Murrina, Murano, 1969
Blown single bubble of amethyst glass with folded, squeezed, and flared ring
4 x 14 ¹/₂ x 14 ¹/₂ (10.2 x 36.8 x 36.8 cm)
Collection of the artist

3 (PL. 2)
"Roman Technique" Bowl
Experimental design, La Murrina, Murano, 1969
Blown colorless glass with topaz trailed spiral, folded and squeezed extrusion
2 ¹/₂ x 6 ¹/₄ x 6 ¹/₄ (6.3 x 15.9 x 15.9 cm)
Collection of the artist

4 (FIG. 92)
Borsella d'Oro (Golden Jacks) Award from the first San Nicolò Exhibition, 1968
2 ¹/₄ x 17 x 5 (5.7 x 43.2 x 12.7 cm)
Collection of the artist

5 (PL. 4)
Vessel
La Murrina, Murano, around 1970
Blown colorless glass overlaid with green glass
9 ¹/₂ x 11 ¹/₂ x 5 ¹/₂ (24.1 x 29.2 x 14 cm)
Private Collection

6 (PL. 5)
Varigola Lamp
La Murrina, Murano, 1970
Blown colorless glass overlaid with white glass; electrical component
Overall: 13 ¹/₂ x 18 x 13 (34.3 x 45.7 x 33 cm)
Collection of Vanna and Lorenzo Quintavalle

7 (PL. 6, 7)
Gropo Plate
Effetre International, Murano, around 1979
Blown white glass with black *zanfirico* cane
2 x 17 x 17 (5 x 43.2 x 43.2 cm)
Collection of Marina Angelin

8 (PL. 7)
Gropo Vessel
Effetre International, Murano, around 1979
Blown white glass with black *zanfirico* cane
13 ¹/₄ x 5 ³/₄ x 5 ³/₄ (33.7 x 14.6 x 14.6 cm)
Collection of the artist

9 (PL. 8)
Vessel
Lino Tagliapietra and Andries Dirk Copier
Made at Effetre International, Murano, 1981
Blown white glass with deep amethyst (appearing black) overlay, white spiral wrap, heavy irregular trailing
8 ¹/₄ x 8 ¹/₄ x 8 ¹/₄ (21 x 21 x 21 cm)
Collection of Silvano and Nelli Tagliapietra

10 (PL. 9)
Vessel
Lino Tagliapietra and Andries Dirk Copier
Made at Effetre International, Murano, 1981
Blown colorless glass with white canes, dark amethyst (appearing black) applications, spiral lip wrap, *zanfirico* cane composition
9 x 11 x 11 (22.7 x 28.2 x 28.2 cm)
Collection of the Düsseldorf, museum kunst palast, Glasmuseum Hentrich (P 1982-13)

11 (PL. 10)
Low Bowl
Lino Tagliapietra and Andries Dirk Copier
Made at Effetre International, Murano, around 1981
Blown colorless glass with white *mezza filigrana* canes, conical "kick" base, *incalmo* rim
4 x 18 x 18 (10.2 x 45.7 x 45.7 cm)
Collection of Marina Angelin

12 (PL. 11)
Footed Vessel
Lino Tagliapietra and Andries Dirk Copier
Made at Effetre International, Murano, 1981
Blown opal-white glass, deflated *incalmo* bubble with *mezza filigrana* cane and spiral wrap
11 x 9 ³/₄ x 9 ³/₄ (27.9 x 24.8 x 24.8 cm)
Collection of the artist

13 (PL. 12)
Vessel
Lino Tagliapietra and Andries Dirk Copier
Made at Effetre International, Murano, 1984
Blown glass with canes and color applications
Height: 9 3/4 x 9 3/4 x 7 1/8 (25 x 25 x 17.8 cm)
Private Collection

14 (PL. 13)
Samarcanda Vessel
Effetre International, Murano, 1981
Blown glass with blue and pink canes,
turned axis
10 1/4 x 8 1/2 x 8 1/2 (26 x 22 x 22 cm)
Collection of Anna and Mario Ferro

15–19 (PL. 15)
Five *Eggs*
Lino Tagliapietra and Marina Angelin
Effetre International, Murano, for Oggetti USA,
around 1982
Mold-blown glass with applied color and *murrine*
Tallest (red): 10 1/2 x 8 x 8
(26.7 x 20.3 x 20.3 cm)
Private Collection (red, white, purple),
Collection of the artist (black), Collection of
Marina Tagliapietra (yellow)

20 (PL. 18)
Terra Aperta Plate
Lino Tagliapietra and Marina Angelin
Experimental design, Effetre International,
Murano, 1982
Colorless glass with trailed spirals, turned axis;
metal stand
Height (including stand): 21 3/4 (55.2 cm); glass
diameter: 15 1/4 (38.7 cm)
Collection of the artist

21 (PL. 19)
Noce dell'Amore Vessel
Experimental design, Effetre International,
Murano, 1982
Blown glass with color application
11 3/4 x 6 1/2 x 6 (29.8 x 16.5 x 15.2 cm)
Private Collection

22 (PL. 16, 17)
Vessel
Lino Tagliapietra and Marina Angelin
Experimental design, Effetre International,
Murano, 1983
Twisted black and white *zanfirico* canes over an
inserted liner of vertical black and white canes,
red lip wrap
7 1/4 x 8 3/4 x 8 3/4 (18.4 x 22.2 x 22.2 cm)
Collection of the artist

23 (PL. 14)
Vessel
Lino Tagliapietra and Marina Angelin
Effetre International, Murano, for Oggetti USA,
1983–1984
Triple *incalmi orizzonte* blue glass with black
canes, hollow folded rim
9 1/4 x 12 1/2 x 12 1/2 (23.5 x 31.7 x 31.7 cm)
Collection of the artist

24 (PL. 20)
Psycho Vessel
Lino Tagliapietra and Marina Angelin
Effetre International, Murano,
designed in 1983, dated 1984
Blown black glass with red canes, red lip wrap,
turned axis
12 1/8 x 5 1/2 x 5 1/2 (30.8 x 14.3 x 14.3 cm)
Collection of the Corning Museum of Glass
(84.3.213)

25 (FIG. 11)
Orfeo Vessel
Lino Tagliapietra and Marina Angelin
Experimental design, Effetre International,
Murano, around 1984
Blown multiple *incalmi* glass with canes and
color applications
9 1/2 x 4 x 6 5/8 (24.1 x 10.2 x 15.2 cm)
Collection of Rosa Barovier Mentasti

26 (FIG. 10)
Orfeo Vessel design sketch
Marina Angelin, around 1984
Ink on paper
8 x 6 (20.3 x 15.2 cm)
Private Collection

27 (PL. 21)
Low *Kratos* Bowl
Effetre International, Murano, around 1984
Blown black glass with red canes, folded and
flared ring
4 x 15 x 15 (10.2 x 38.1 x 38.1 cm)
Collection of the artist

28 (PL. 21)
Kratos Vessel
Effetre International, Murano, around 1984
Blown black glass with red canes, folded and
flared rim
10 x 9 x 9 (25.4 x 22.9 x 22.9 cm)
Private Collection

29 (PL. 23)
Teodorico Platter
Prototype design, Effetre International,
Murano, 1985
Blown colorless glass with black canes
2 1/2 x 27 x 16 1/2 (6.3 x 68.6 x 41.9 cm)
Collection of the artist

30 (PL. 22)
Pueblo Vessel
Lino Tagliapietra and Marina Angelin
Prototype design, Effetre International,
Murano, 1985
Blown triple *incalmi* dark brown glass with
multicolor canes and spiral wrap
9 x 12 1/4 x 12 1/4 (22.9 x 31.1 x 31.1 cm)
Collection of Anna and Mario Ferro

31 (PL. 25)
Rosa Vessel
Prototype design, Effetre International, Murano,
1985
Blown black glass with floral *murrine* applications
9 1/2 x 7 x 3 3/4 (24.1 x 17.8 x 9.5 cm)
Collection of the artist

32 (PL. 24)
Selection of *murrine* cane slices
Various dates
Bundled colored rods, pulled; cut, polished
Varying diameters, 1/2 to 2 (1.3 to 5 cm)
Collection of the artist and Marina Angelin

33 (PL. 26)
Rainbow Vessel
Effetre International, Murano, 1985
Blown colorless glass with multicolor canes in
relief, blue lip wrap
9 1/2 x 10 x 10 (24.1 x 25.4 x 25.4 cm)
Collection of the artist

34 (PL. 27, 28)
Low Bowl with Double Hollow Fold Rim
Effetre International, Murano, around 1986
Blown black glass with liner of white with black
canes, red wrap, double hollow folded rim
5 x 17 1/2 x 17 1/2 (12.7 x 14.4 x 14.4 cm)
Collection of the artist

35 (PL. 27)
Vessel with Hollow Folded Rim
Effetre International, Murano, 1986
Blown white glass with black canes cased in
black, red wrap, hollow folded rim
12 3/4 x 12 3/4 x 12 3/4 (32.4 x 32.4 x 32.4 cm)
Private Collection

36 (PL. 31)
Giada Plate
Effetre International, Murano, around 1986
Blown triple *incalmi* glass with canes
1 1/8 x 19 1/2 x 19 1/2 (2.8 x 49.3 x 49.3 cm)
Collection of the Corning Museum of Glass,
Corning, New York (88.3.25); Gift of Emanuel
and Phyllis Lacher

37 (PL. 30)
Tessuto Vessel
Effetre International, Murano, around 1986
Blown colorless glass with vertical canes,
multiple wraps
15 x 6 5/8 x 9 (38.2 x 17 x 23 cm)
Collection of the Corning Museum of Glass,
Corning, New York (88.3.26); Gift of Emanuel
and Phyllis Lacher

38 (PL. 29)
Saturno Lamp
Effetre International, Murano, around 1987
Blown black *incalmo* glass with white interior,
flared colorless ring with red wrap
Glass: 3 1/8 x 7 x 7 (7.9 x 17.8 x 17.8 cm)
Collection of the artist

FIG. 87. These tweezers were given by Attilio Frondi to Lino when he left the employment of Maestro Vetreria Archimede Seguso in 1955 (CAT. 119)

FIG. 88. Glassblowing tools (left to right): calipers, two straight shears, diamond shears, jacks, round crimps, straight shears, line crimps, *pacioffi* (missing wooden inserts), and *soffietto* (CAT. 119)

166

39 (PL. 32)
Covered Bowl with Artichoke Flower Handle
Experimental design, Effetre International,
Murano, around 1987
Blown blue glass cover and bowl with folded
rims, tooled handle with gold leaf, applied base
10 ¼ X 14 X 14 (26 X 35.6 X 35.6 cm)
Collection of Anna and Mario Ferro

40 (PL. 33)
Covered Bowl
Experimental design, Effetre International,
Murano, around 1987
Blown glass cover and bowl with folded rims,
tooled handle
10 ½ X 16 ¼ X 16 ¼ (26.7 X 41.3 X 41.3 cm)
Collection of the artist

41 (PL. 34)
Dish with Solid Ball
Experimental design, Effetre International,
Murano, around 1987
Blown blue glass with conical "kick" base,
yellow solid *incalmo* ball
6 X 16 ¾ X 16 ¾ (15.2 X 42.5 X 42.5 cm)
Collection of Guido Ferro

42 (PL. 35)
Canetto Vessel
Experimental design, Effetre International,
Murano, 1988
Blown black glass with two types of cut white
canes cased in colorless glass
14 ½ X 7 ½ X 7 ½ (36.8 X 19 X 19 cm)
Collection of the artist

43 (FIG. 45)
T-shirt: "Are you sure Lino done it this way?"
Noble Effort Design, Whidbey Island,
Washington, around 1988
Silk-screen printing on cotton
Collection of Johanna and Richard Marquis

44 (PL. 36)
Viale
Lino Tagliapietra and Dan Dailey
Blown glass by Lino Tagliapietra, painting and
coldworking by Dan Dailey, 1989–1993
Blown glass; sandblasted, acid polished, vitreous
enamel painting
27 X 9 X 9 (68.6 X 23 X 23 cm)
The Archives of Dan Dailey

45 (PL. 37)
Faro
Lino Tagliapietra and Dan Dailey
Blown glass by Lino Tagliapietra, painting and
coldworking by Dan Dailey, 1989–1993
Blown glass; sandblasted, acid polished, vitreous
enamel painting
14 ½ X 8 X 8 (36.8 X 20.3 X 20.3 cm)
The Archives of Dan Dailey

46 (PL. 38)
Vessel, 1990
Blown glass with green and black *zanfirico* canes
15 ¾ X 8 X 8 (40 X 20.3 X 20.3 cm)
Collection of the artist

47 (PL. 39)
Saturneo, 1990
Blown *incalmo* glass with folded, squeezed, and
flared ring
10 ½ X 10 ½ X 10 ½ (26.7 X 26.7 X 26.7 cm)
Private Collection

48 (PL. 40)
Red *Occhi* Vessel, 1991
Blown colorless glass with vertical orange, red,
and amethyst canes, red overlay, black trailed
spiral; cut and polished lenses
11 ½ X 10 X 6 (29.2 X 25.4 X 15.2 cm)
Collection of the artist

49 (PL. 42)
Saturno, 1993
Blown triple *incalmi* glass, flared ring with black
rim wrap
5 ¼ X 14 ¾ X 14 ¾ (13.3 X 37.4 X 37.4 cm)
Private Collection

50 (PL. 41)
Hopi, 1993
Blown glass with twisted and pinched canes
18 X 9 ¾ X 9 ¾ (45.7 X 25 X 25 cm)
Private Collection

51 (PL. 43)
Alfabeto: "E," 1993
Blown colorless glass with multicolor spiral
wraps, folded and cut while hot
6 ¼ X 8 ¼ X 5 (15.9 X 21 X 12.7 cm)
Collection of the artist

52 (PL. 44)
Faraónico Vessel, 1993
Blown black glass with applied dichroic cane
composition
19 ¼ X 6 ¾ X 6 ¾ (48.9 X 17.1 X 17.1 cm)
Collection of Silvano and Nelli Tagliapietra

53 (PL. 45)
Decroico Panel, 1993
Fused dichroic glass canes; metal stand
17 ³/₄ x 16 ¹/₄ x ¹/₄ (45 x 41.3 x .6 cm)
Private Collection

54 (PL. 46, 47)
Notte del Redentore Vessel, 1995
Blown colorless glass with multicolor wraps and
irregular black trailing, vertical squeezed crease
on one side
16 ¹/₂ x 6 x 3 ¹/₂ (41.9 x 15.2 x 8.9 cm)
Collection of Marina Tagliapietra

55 (PL. 48)
Mukilteo, 1996
Blown glass with multicolor and multilayer
canes; cut
13 ¹/₂ x 12 x 6 (34.3 x 30.4 x 15.2 cm)
Courtesy of Lino Tagliapietra, Inc.

56 (PL. 49)
Madras, 1996
Blown glass with multicolor and multilayer
irregular canes
15 ³/₄ x 12 x 3 ¹/₂ (40 x 30.5 x 8.9 cm)
Courtesy of Lino Tagliapietra, Inc.

57 (PL. 50)
Madras, 1998
Blown glass with multicolor and multilayer
canes; cut
18 ¹/₂ x 11 ¹/₂ x 6 (47 x 29.2 x 15.2 cm)
Courtesy of Lino Tagliapietra, Inc.

58 (PL. 51)
Manhattan Sunset, 1997
Blown glass with canes; cut; steel and glass base
Overall: 67 x 60 x 20 (170.2 x 152.4 x 50.8 cm)
Collection of the Museum of Glass, Tacoma,
Washington

59 (PL. 52)
Fenice II
Steuben Glass, Corning, New York, 1998
Blown colorless lead glass; cut
13 x 3 ¹/₈ x 8 (33 x 8 x 20.4 cm)
Collection of the Corning Museum of Glass,
Corning, New York (2000.4.8); Gift of Royal &
Sun Alliance and Christina Rifkin

60 (PL. 54)
Saturno
Steuben Glass, Corning, New York, 1998
Blown colorless lead glass *incalmo*, flared ring;
battuto cutting
6 ¹/₂ x 15 x 15 (16.6 x 37.9 x 37.9 cm)
Collection of the Corning Museum of Glass
(2000.4.54); Gift of Steuben Glass, Inc.

61 (PL. 55)
Akira I
Blown at Steuben Glass, Corning,
New York, 1998
Blown colorless lead glass
12 ³/₄ x 11 x 5 ¹/₄ (32.4 x 27.9 x 13.3 cm)
Courtesy of Lino Tagliapietra, Inc.

62 (PL. 53)
Reflessi II
Blown at Steuben Glass, Corning,
New York, 1998
Blown colorless lead glass with twisted
canes in relief
16 ¹/₄ x 11 ³/₄ x 7 ¹/₂ (41.3 x 29.8 x 19 cm)
Courtesy of Lino Tagliapietra, Inc.

63 (PL. 57)
Batman, 1998
Blown glass with red and black canes, turned
axis; *battuto* cutting
11 ¹/₂ x 15 ¹/₄ x 3 ¹/₂ (29.2 x 38.7 x 8.9 cm)
Courtesy of Lino Tagliapietra, Inc.

64 (PL. 59)
Batman, 1998
Blown glass with red canes, turned axis;
inciso cutting
13 ¹/₄ x 12 ¹/₄ x 3 ³/₄ (33.7 x 31.1 x 9.5 cm)
Courtesy of Lino Tagliapietra, Inc.

65 (PL. 58)
Batman, 1998
Blown glass with blue and yellow canes, turned
axis; *inciso* cutting
14 x 11 x 4 (35.6 x 28 x 10.1 cm)
Courtesy of Lino Tagliapietra, Inc.

66 (PL. 56)
Batman, 1998
Blown glass with composite canes, turned axis;
inciso cutting
10 ¹/₂ x 13 x 4 (26.7 x 33 x 10.1 cm)
Courtesy of Lino Tagliapietra, Inc.

67 (PL. 60)
Batman, 1998
Blown glass with composite and yellow canes,
turned axis; *inciso* cutting
9 ³/₄ x 19 x 3 ¹/₄ (24.5 x 48.3 x 8.3 cm)
Courtesy of Lino Tagliapietra, Inc.

68 (PL. 61)
Endeavor (installation of 35 boats), 1998–2003
Blown glass with multicolor canes; cut
Individual boats: 45 x 5 x 5 ¹/₄
(114.3 x 12.7 x 13.3 cm) to 79 x 5 ¹/₄ x 8 ¹/₂
(200.7 x 14 x 21.6 cm)
Courtesy of Lino Tagliapietra, Inc.

69 (PL. 80)
Eve, 1998
Blown glass with canes, creased on one side; cut
28 x 9 x 7 ¹/₂ (71.1 x 22.9 x 19 cm)
Courtesy of Lino Tagliapietra, Inc.

70 (PL. 62)
Saturno, 1998
Blown *incalmo* glass with flared ring, multicolor
wraps and irregular trailing; metal stand
26 x 29 x 6 (66 x 73.7 x 15.2 cm)
Courtesy of Lino Tagliapietra, Inc.

71 (PL. 63)
Tholtico, 1998
Blown glass with composite canes; cut
18 ¹/₂ x 8 ¹/₂ x 8 ¹/₂ (47 x 21.6 x 21.6 cm)
Courtesy of Lino Tagliapietra, Inc.

72 (PL. 64)
Tholtico, 1999
Blown glass with composite canes; cut
14 ¹/₄ x 12 ¹/₂ x 12 ¹/₂ (36.2 x 31.7 x 31.7 cm)
Courtesy of Lino Tagliapietra, Inc.

73 (PL. 65)
Provenza, 1999
Blown triple *incalmi* glass with yellow and black
flat canes; cut
15 ¹/₂ x 15 ¹/₂ x 6 ³/₄ (39.4 x 39.4 x 17.1 cm)
Courtesy of Lino Tagliapietra, Inc.

74 (PL. 66)
Provenza, 2000
Blown red glass with composition of yellow
and black flat canes
20 ¹/₄ x 15 x 9 (51.4 x 38.1 x 22.9 cm)
Courtesy of Lino Tagliapietra, Inc.

75 (PL. 67)
Provenza, 2006
Blown blue glass with composition of yellow and
black flat canes; cut
20 ¹/₂ x 8 ¹/₂ x 8 ¹/₂ (52 x 21.6 x 21.6 cm)
Courtesy of Lino Tagliapietra, Inc.

76 (PL. 68)
Spirale, 1999
Blown glass with canes, squeezed and twisted
27 ¹/₂ x 5 ¹/₂ x 5 ¹/₂ (69.8 x 14 x 14 cm)
Private Collection

77 (PL. 69)
Etna, 1999
Blown colorless glass cased in black and brown,
oxygen-reduced surface; cut
12 x 12 ¹/₄ x 7 ³/₄ (30.5 x 31.1 x 19.7 cm)
Courtesy of Lino Tagliapietra, Inc.

78 (PL. 70)
Bisanzio
Made at Bullseye Glass, Portland, Oregon, 1999
Fused cane lengths and *murrine*; metal stand
Panel: 20 x 29 x 1 (50.8 x 73.7 x 2.5 cm)
Courtesy of Lino Tagliapietra, Inc.

79 (PL. 71)
George
Made at Bullseye Glass, Portland, Oregon, 1999
Fused cane lengths and *murrine*; metal stand
Panel: 60 1/4 X 30 X 1 (153 X 76.2 X 2.5 cm)
Courtesy of Lino Tagliapietra, Inc.

80 (PL. 74)
Natoalos, 2000
Blown glass with *mezza filigrana* canes,
squeezed and folded; metal stand
Glass: 23 1/2 X 24 1/4 X 11 1/2
(59.7 X 61.6 X 29.2 cm)
Courtesy of Lino Tagliapietra, Inc.

81 (PL. 72)
Nubia, 2000
Blown triple *incalmi* glass with black and white
canes, Pilchuck '96 technique; cut
15 1/2 X 10 1/4 X 7 1/4 (39.4 X 26 X 18.4 cm)
Courtesy of Lino Tagliapietra, Inc.

82 (PL. 73)
Trullo, 2000
Blown glass with canes; cut and then encased in
colorless glass
18 1/2 X 14 1/2 X 14 1/2 (47 X 36.8 X 36.8 cm)
Courtesy of Lino Tagliapietra, Inc.

83 (PL. 75)
Venere in Seta, 2000
Blown glass with multicolor and multilayered
canes; cut
21 1/2 X 7 3/4 X 5 1/2 (54.6 X 19.7 X 14 cm)
Courtesy of Lino Tagliapietra, Inc.

84 (PL. 76)
Cornacchia, 2000
Blown *incalmo* glass with irregular *zanfirico*
canes, turned axis; cut
12 1/4 X 12 X 4 3/4 (31.1 X 30.5 X 12 cm)
Courtesy of Lino Tagliapietra, Inc.

85 (PL. 78)
Bilbao, 2001
Blown glass with multiple *incalmi*, multicolor
canes, turned axis; *battuto* and *inciso* cutting
24 1/2 X 10 X 7 (62.2 X 25.4 X 17.8 cm)
Courtesy of Lino Tagliapietra, Inc.

86 (PL. 77)
Hopi, 2001
Blown triple *incalmi* glass with red and
black canes
13 1/4 X 14 1/2 X 14 1/2 (33.7 X 36.8 X 36.8 cm)
Courtesy of Lino Tagliapietra, Inc.

87 (PL. 79)
Borneo, 2001
Blown glass with twisted yellow canes in relief
31 1/4 X 10 X 10 (79.4 X 25.4 X 25.4 cm)
Courtesy of Lino Tagliapietra, Inc.

88 (PL. 82)
Angel Tear, 2002
Blown glass with multicolored canes, turned axis
55 X 12 X 6 (139.7 X 30.5 X 15.2 cm)
Courtesy of Lino Tagliapietra, Inc.

89 (PL. 81)
Curaçao, 2002
Blown *incalmo* glass with blue canes; cut
30 3/4 X 8 X 7 1/2 (78.1 X 20.3 X 19 cm)
Courtesy of Lino Tagliapietra, Inc.

90 (PL. 83)
Puffin, 2002
Blown *incalmo* glass with overlaid color,
turned axis; cut
17 3/4 X 9 3/4 X 6 3/4 (45.1 X 24.8 X 17.1 cm)
Courtesy of Lino Tagliapietra, Inc.

91 (PL. 84)
Riverstone, 2002
Blown glass with irregular *zanfirico* canes,
spiral wrap, turned axis; cut
18 X 17 1/2 X 6 (45.7 X 44.4 X 15.2 cm)
Courtesy of Lino Tagliapietra, Inc.

92 (PL. 85)
Oca, 2002
Blown triple *incalmi* glass with black and white
canes, Pilchuck '96 technique; cut
42 1/4 X 9 1/2 X 7 1/2 (107.3 X 24.1 X 19 cm)
Courtesy of Lino Tagliapietra, Inc.

93 (PL. 86)
Oca, 2002
Blown glass with black canes, Pilchuck '96
technique; cut
50 1/4 X 8 3/4 X 6 1/4 (127.6 X 22.2 X 15.9 cm)
Courtesy of Lino Tagliapietra, Inc.

94 (PL. 89)
Hopi, 2003
Blown glass with twisted and pinched canes
12 1/2 X 16 1/4 X 16 1/4 (31.7 X 41.3 X 41.3 cm)
Courtesy of Lino Tagliapietra, Inc.

95 (PL. 87)
Hopi, 2003
Blown glass with twisted and pinched canes
13 3/4 X 16 1/4 X 16 1/4 (34.9 X 41.3 X 41.3 cm)
Courtesy of Lino Tagliapietra, Inc.

96 (PL. 88)
Hopi, 2003
Blown glass with twisted and pinched canes
14 X 15 X 15 (35.6 X 38.1 X 38.1 cm)
Courtesy of Lino Tagliapietra, Inc.

97 (PL. 90, 91)
Atlantis, 2003
Blown *pulegoso*, applied, twisted, and
pinched canes
25 1/2 X 12 1/4 X 6 1/4 (64.8 X 31.1 X 15.9 cm)
Courtesy of Lino Tagliapietra, Inc.

98 (PL. 92)
Silea, 2003
Blown glass with *zanfirico* cane patchwork
29 1/2 X 9 X 6 3/4 (74.9 X 22.9 X 17.1 cm)
Courtesy of Lino Tagliapietra, Inc.

99 (PL. 93)
Dinosaur, 2004
Blown glass with multiple *incalmi*,
turned axis; cut
70 1/2 X 11 X 6 1/2 (179.1 X 27.9 X 16.5 cm)
Courtesy of Lino Tagliapietra, Inc.

100 (PL. 94)
Stromboli, 2004
Blown glass with *murrine*; cut
17 1/4 X 10 1/2 X 5 1/2 (43.8 X 26.7 X 14 cm)
Courtesy of Lino Tagliapietra, Inc.

101 (PL. 95)
Stromboli, 2004
Blown glass with *murrine*; cut
20 1/4 X 10 X 6 1/4 (51.4 X 25.4 X 15.9 cm)
Courtesy of Lino Tagliapietra, Inc.

102 (PL. 96)
Stromboli, 2004
Blown glass with *murrine*; cut
23 1/4 X 9 X 6 (59.1 X 22.9 X 15.2 cm)
Collection of the artist

103 (PL. 99)
Cello, 2006
Blown glass with criss-crossed canes, turned axis
27 X 16 3/4 X 7 1/4 (68.6 X 42.5 X 18.4 cm)
Courtesy of Lino Tagliapietra, Inc.

104 (PL. 97, 98)
Dinosaur, 2006
Blown multiple *incalmi* glass with canes, turned
axis; *inciso* cutting
61 X 17 X 5 3/4 (154.9 X 43.2 X 14.6 cm)
Courtesy of Lino Tagliapietra, Inc.

105 (PL. 100)
Mandara, 2006
Blown glass with multiple *incalmi*, criss-crossed
canes, Pilchuck '96 technique; cut
16 3/4 X 11 X 5 1/2 (42.5 X 27.9 X 14 cm)
Courtesy of Lino Tagliapietra, Inc.

106 (PL. 101)
Mandara, 2006
Blown glass with multiple *incalmi*, criss-crossed
canes, Pilchuck '96 technique; cut
22 3/4 X 15 3/4 X 7 1/2 (57.8 X 40 X 19.1 cm)
Courtesy of Lino Tagliapietra, Inc.

107 (PL. 102)
Mandara, 2006
Blown glass with multiple *incalmi*, criss-crossed
canes, Pilchuck '96 technique; cut
36 1/2 X 6 1/4 X 7 1/4 (92.7 X 15.9 X 18.4 cm)
Courtesy of Lino Tagliapietra, Inc.

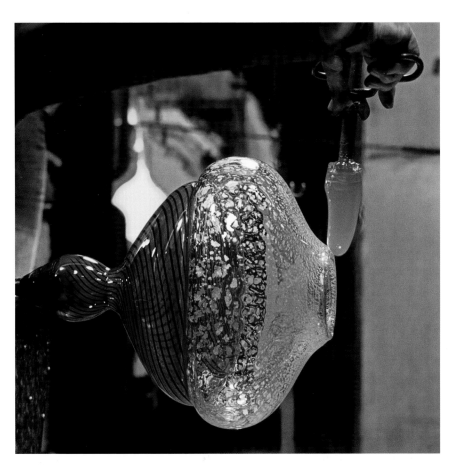

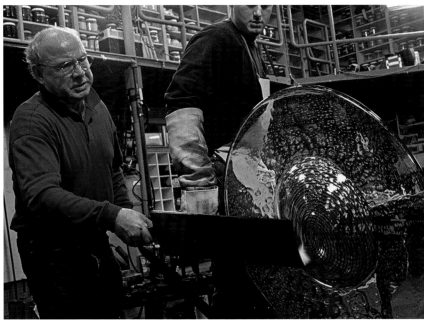

108 (PL. 103)
Fenice, 2006
Blown glass with multiple *incalmi*; cut
10 ³/₄ X 38 ¹/₂ X 6 (27.3 X 97.8 X 15.2 cm)
Courtesy of Lino Tagliapietra, Inc.

109 (PL. 104)
Small *Saturneo*, 2006
Made at Nagoya University of Arts, Japan
Blown colorless glass with folded and flared ring,
conical "kick" base
3 ¹/₄ X 9 ¹/₄ X 9 ¹/₄ (8.3 X 23.5 X 23.5 cm)
Collection of the artist

110 (PL. 105)
Piccadilly, 2006
Blown multiple *incalmi* glass and multicolor
canes; cut
14 ¹/₄ X 17 ¹/₂ X 17 ¹/₂ (36.2 X 44.4 X 44.4 cm)
Courtesy of Lino Tagliapietra, Inc.

111 (PL. 106)
Medusa, 2006
Blown glass with multiple inserted *incalmi* with
canes, multiple turned axes; cut
15 ³/₄ X 17 ¹/₄ X 6 (40 X 43.8 X 15.2 cm)
Courtesy of Lino Tagliapietra, Inc.

112 (PL. 107)
Medusa, 2007
Blown glass with multiple inserted *incalmi* with
canes, multiple turned axes; cut
18 ¹/₂ X 19 ³/₄ X 6 ¹/₄ (47 X 50.1 X 15.9 cm)
Courtesy of Lino Tagliapietra, Inc.

113 (PL. 108)
Makah, 2007
Blown glass with multiple *incalmi*, criss-crossed
canes, Pilchuck '96 technique; cut
25 X 11 ¹/₄ X 6 ¹/₂ (63.5 X 28.6 X 16.5 cm)
Courtesy of Lino Tagliapietra, Inc.

114 (PL. 109)
Ostuni, 2007
Blown glass with canes; cut
22 X 13 ³/₄ X 8 ¹/₂ (55.9 X 34.9 X 21.6 cm)
Courtesy of Lino Tagliapietra, Inc.

115 (PL. 111)
Cornacchia, 2007
Blown *incalmo* glass with black canes,
turned axis; cut
16 X 20 ³/₄ X 7 ³/₄ (40.6 X 52.7 X 19.7 cm)
Courtesy of Lino Tagliapietra, Inc.

116 (PL. 110)
Asola, 2007
Blown colorless glass with canes
22 ¹/₂ X 13 ³/₄ X 7 (57.1 X 34.9 X 17.8 cm)
Courtesy of Lino Tagliapietra, Inc.

117 (PL. 112)
Dinosaur, 2007
Blown colorless glass, turned axis; *inciso* cutting
55 X 17 X 6 ¹/₂ (139.7 X 43.1 X 16.5 cm)
Courtesy of Lino Tagliapietra, Inc.

118 (PL. 113)
Selection of *Bonboniere* (party favors)
Various dates and techniques
Approximate maximum diameter: 4 (10.2 cm)
Collection of the artist

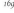169

119 (FIGS. 87, 88)
Selection of glassblowing tools: calipers, two
straight shears, diamond shears, jacks, round
crimps, straight shears, line crimps, *pacioffi*
(missing wooden inserts), and *soffietto*
Collection of the artist

120 (PL. 115)
Goblet in late 16th- to early 17th-century design
Made at the Glass Eye studio, Seattle,
Washington, 1983
Blown glass, *mezza stampaùra* technique
6 ³/₄ X 4 ¹/₄ X 4 ¹/₄ (17.2 X 10.8 X 10.8 cm)
Collection of Dante and Alison Marioni

121 (PL. 116, 117)
Covered Dragon-stem Goblet
Made at the Haystack Mountain School of
Crafts, Maine, 1992
Blown glass with folded rims, hotworked
dragon stem and handle
12 X 3 ¹/₂ X 3 ¹/₂ (30.5 X 8.9 X 8.9 cm)
Collection of Dante and Alison Marioni

122 (PL. 115)
Goblet, mid-16th-century design, 1997
Blown colorless glass with hollow stem
8 x 5 3/4 x 5 3/4 (20.3 x 14.6 x 14.6 cm)
Private Collection

123 (PL. 115)
Goblet
Made at Marquis Studio, Whidbey Island,
Washington, around 1989
Blown *incalmo* (one bubble with canes in the
reticello technique), red rim wraps, hollow stem
6 7/8 x 5 1/4 x 5 1/4 (17.5 x 13.3 x 13.3 cm)
Collection of Johanna and Richard Marquis

124
Goblet
Made at Marquis Studio, Whidbey Island,
Washington, around 1989
Blown glass flute bowl, double-cup stem
8 1/4 x 3 3/4 x 3 3/4 (21 x 9.5 x 9.5 cm)
Collection of Johanna and Richard Marquis

125 (PL. 122)
Dragon-stem Goblet, 1991–1994
Blown glass bowl and foot with white *zanfirico*
canes, hotworked dragon stem with gold leaf and
red tongue
7 5/8 x 4 13/16 x 4 13/16 (19.4 x 12.2 x 12.2 cm)
George R. Stroemple Collection

126
Amphoriskos-stem Goblet, 1991–1994
Blown glass bowl and foot with white *zanfirico*
canes, wide bowl with tapered sides and "semi-
collapsed" conical base, hollow *amphoriskos* stem
with diagonal white canes, applied handles with
gold leaf
7 7/8 x 5 x 5 (20 x 12.7 x 12.7 cm)
George R. Stroemple Collection

127
Ruby Goblet, 1991–1994
Blown ruby glass, hollow baluster stem with
knop, gold leaf spiraling
7 2/16 x 5 1/8 x 5 1/8 (18.1 x 13 x 13 cm)
George R. Stroemple Collection

128
Amphoriskos-stem Goblet, 1991–1994
Blown glass bowl and foot with white *zanfirico*
canes, hollow *amphoriskos* stem with diagonal
blue and green canes, applied colorless handles
5 9/16 x 4 11/16 x 4 11/16 (14.1 x 11.9 x 11.9 cm)
George R. Stroemple Collection

129 (PL. 121)
Goblet, 1991–1994
Blown glass bowl and foot with *zanfirico* canes,
red rim wrap; hollow ribbed stem with red-
tipped petal motif and scalloped applications
6 1/4 x 5 1/16 x 5 1/16 (15.9 x 12.9 x 12.9 cm)
George R. Stroemple Collection

130
Goblet, 1991–1994
Blown glass bowl and foot with white *zanfirico*
canes, pink rim wraps, hollow vertical ribbed
stem with knop in light gray, scalloped
applications
6 3/4 x 5 x 5 (17.1 x 12.7 x 12.7 cm)
George R. Stroemple Collection

131
Goblet, 1991–1994
Blown glass with overall spiraling white *filigrana*
canes, band of alternating pink and blue canes
tapers from bowl to foot, hollow baluster stem
6 1/4 x 4 1/2 x 4 1/2 (15.9 x 11.4 x 11.4 cm)
George R. Stroemple Collection

132 (PL. 124)
Goblet, 1991–1994
Blown glass bowl and foot with pink and blue
zanfirico canes, hollow optic-ribbed stem with
four pinched vertical applications
7 1/2 x 4 1/2 x 4 1/2 (19 x 11.4 x 11.4 cm)
George R. Stroemple Collection

133 (PL. 119)
Swan-stem Goblet, 1991–1994
Blown green glass bowl and foot, hotworked
swan stem of colorless glass with gold leaf
5 5/8 x 4 13/16 x 4 13/16 (14.3 x 12.2 x 12.2 cm)
George R. Stroemple Collection

134 (PL. 120)
Notte del Redentore Goblet
Made at Marquis Studio, Whidbey Island,
Washington, 1991–1994
Blown colorless glass with overall multicolor
wraps and irregular black trailing, bucket-shaped
bowl and foot
7 1/8 x 5 1/4 x 5 1/4 (18.1 x 13.3 x 13.3 cm)
George R. Stroemple Collection

135
Dolphin-stem Goblet, 1991–1994
Blown glass bowl and foot with black *zanfirico*
canes, hotworked dolphin stem with gold leaf
and short hollow baluster section
6 13/16 x 5 3/4 x 5 3/4 (17.3 x 14.6 x 14.6 cm)
George R. Stroemple Collection

136
Amphoriskos-stem Goblet, 1991–1994
Blown glass bowl and foot with pink, blue, and
white *zanfirico* canes, hollow *amphoriskos* stem
with gold leaf, applied red handles and wrap
5 3/8 x 5 1/4 x 5 1/4 (13.6 x 13.3 x 13.3 cm)
George R. Stroemple Collection

137
Dragon-stem Goblet, 1991–1994
Craquelure surface glass bowl and foot with gold
leaf, hotworked dragon stem with gold leaf
8 3/4 x 4 9/16 x 4 9/16 (22.2 x 11.6 x 11.6 cm)
George R. Stroemple Collection

138
Goblet, 1991–1994
Blown *mezza stampaùra* glass bowl with *zanfirico*
canes, hollow stem with red wrap and gold leaf,
and vertical scalloped applications
6 1/16 x 5 5/16 x 5 5/16 (15.4 x 13.5 x 13.5 cm)
George R. Stroemple Collection

139 (PL. 118)
Goblet, 1991–1994
Blown glass bowl and foot of light blue-green
glass with spiral pattern, blue *incalmo* band
on bowl, hollow tapered stem with black
zanfirico canes
9 1/8 x 5 5/8 x 5 5/8 (23.2 x 14.3 x 14.3 cm)
George R. Stroemple Collection

140 (PL. 118, 120)
Goblet, 1991–1994
Blown glass bowl and bell-shaped foot, columnar
stem with spiral wrap and hollow knops
8 11/16 x 4 3/8 x 4 3/8 (22.1 x 11.1 x 11.1 cm)
George R. Stroemple Collection

141
Goblet
Made at Marquis Studio, Whidbey Island,
Washington, 1991–1994
Blown green glass conical bowl with red ribs and
rim wrap, solid straight green stem, knop with
spiraling red canes
9 x 5 x 5 (22.9 x 12.7 x 12.7 cm)
George R. Stroemple Collection

142 (PL. 118, 123)
Goblet
Made at Marquis Studio, Whidbey Island,
Washington, 1991–1994
Blown glass bowl and foot of light blue with
spiraling green canes, hollow amber tapered stem
with spiraling
8 7/8 x 5 3/4 x 5 3/4 (22.5 x 14.6 x 14.6 cm)
George R. Stroemple Collection

143 (PL. 118, 120)
Goblet, 1991–1994
Blown glass bowl with raised pink canes and
brown *incalmo* band, hollow stem with canes and
optical ribbing, raised pink canes on foot
8 9/16 x 4 13/16 x 4 13/16 (21.7 x 12.2 x 12.2 cm)
George R. Stroemple Collection

144 (PL. 118)
Goblet
Made at Marquis Studio, Whidbey Island,
Washington, 1991–1994
Blown glass conical bowl and foot with spiraling
black canes, blue rim wraps, hollow tapered stem
with vertical blue canes
9 7/8 x 6 11/16 x 6 11/16 (25.1 x 17 x 17 cm)
George R. Stroemple Collection

145
Goblet, 1991–1994
Blown glass bowl and foot with white *zanfirico*
canes, stem comprised of a stacked pair of
hollow knop and baluster components
8 7/8 x 6 5/16 x 6 5/16 (22.5 x 16 x 16 cm)
George R. Stroemple Collection

146
Goblet
Made at Marquis Studio, Whidbey Island,
Washington, 1991–1994
Blown glass bowl (flute) and foot with blue canes
in the *reticello* technique, hollow tapered stem
with spiraling blue canes
11 $^7/_8$ x 4 x 4 (30.2 x 10.2 x 10.2 cm)
George R. Stroemple Collection

147
Double Dragon / Serpent-stem Goblet,
1991–1994
Blown glass bowl and foot with white *mezza
filigrana* canes, red rim wraps, symmetrical
hotworked double dragon / serpent stem
9 $^1/_8$ x 3 $^5/_8$ x 3 $^5/_8$ (23.2 x 9.2 x 9.2 cm)
George R. Stroemple Collection

148
Dragon / Serpent-stem Goblet, 1991–1994
Blown pink glass *zanfirico* bowl and foot,
hotworked dragon / serpent "knot" stem with
blue canes and gold leaf
5 $^{15}/_{16}$ x 3 $^5/_8$ x 3 $^5/_8$ (15.1 x 9.2 x 9.2 cm)
George R. Stroemple Collection

149
Goblet
Made at Marquis Studio, Whidbey Island,
Washington, 1991–1994
Blown glass with red and black canes, hollow
stem with twisted black canes
9 $^{11}/_{16}$ x 3 $^1/_2$ x 3 $^1/_2$ (24.6 x 8.9 x 8.9 cm)
George R. Stroemple Collection

150 (PL. 118)
Goblet
Made at Marquis Studio, Whidbey Island,
Washington, 1991–1994
Blown triple *incalmi* glass bowl with red band
and two-color *mezza filigrana*, hollow stem with
optic ribbing and twisted canes, white *mezza
filigrana* foot
10 $^1/_8$ x 3 $^3/_8$ x 3 $^3/_8$ (25.7 x 8.6 x 8.6 cm)
George R. Stroemple Collection

151
Swan-stem Goblet, 1991–1994
Blown glass bowl and foot with twisted ribbon
canes, solid hotworked swan stem with gold leaf
8 $^3/_8$ x 3 $^{11}/_{16}$ x 3 $^{11}/_{16}$ (21.3 x 9.4 x 9.4 cm)
George R. Stroemple Collection

152
Ruby Goblet, 1991–1994
Blown ruby glass with hollow stem of graduated
knops descending in size
8 $^1/_{16}$ x 3 $^{11}/_{16}$ x 3 $^{11}/_{16}$ (20.5 x 9.4 x 9.4 cm)
George R. Stroemple Collection

153
Spirale Goblet
Made at Marquis Studio, Whidbey Island,
Washington, 1991–1994
Blown glass bowl and stem with canes and
internal spirals
8 $^1/_{16}$ x 3 $^1/_{16}$ x 3 $^1/_{16}$ (20.5 x 7.8 x 7.8 cm)
George R. Stroemple Collection

154
Floral Goblet, 1991–1994
Blown glass bowl and foot with amethyst and
green canes, hollow stem with optic-ribbing and
twisted canes, application of tooled blossoms
with gold leaf leaves and coils
9 x 6 $^1/_4$ x 6 $^1/_4$ (22.9 x 15.9 x 15.9 cm)
George R. Stroemple Collection

155
Dragon / Serpent-stem Goblet, 1991–1994
Blown glass bowl and foot with white canes,
hotworked dragon / serpent "knot" stem with red
canes and gold leaf
9 $^1/_8$ x 3 $^5/_8$ x 3 $^5/_8$ (23.2 x 9.2 x 9.2 cm)
George R. Stroemple Collection

156
Spirale Goblet
Made at Marquis Studio, Whidbey Island,
Washington, 1991–1994
Blown glass bowl (flute) with canes and internal
spirals, hollow spherical knop stem with canes
10 x 3 $^3/_{16}$ x 3 $^3/_{16}$ (25.4 x 8.1 x 8.1 cm)
George R. Stroemple Collection

157
Dolphin-stem Goblet, 1991–1994
Blown glass bowl and foot with blue *zanfirico*
canes, blue solid hotworked dolphin stem with
red eye
6 $^1/_2$ x 3 $^1/_2$ x 3 $^1/_2$ (16.5 x 8.9 x 8.9 cm)
George R. Stroemple Collection

158 (PL. 119)
Feather-stem Goblet
Made at Marquis Studio, Whidbey Island,
Washington, 1991–1994
Blown ruby glass bowl and foot, hotworked
feather stem with gold leaf
7 $^1/_2$ x 3 x 3 (19 x 7.6 x 7.6 cm)
George R. Stroemple Collection

159
C-stem Goblet, 1991–1994
Blown glass bowl (flute) and foot with spiraling
orange, amber, and white canes; hotworked "C"-
shaped striped stem with ribbed knop
6 $^1/_2$ x 3 $^1/_2$ x 3 $^1/_2$ (16.5 x 8.9 x 8.9 cm)
George R. Stroemple Collection

160 (PL. 119)
Goblet, 1991–1994
Blown glass bowl and foot with light green
zanfirico canes, bowl has narrow brown *incalmo*
band, hollow baluster stem with petals and
vertical canes
6 $^5/_8$ x 6 $^1/_2$ x 6 $^1/_2$ (16.8 x 16.5 x 16.5 cm)
George R. Stroemple Collection

161
Goblet, 1991–1994
Blown glass conical bowl and foot with red
canes in large stylized diamond pattern, hollow
baluster stem
6 $^5/_8$ x 6 $^1/_2$ x 6 $^1/_2$ (16.8 x 16.5 x 16.5 cm)
George R. Stroemple Collection

162
Floral Goblet, 1991–1994
Blown glass bowl and foot with gold leaf
spiraling, hotworked stem of two large pink
blossoms (one with blue tips) and gold leaf coils
7 $^7/_8$ x 6 x 6 (20 x 15.2 x 15.2 cm)
George R. Stroemple Collection

163
Goblet, 1991–1994
Blown glass bowl and foot, hollow tapered stem,
overall blue and black *zanfirico* canes
7 $^1/_8$ x 6 $^5/_8$ x 6 $^5/_8$ (18.1 x 16.8 x 16.8 cm)
George R. Stroemple Collection

164 (PL. 125)
Saturno Goblet, 1995
Blown glass bowl (flute) with *Saturno*
stem and canes
9 $^1/_2$ x 4 $^1/_4$ x 4 $^1/_4$ (24.1 x 10.8 x 10.8 cm)
Private Collection

165 (PL. 125)
Goblet, 1991
Blown "Madonna blue" glass encased in ruby
glass with gold leaf, hollow stem
9 x 4 $^3/_4$ x 4 $^3/_4$ (22.9 x 12.1 x 12.1 cm)
Private Collection

166 (PL. 125)
Dolphin-stem Goblet, 1997
Blown glass with canes, hotworked stem with
gold leaf
10 $^3/_4$ x 3 $^3/_4$ x 3 $^3/_4$ (27.3 x 9.5 cm)
Private Collection

167 (PL. 125)
Goblet, 1999
Blown glass bowl and foot with white canes in
reticello technique, hollow stem with black canes
8 $^1/_4$ x 4 x 4 (21 x 10.2 x 10.2 cm)
Private Collection

168 (PL. 125)
Goblet, 2000
Blown glass bowl and foot with red canes,
hollow stem with blue canes
10 x 4 x 4 (25.4 x 10.2 x 10.2 cm)
Private Collection

169 (PL. 125)
Goblet, 2003
Blown *pulegoso* glass, hollow stem with
applications
9 $^1/_2$ x 5 x 5 (24.1 x 12.7 x 12.7 cm)
Private Collection

SERIES AND INSTALLATIONS

This list, assembled by Cecilia Chung, Director of Lino Tagliapietra, Inc., is a chronology of the key series and installations created by Lino Tagliapietra as an independent artist. It should be noted that the creation of many of the designs and their variations is ongoing, and that the series often overlap one another. In addition, prior to late 1996 there was little uniformity in titling the work; therefore, some similar designs have different names. Closely related examples are grouped together and explained in the footnotes. Lino Tagliapietra has also made numerous unique objects that are not included here.

Initial Date and Title with Subsequent Variations

1987	1996	1999	2003			
Spirale	*Riverstone*	*Ala*	*Venice*[10]			
		Altare				
1988	1997	*Coinbra*	2005			
Saturno[1]	*Cantu*	*La Carta dei Songi*[7]	*Medusa*			
	Dinosaur, Concerto, Concerto di Primavera,	*Oca*	*Piccadilly*			
1990	*Samba do Brasil, Diaspora,*	*Ostuni*				
Saturneo[2]	*Esodo, Lettera*[6]	*Silea*	2006			
	Eve		*Makah*			
1993	*Hama Hama*	2000	*Marumea*[11]			
Gabbia	Spider	Borneo[3]	*Venere in Seta*	*Spigatoni	Bilbao*[8]	*Pietraluna*
Hopi			*Saba*			
Natoalos	1998	2001				
	Batman	*Stromboli*	2007			
1995	*Coronado*		*Asola*			
Angel Tear	*Fenice*	2002	*Beirut*			
Gondola	Endeavor, Adriatica,	*Golden Age*	*Cello*	*Corinto*		
Festa della Sensa, Flying Boats[4]	*Pago Pago*	*Mandara*	*Dover*			
Madras	*Provenza*	*Masai, Masai d'Oro*[9]	*Luna*			
Window, Foemina, Metamauco,	*Tholtico*	*Vittoria*	*Nogales*			
Manhattan Sunset, Giudecca[5]			*Positano*			

Notes

1 The *Saturno* was first developed by Lino Tagliapietra around 1976, while he was still working in industry.

2 The *Saturneo* was developed around 1966.

3 *Gabbia*, *Spider*, and *Borneo* are titles of the same series. *Gabbia* and *Spider* were used in 1993 and *Borneo* has been used since 1996. The *Rainbow* series created in 1985 for Effetre International used the same technique.

4 *Gondola*, *Endeavor*, *Cristallo*, and *Adriatica* are titles for the "boat" forms. *Gondola* is used in Italy while *Endeavor* is used in the United States. In 1996, a single colorless boat with white canes was entitled *Cristallo*. In 2006, the name *Adriatica* was given to a new series of colorless boats. An ensemble of boats entitled *Festa della Sensa* first appeared in Galleria Marina Barovier in

1997. It reappeared in 2000 as the title of Tagliapietra's exhibition at the William Traver Gallery in Seattle. Twenty boats were installed in the Sala della Quarantia Civile in the Palazzo Ducale for the second *Venezia Aperto Vetro* exhibition in 1998. This installation was entitled *Flying Boats*.

5 The series *Foemina* was created in 1996. It took the voluptuous curved body of the 1995 *Window* form and extended it with a slender neck inspired by the familiar shape of Venetian chimneys. In that same year, a group of *Window* and *Foemina* pieces was installed in the first *Venezia Aperto Vetro* exhibition as the installation *Metamauco*. In 1998 another group of *Window* and *Foemina* pieces was made for exhibition at the Heller Gallery in New York City. That second installation was called *Manhattan Sunset*. A third installation of *Window* and *Foemina*

pieces called *Giudecca* was created in 2000 for the exhibition *A. D. Copier & Lino Tagliapietra: Inspiratie in glas, Inspiration in Glass* at the Gemeentemuseum Den Haag.

6 *Concerto*, *Concerto di Primavera*, and *Samba do Brasil* were ensembles of pieces drawn largely from the *Dinosaur* series. *Diaspora*, *Esodo*, and *Lettera* were ensembles of miniature *Dinosaurs*.

7 *La Carta dei Songi* is a series of panels created at Bullseye Glass.

8 *Spigatoni* and *Bilbao* are titles for the same series. *Spigatoni* was used in Italy and *Bilbao* in the United States.

9 *Masai* is a multipiece wall installation. *Masai d'Oro* is a version of *Masai* in gold.

10 *Venice* is a blown and fused glass panel.

11 *Marumea* is a multipiece wall installation.

173

ESSENTIAL LINO: A SELECTION OF RESOURCES

Note: An extensive bibliography on Lino Tagliapietra is available upon request from the Rakow Library of the Corning Museum of Glass.

Books and Catalogues

Barovier, Marino, ed. *Tagliapietra: A Venetian Glass Maestro*. Dublin: Vitrum / Links for Publishing, 1998.

Barovier, Marino. *Lino Tagliapietra*. Privately published on the occasion of Lino Tagliapietra's 70th Birthday. Venice: Trevisanstampa, 2004.

Bullseye Connection Gallery. *Lino Tagliapietra at Bullseye Glass: Masterworks from Furnace and Kiln*. Portland, OR: Bullseye Connection Gallery, 1999.

Columbus Museum of Art. *The Art of Lino Tagliapietra: Concerto in Glass*. Columbus, OH: Columbus Museum of Art, 2003.

Eliëns, Titus M. *A. D. Copier & Lino Tagliapietra: Inspiratie in glas, Inspiration in Glass*. Den Haag: Gemeentemuseum; Gent: Snoeck-Ducajo & Zoon, 2000.

Fuller Museum of Art, and Society of Arts and Crafts. *Lino Tagliapietra*. Brockton, MA: Fuller Museum of Art; Boston: Society of Arts and Crafts; Braintree, MA: MacDonald & Evans, 2001.

Galleria Marina Barovier. *Lino Tagliapietra, 50 Anni di Vetro*. Venezia: Galleria Marina Barovier, 1996.

Gemeentemuseum Arnhem. *A. D. Copier 1986: Filigrane Interferenti®, Nieuwe Unica A. D. Copier, Uitvoering in Samenwerking met Effetre International Murano*. Arnhem, the Netherlands: Gemeentemuseum Arnhem, 1986.

Glasmuseum Ebeltoft. *Lino Tagliapietra, 18th May–6th October 1996*. Ebeltoft, Denmark: Glasmuseum, 1996.

Haags Gemeentemuseum; Gemeentemuseum Van Reekummuseum Apeldoorn. *A. D. Copier, Dialoog met glas*. Haags Gemeentemuseum; Gemeentemuseum Van Reekummuseum Apeldoorn, 1982.

Friesen Gallery Fine Art. *Lino Tagliapietra: Maestro*. Sun Valley, ID: Friesen Gallery, 2005.

Heller Gallery. *Lino Tagliapietra: La Danza con Fuoco, a Dance with Fire*. New York: Heller Gallery, 2004.

Heller Gallery. *Lino Tagliapietra: Significant Form*. New York: Heller Gallery, 2006.

Leung, T. S. *Lino's Fabulous Food: Eating with the Maestro*. Seattle, WA: Lino Tagliapietra, Inc., 2006.

Marianna Kistler Beach Museum of Art. *Giving Life to Glass: The Art of Lino Tagliapietra*. Manhattan, KS: Kansas State University, 2004.

Marx-Saunders Gallery. *Materia e Poesia, Material & Poetry: Lino Tagliapietra*. Chicago, IL: Marx-Saunders Gallery, Ltd., 2005.

Museum Boymans-Van Beuningen Rotterdam. *Uit het licht van de lagune: textiel van Norelene, glas van Tagliapietra | By the light of the lagoon: Fabrics by Norelene, Glass by Tagliapietra*. Rotterdam: Museum Boymans-Van Beuningen Rotterdam, 1988.

Sarpellon, Giovanni. *Lino Tagliapietra: vetri, glass, verres, glas*. Venice: Arsenale Editrice, 1994.

William Traver Gallery. *Lino Tagliapietra: "La Ballata del Vetro Soffiato," an exhibition marking the Italian maestro's achievement in the world of studio glass*. Seattle, WA: William Traver Gallery, 2002.

Articles

Berndt, Louise. "Murano's Opinion." *Glass (UrbanGlass Art Quarterly)*, no. 56, summer 1994, pp. 36–45.

De Combray, Natalie and Lino Tagliapietra. "Conversation." *Glass (UrbanGlass Art Quarterly)*, no. 39, 1990, pp. 12–13.

Glowen, Ron, Richard Marquis, Lino Tagliapietra, and Tina Oldknow. "1997 Lifetime Achievement Award: Lino Tagliapietra." *Glass Art Society Journal*, 1997, pp. 8–14.

Kangas, Matthew. "What America Taught Lino." *Glass (UrbanGlass Art Quarterly)*, no. 104, Fall 2006, pp. 44–53.

Klein, Dan. "Lino Tagliapietra." *Neues Glas*, no. 2, 1996, pp. 26–33.

Marquis, Richard. "Maestro Lino." *American Craft*, v. 57, no. 6, December 1997 / January 1998, pp. 40–45.

Milne, Victoria, and Benjamin Moore. "Conversation" [about Lino Tagliapietra], *Glass (UrbanGlass Art Quarterly)*, no. 55, summer 1994, pp. 12–15.

Oldknow, Tina. "Conversazione con Lino Tagliapietra, Conversation with Lino Tagliapietra." *Vetro (Centro Studio Vetro, Murano)*, no. 3, April–June 1999, pp. 24–33.

Tagliapietra, Lino. "Letters." *Glass (UrbanGlass Art Quarterly)*, no. 57, Fall 1994, p. 7.

Tagliapietra, Lino. "When There Is an Artist Between the Glass and Me." *Glass Art Society Journal*, 1994, pp. 65–69.

Videos

The Time of Lino, Todd Pottinger, Audio/Visual Producer. Tacoma, WA: Museum of Glass, 2008. 48 min.

Lino Tagliapietra Maestro of Glass, Mark Pingry Productions, 2002. 30 min.

Masters of Murano, Oggetti Films, 1982. 17 min.

The Master Class Series volume I: Cane Working with Lino Tagliapietra, Corning, NY: The Studio of the Corning Museum of Glass, 1998. 30 min.

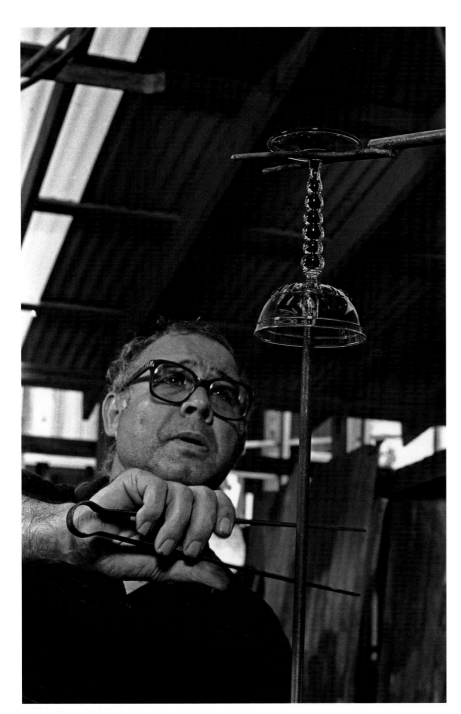

FIG. 91. Making a goblet, 1983

Podcasts

Frantz, Susanne K., and Lino Tagliapietra, *Conversation in the Gallery*, Tacoma, WA: Museum of Glass, 2008; accessed from the museum website www.museumofglass.org, Spring 2008.

Oldknow, Tina. *Meet the Artist 2: Lino Tagliapietra*, Corning, NY: Corning Museum of Glass, 2007, 20 min. www.cmog.org/podcasts/cmog_meet_the_artist.xml.

Context

American Craft Museum. *Venetian Glass: The Nancy Olnick and Giorgio Spanu Collection*. New York: American Craft Museum; Milano: Charta, 2000.

Barovier Mentasti, Rosa. *Vetro Veneziano 1890–1990*, Venice: Arsenale Editrice, 1992.

Barovier Mentasti, Rosa, Attilia Dorigato, Giandominico Romanelli, et al. *Vetri Murano Oggi*. Milan: Electa, 1981.

Carnegie Museum of Art. *Viva Vetro! Glass Alive! Venice and America*. Pittsburgh, PA: Carnegie Museum of Art, 2007.

Dorigato, Attilia, and Dan Klein, eds. *Venezia Aperto Vetro, International New Glass*. Venezia: Arsenale Editrice, 1996.

Dorigato, Attilia, Dan Klein, and Rosa Barovier Mentasti, eds. *Venezia Aperto Vetro 1998, International New Glass*. Milano: Electa, 1998.

Frantz, Susanne K. *Contemporary Glass: A World Survey from the Corning Museum of Glass*. New York: Harry N. Abrams, 1989.

Oldknow, Tina. *Pilchuck: A Glass School*. Seattle, WA: Pilchuck Glass School, 1996.

Polak, Ada. *Glass, Its Tradition and Its Makers*. New York: G. P. Putnam's Sons, 1975.

Ricke, Helmut, and Eva Schmitt. *Italian Glass, Murano–Milan 1930–1970*. Munich and New York: Prestel, 1997.

Scuola Internazionale del Vetro. *Primo, Secondo, Terzo corso per artisti*. Venezia: Arti Grafische Gasparoni, 1977, 1979, 1983.

Tait, Hugh, ed. *Glass, 5,000 Years*. New York: Harry N. Abrams, 1991.

175

176

FIG. 92. *Borsella d'Oro* (Golden Jacks) Award from
the first San Nicolò Exhibition, 1968 (CAT. 4)
First prize awarded to Lino in a glassblowing
competition held only twice in Murano. The *borsella*
(called jacks in Studio Glass terminology) is a tool
for shaping hot glass.

SELECTED PUBLIC COLLECTIONS

Carnegie Museum of Art, Pittsburgh, Pennsylvania

Chrysler Museum of Art, Norfolk, Virginia

Columbia Museum of Art, Columbia, South Carolina

Columbus Museum of Art, Columbus, Ohio

Corning Museum of Glass, Corning, New York

Dayton Art Institute, Dayton, Ohio

Detroit Institute of Arts, Detroit, Michigan

Fuller Craft Museum, Brockton, Massachusetts

Glasmuseet Ebeltoft, Ebeltoft, Denmark

Hokkaido Museum of Modern Art, Sapporo, Japan

Kestner-Museum, Hanover, Germany

Kitazawa Museum of Art, Suwa, Japan

de Young Museum, San Francisco, California

Marianna Kistler Beach Museum of Art, Manhattan, Kansas

Metropolitan Museum of Art, New York, New York

Mint Museum of Craft + Design, Charlotte, North Carolina

Musée de design et d'arts appliqués contemporains, Lausanne, Switzerland

Musée des Arts décoratifs, Paris, France

Museo del Vidrio, Monterrey, Mexico

Museum Boymans Van Beuningen, Rotterdam, the Netherlands

Museum of Fine Arts, Houston, Texas

Museum of Glass, Tacoma, Washington

National Museum of Modern Art, Tokyo, Japan

Orlando Museum of Art, Orlando, Florida

Racine Art Museum, Racine, Wisconsin

Statens Museum for Kunst, Copenhagen, Denmark

Seattle Art Museum, Seattle, Washington

Spencer Museum of Art, University of Kansas, Lawrence, Kansas

Toledo Museum of Art, Toledo, Ohio

Toyama City Institute of Glass Art, Toyama, Japan

Victoria and Albert Museum, London, England

GLOSSARY

This list is limited to terms used in this publication. It was assembled from a number of published resources and an extensive online glossary accessed through http://www.barovier.com.

Amphoriskos (Greek): A flask with two small side handles that often has a pointed base.

Annealing: The gradual cooling of an object to avoid internal stresses that may lead to breakage.

Axis, changed or turned: The process of reorienting the inflated glass bubble and its design by opening a new hole and transferring the piece to a different blowpipe.

Batch: The mixture of raw materials that is melted to make glass. The glass recipe usually calls for silica (from sand, flint, or quartz), an alkali (in the form of soda ash or potash), lime, and fragments of previously made glass, called "cullet," to act as a flux, reducing the time or temperature needed to melt the recipe ingredients.

Battuto (It. beaten): Small, superficial cuts on the glass, often olive-shaped, that are placed side by side to produce a texture reminiscent of hammered or beaten metal. The cuts may be polished or left with a matte finish.

Bench: The chair on which the glassblower sits to work. The blowpipe or pontil holding the molten glass is rolled back and forth on the seat's flat, extended arms as the glassblower shapes the glass. The hot glass may be worked solid or inflated into a bubble.

Block: A wooden, ladle-shaped tool used to give a rounded shape to a hot gather of glass. The block is kept wet to reduce charring and to create a "cushion" of steam between it and the glass.

Blowing: The process of forming an object by inflating a gather of molten glass on the end of a blowpipe.

Blowpipe: A hollow iron or steel tube, usually four to five feet long and slightly flared at one end and with a mouthpiece on the other. The glassblower slowly twists the slightly flared end of the pipe into the molten glass to collect the gob or gather.

Cane: Glass that is heated and then stretched into a thin rod. Several sections of cane may be fused together as a composite to create a pattern in cross-section. Slices of such a cane are called *murrine*.

Cased glass: A work is cased when a minimum of one layer of glass is covered with another. The outer layer is usually blown first, with the inner layer then blown into it. Part of the outer layer may be cut away to reveal another color of glass underneath.

Coldwork, coldworking: General terms for procedures done to the glass when it is in a cooled state. The processes may include cutting, engraving, grinding, and sandblasting.

Cutting or engraving: A technique for shaping or decorating glass using a rotating wheel attached to a lathe. The wheel, of stone, wood, or metal (frequently copper), is fed with an abrasive in order to grind away part of the glass surface. Most of Lino Tagliapietra's precision cutting is done using wheels covered with finely crushed diamond grit.

Dichroic glass: A type of glass whose physical properties enable it to appear as one color in reflected light, and another color when the light is transmitted through it.

Façon de Venise (Fr. Venetian style): Glass made outside of the Venetian territories in imitation of Venetian / Muranese production. It was popular in many parts of the Europe during the sixteenth and seventeenth centuries.

Filigrana (It. filigree): In American usage, a general term for a composite cane with internal linear patterning formed from lengths of bundled, fused, and pulled canes. Colorless glass encases parallel or twisted lines of colored and / or white cane, producing an effect that may be reminiscent of lace or filigree. There are various types of *filigrana* including *mezza filigrana*, *reticello*, and *zanfirico*.

Filigrana glass, *vetro a filigrana* (It. filigree glass): The collective term for blown glass incorporating canes as decoration. The style originated in Muranese glass factories in the first half of the sixteenth century and spread rapidly to other parts of Europe where *Façon de Venise* glass was being produced.

Furnace: An enclosed oven used to melt the batch mixture and keep the glass in a molten state, and also to reheat partly formed objects by inserting them through the side opening called the "glory hole."

Gaffer: The lead glassblower.

Gather: The collection of molten glass from the furnace on the end of the blowpipe or pontil. The mass of glass on the pipe may also be called "a gather."

Glory hole: The opening on the side of a glass furnace from which the glassblower gathers the hot glass, or into which the glass is inserted for reheating.

Hot application: Components fused to the molten glass stage during production. Applications may include trailing, handles, flowers, ribbons, spirals, and other sculptural elements.

Incalmo (It., plural incalmi): Two or more bubbles of molten glass that are opened, perfectly aligned at their rims, and then joined to form a single shape with a sharply delineated band or bands.

Inciso, incisone (It. incised): Decoration of narrow parallel lines cut into the surface of cooled glass.

Jacks (It. borsella): A tong-like metal tool for shaping the molten glass—to widen or narrow openings, to apply pressure, and to elongate. Variations of jacks designed for specific purposes include the borsella da siègar (segare: to saw), borsella da pissegàr (pízzicare: to pinch), borsella a gelosia (small blades for a small pinch), and borsella a squataròn (blades with crosswise grooves for squeezing and twisting).

Kick: A concave area in the base of a blown object where it has been pushed in by the pontil or another tool while the glass is hot.

Knop: A knob of glass, either solid or hollow, often used in the stem or cover finial of a goblet.

Lead glass: Glass that contains a high percentage of lead oxide (at least 20 percent of the batch mixture). It has a high refractive index (a measure of how intensely the glass changes the direction, or bend, of light waves striking its surface), which gives lead glass an exceptional brilliance when it is cut in facets. Sometimes colorless lead glass is erroneously called "crystal."

Maestro (It. master, plural maestri): A glassblower who has advanced to the highest level.

Maestrino (It. plural maestrini): An aspiring maestro.

Martelé (Fr. hammered): See: Batutto

Marver, marvering table: A smooth, flat surface (usually metal) on which the hot glass is rolled or pressed (verb: marvering) to smooth it, give it shape, and to secure it firmly to the blowpipe or punty. Sometimes surface embellishments are placed on the marver so they can be picked up on the molten glass.

Mezza filigrana (It.): Decoration of filigrana canes containing straight, parallel, white or colored threads worked to take on a diagonal slant. The effect is of closely spaced, concentric spiraling over the blown form.

Mezza stampaùra, mezza forma, mezza stampatura (It. half molding): A technique for producing vertical ribs on the lower portion of a blown glass vessel, first by adding molten glass to the bubble, and then pressing and blowing into an open optic(al) mold.

Murrina (It., plural murrine): A slice of a composite cane that forms an image or pattern in cross section. Murrine may be incorporated into the blown bubble to create one type of mosaic glass.

Optic(al) mold: A mold (usually of one piece and slightly conical) that is open at the top so that a bubble of hot glass may be pushed and blown into it and then withdrawn. The interior of the mold has a pattern in relief that is impressed upon the glass.

Piazza (It. plural piazze): The station centered around a glassblower's bench and usually made up of three to five workers. The basic positions are maestro (master glassblower), servente (first assistant), and garzone (general helper).

Pilchuck '96: A multi-step technique developed by Lino Tagliapietra to produce lines of color running vertically or diagonally through the blown glass.

Pulegoso (It.): From the dialect púlega, small bubble. Glass that contains minute, chemically induced bubbles that produce a foamlike appearance.

Punty, punty iron, pontil, pontil rod: A solid metal rod about the same length as the blowpipe, but slightly narrower in diameter. An object is usually transferred from the blowpipe to the punty for finishing at the furnace. To insure that the object adheres, the tip of the punty is prepared with a small gather or "bit" of molten glass; thus pontil can refer to the rod itself and also to the small glass gather that connects the rod to the piece being worked. The scar on the bottom of a finished piece left when the punty was broken off is called the "punty mark." The punty may also be used to gather glass that does not need to be blown, such as an application.

Reticello, vetro a reticello (It. small network, network glass): Glass with tightly crisscrossed filigrana canes forming a lattice pattern. Tiny bubbles may be deliberately entrapped between each of the cane intersections.

Ruby glass: A deep red glass; the color is obtained by adding gold chloride to the batch.

Soda-lime glass: Historically, the most common form of glass, and the type used for most Venetian glassmaking. It usually contains about 60–75 percent silica, 12–18 percent soda, and 5–12 percent lime. The glass is relatively light and remains workable over a wide range of temperatures.

Solid sculpting at the furnace: Shaping molten glass without inflating it.

Trail, trailing: A decorating process in which a strand or thread of molten glass is pulled directly from a gather onto the surface of the object being formed. The technique can produce a thin ring or a continuous spiral (wrap) as it winds around a rotating bubble of glass, or it may be applied in a free-form pattern. The still hot trail may subsequently be tooled into other patterns.

Vitreous enamel: An opaque or transparent glass colored with a metallic oxide that fuses at a relatively low temperature. When ground to a powder and mixed with a binder it may be used as painting medium on glass. Firing in a kiln burns away the binder and affixes the enamel to the surface of the glass base.

Wrap: See Trail.

Zanfirico, a retorti (It.): Intricate composite filigrana cane with a twisted and spiraling internal pattern of lines.

PHOTO CREDITS

With noted exceptions, all photos of objects are by Russell Johnson, courtesy of Lino Tagliapietra, Inc.

Francesco Barasciutti, courtesy of Lino Tagliapietra, Inc.: FIG. 49

Courtesy of Centre College, Danville, Kentucky: FIG. 84

Courtesy of the Corning Museum of Glass, Corning, New York: FIG. 71; PL. 54

Kellmis Fernandez, courtesy of the archives of Dan Dailey: FIG. 72

Susanne K. Frantz: FIGS. 48, 51, 53, 77

Courtesy of Glass Art Society, Seattle, Washington: FIG. 75

Arno Hammacher, courtesy of Dorris U. Kuyken-Schneider: FIG. 60

Russell Johnson: FIGS. 12, 19, 43, 47, 70, 74, 78, 79, 80, 81, 85, 86, 89, 90, 91

Russell Johnson, courtesy of Bullseye Glass, Portland, Oregon: FIGS. 76, 83

Russell Johnson and Jeff Curtis: FIGS. 2, 3, 4, 5, 7, 11, 87, 88, 92; PL. 1, 2, 3, 5, 6, 7, 8, 10, 11, 13, 14, 15, 16, 17, 18, 21, 22, 23, 24, 25, 26, 27, 28, 29, 32, 33, 34, 35, 38, 40, 43, 44, 46, 47, 53, 104, 113, 115, 116, 117, 125

Horst Kolberg, courtesy of the Düsseldorf, museum kunst palast, Glasmuseum Hentrich: FIGS. 25, 26, 27, 28, 34, 37, 38, 40, 42

Dorris U. Kuyken-Schneider: FIG. 59

Justin Kuravackal, courtesy of the Museum of Glass, Tacoma, Washington: FIG. 1, 92

Courtesy of Lino Tagliapietra, Inc.: FIGS. 21, 46, 50, 52, 54, 56, 57, 58, 61, 62, 63, 65, 68, 73, 82

Greg R. Miller: PL. 61

Courtesy of Ministero per I Beni e le Attivita Culturali—Soprintendenza per I Beni Archeologici del Veneto, Padova, Italy and Museo Vetrario, Murano, Italy: FIGS. 22, 23, 24

Courtesy of Benjamin Moore: FIGS. 6, 64

Benjamin Moore, courtesy of the Pilchuck Glass School, Stanwood, Washington: FIG. 66

Courtesy of Oggetti, Miami, Florida: FIG. 67

Hans Oostrum: FIG. 8; PL. 12

Duncan Price: FIGS. 10, 16, 45; PL. 51

Terry Rishel: PL. 114, 118, 119, 120, 121, 122, 123, 124

Courtesy of the Steinberg Foundation Archive, Vaduz: FIGS. 29, 30, 31, 32, 33, 35, 36, 39, 41

Bill Truslow, courtesy of The Archives of Dan Dailey: FIG. 13; PL. 36, 37

Nicholas Williams, courtesy of the Corning Museum of Glass, Corning, New York: FIGS. 9, 69; PL. 20, 30, 31, 52

Opposite:
FIG. 92. Lino at the Museum of Glass, 2007

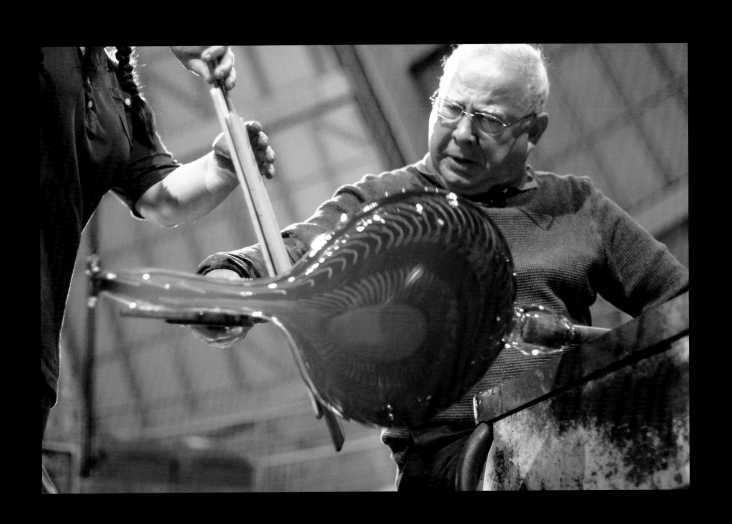

This publication is sponsored by

Rebecca and Jack Benaroya

The Paul G. Allen Family Foundation

Russell Investments

Windgate Charitable Foundation

Heritage Bank

The Boeing Company

Click! Network

The Seattle Times

and the

Seattle Post-Intelligencer

183

Lino Tagliapietra in Retrospect: A Modern Renaissance in Italian Glass is published in conjunction with the exhibition of the same name, organized by and presented at the Museum of Glass, Tacoma, Washington, from February 23–August 24, 2008, and with an exhibition tour 2008–2010.

ISBN 978-0-295-98825-2
Library of Congress Control Number: 2008900406

Published by
Museum of Glass
1801 Dock Street
Tacoma, WA 98402-3217
www.museumofglass.org

In association with
University of Washington Press
P.O. Box 50096
Seattle, WA 98145-5096
www.washington.edu/uwpress

Printed in Singapore